FEVER WITHIN

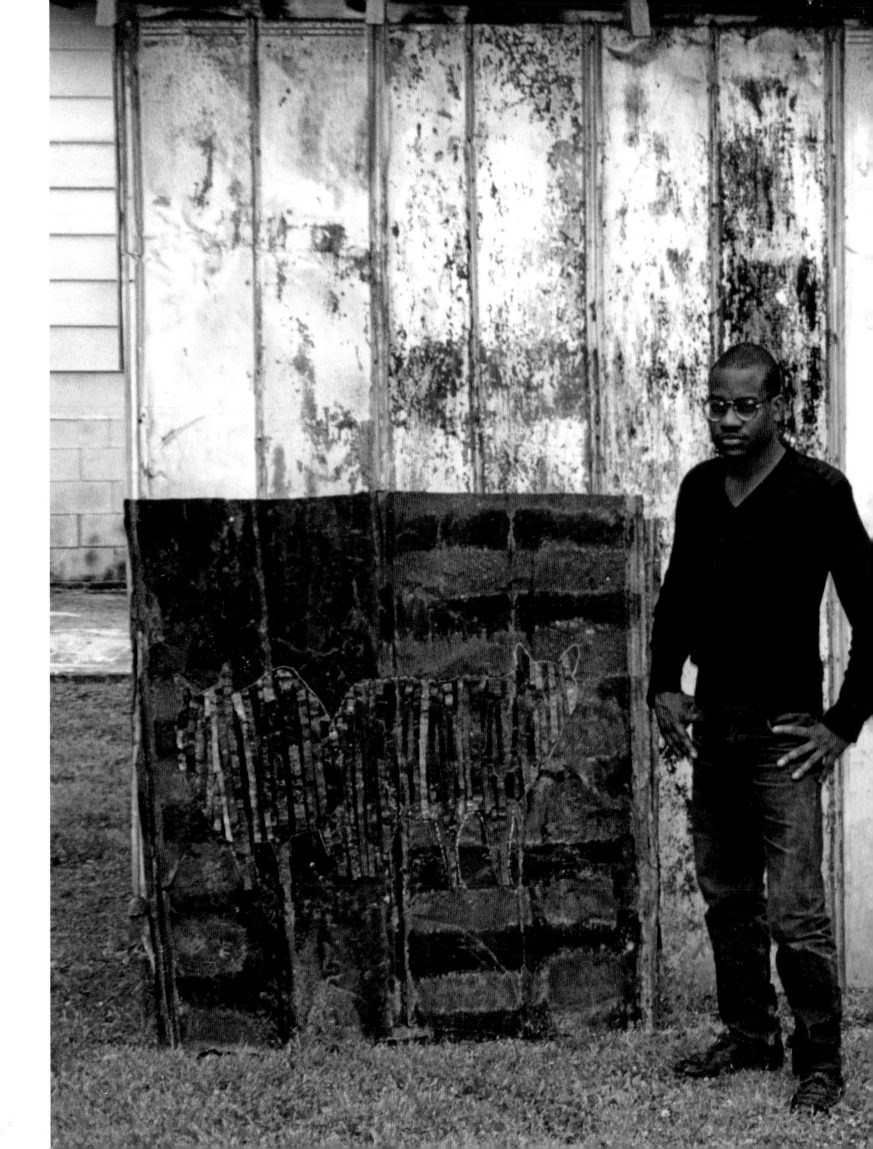

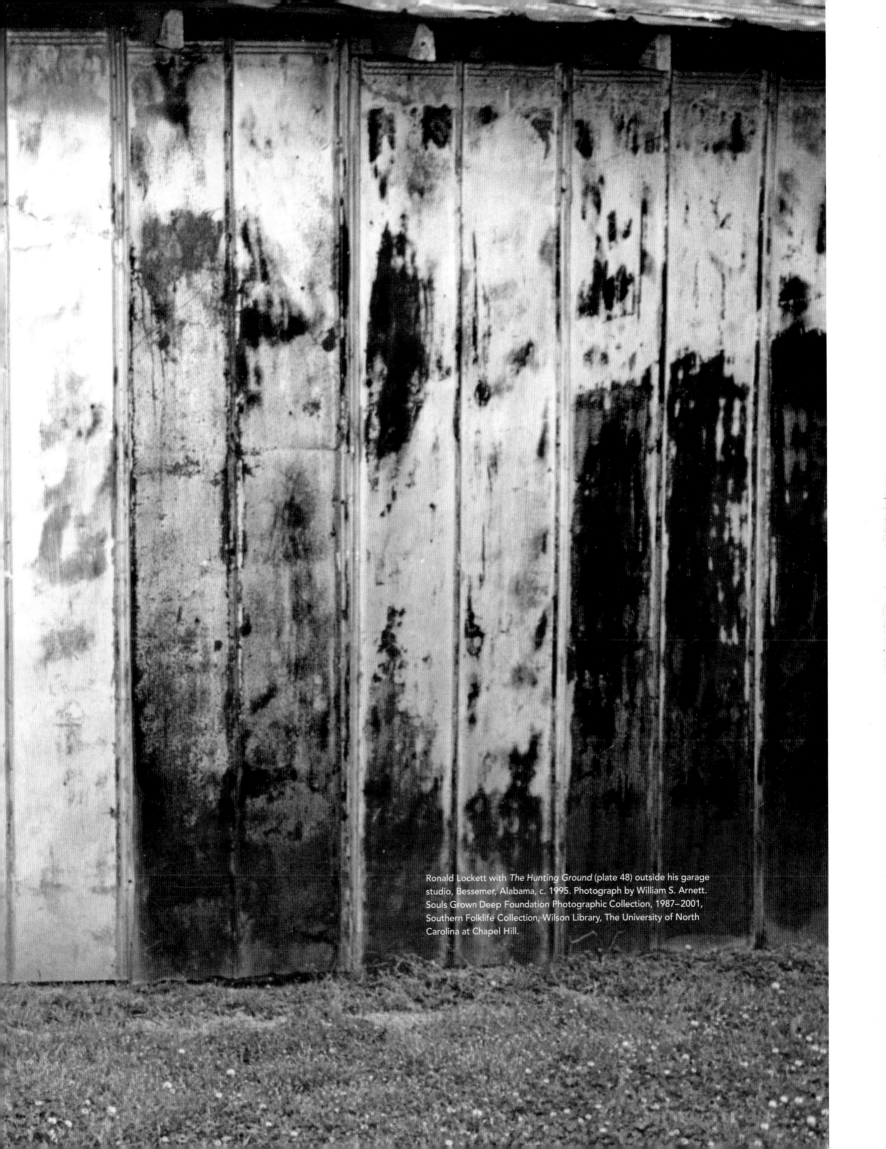

Ronald Lockett with *The Hunting Ground* (plate 48) outside his garage
studio, Bessemer, Alabama, c. 1995. Photograph by William S. Arnett.
Souls Grown Deep Foundation Photographic Collection, 1987–2001,
Southern Folklife Collection, Wilson Library, The University of North
Carolina at Chapel Hill.

FEVER WITHIN

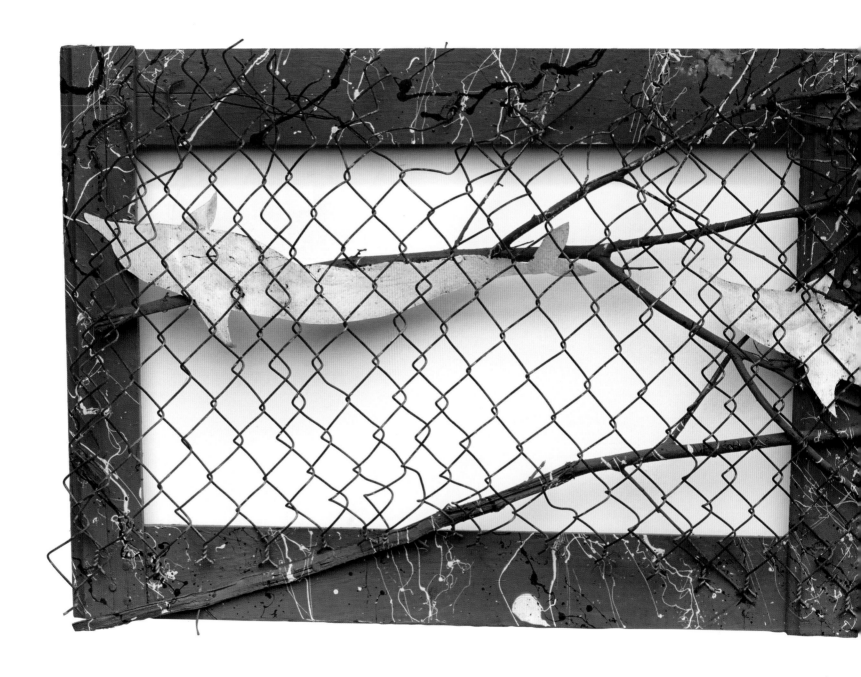

EDITED BY BERNARD L. HERMAN

The Art of Ronald Lockett

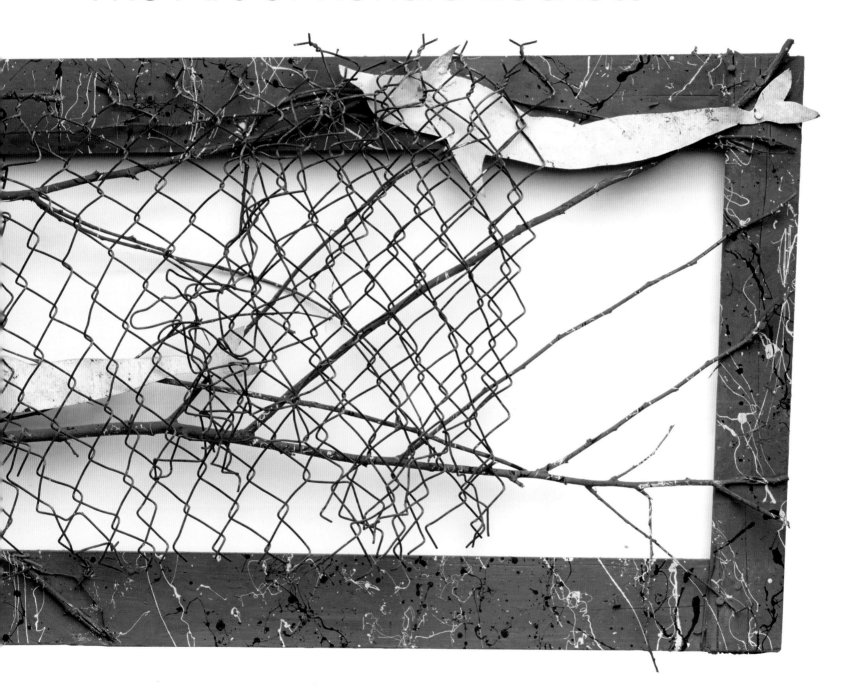

The University of North Carolina Press CHAPEL HILL

This book was published with support from the
Chair's Discretionary Fund to Support Southern Studies
at the University of North Carolina at Chapel Hill.

Manufactured in China
Designed and set by Kimberly Bryant in Miller and Avenir types

Cover illustration: Detail of Ronald Lockett's *Once Something Has
Lived It Can Never Really Die* (1996). 57 × 50.5 × 4 in. Cut tin, sticks,
chicken wire, industrial sealing compound, and found steel on wood.
William S. Arnett Collection of the Souls Grown Deep Foundation.
Photograph by Stephen Pitkin / Pitkin Studio, HELIOTRACK
automated lighting.

Library of Congress Cataloging-in-Publication Data
Fever within : the art of Ronald Lockett / edited by Bernard L. Herman.
 pages cm
Includes bibliographical references and index.
ISBN 978-1-4696-2762-5 (cloth : alk. paper)
ISBN 978-1-4696-2763-2 (ebook)
1. Lockett, Ronald, 1965–1998—Criticism and interpretation.
I. Herman, Bernard L., 1951– editor.
N6537.L6343F48 2016
700.92—dc23 2015035750

For William S. Arnett

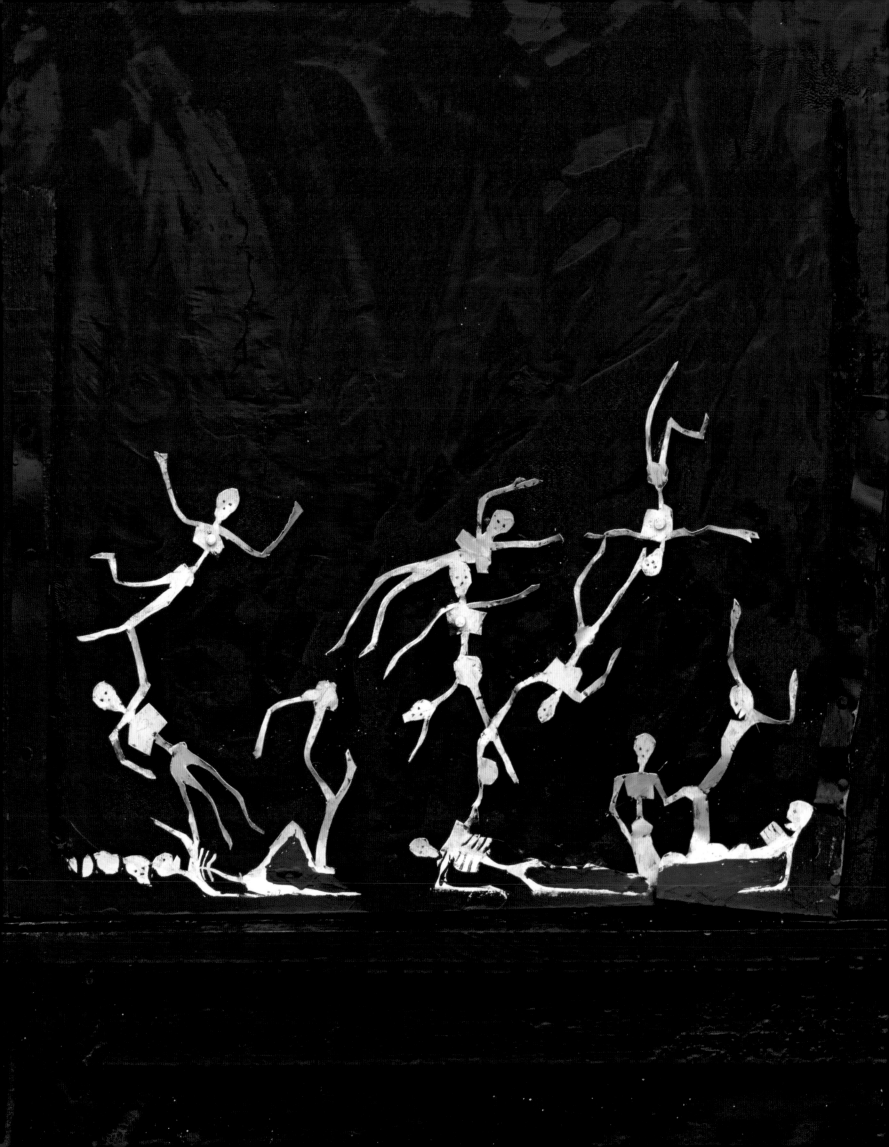

CONTENTS

ACKNOWLEDGMENTS

Total immersion marked my first encounter with the art of Ronald Lockett. Researching an essay on the architecture of quilts made in Gee's Bend, Alabama, I traveled to the Souls Grown Deep Collection in Atlanta, Georgia, to see the quilts and then travel to Alabama to interview the quilt makers. During a break in examining the quiltmakers' art at Souls Grown Deep, Bill Arnett, and his sons Paul and Matt invited me to explore the larger collection that included extraordinary works by Thornton Dial, Lonnie Holley, Joe Minter, Mary T. Smith, and many others. The power and array of the art was imagination-shattering. And then we came to a grouping of roughly four-foot-square mixed-media compositions constructed primarily of weathered and distressed metal siding and grating. Quiet works, blurring the boundaries between sculpture and painting, they radiated an emotional intensity that continues to haunt me. Later I learned that these works included part of a series on the Oklahoma City bombings fabricated by Ronald Lockett, a young Bessemer artist who died in 1998. Looking back on that first encounter and the privilege of working with Lockett's greater creative oeuvre, I realize that a doorway had opened onto a deeply affecting and artistically powerful universe. It was my good fortune to be invited into that space.

This collection of essays on the art of Ronald Lockett arose out of conversations with the visionary founder of the Souls Grown Deep Foundation: Bill Arnett, to whom this book is dedicated. Bill introduced me to Lockett's art and encouraged this project from the start. Standing in front of Lockett's *Oklahoma* series for the first time in the autumn of 2003, unable to process the power of the objects in front of me, I didn't need any persuasion. As Bill spoke and I listened, our goals took form and the long process of fieldwork, research, and reflection began. Throughout the entirety of our enterprise, Bill made the art available for study and offered his own thoughts and insights at crucial moments. Even on the occasions when we argued and disagreed, I knew he was right and invariably came away more deeply informed. Thus the first

and deepest acknowledgment goes to Bill Arnett, without whom there would be no book, no accompanying exhibition, and very likely no significant surviving body of Lockett's art.

My second measure of gratitude goes to Emily Kass, former director of the Ackland Art Museum at the University of North Carolina at Chapel Hill. Attempting to advance the art and artistic importance of a largely unknown individual more often than not labeled a "folk artist" and body of work that gives the lie to that categorization is no small task. Emily was there at the start and remained faithful to the project throughout. Without her bold vision and commitment to this book and the exhibition it accompanies, the project would have faltered. Peter Nisbet, Emily's successor at the Ackland, along with a dynamic team of museum colleagues, including Carolyn Allmendinger, Scott Hankins, Amanda Hughes, and Lauren Turner, intervened at all the critical moments.

This book is published on the occasion of the exhibition *Fever Within: The Art of Ronald Lockett*. Organized by the Ackland Art Museum at the University of North Carolina at Chapel Hill, the exhibition opened at the American Folk Art Museum, New York, 21 June–18 September 2016, before traveling to the High Museum of Art, Atlanta, Georgia, 9 October 2016–8 January 2017, and closing at the Ackland Art Museum, 27 January–9 April 2017.

Colleagues and friends at the Souls Grown Deep Foundation and William S. Arnett Collection responded over and over again to requests for information, images, and contacts. Without the timely assistance and good nature of Laura Bickford and Scott Browning this project surely would have foundered. Michael Sellman was always there to guide the logistics of our endeavor.

My thanks go to the authors whose ideas fill these pages: Paul Arnett, Sharon Holland, Katherine Jentleson, Thomas Lax, and Colin Rhodes. Each of them contributed insights into the complexities of Lockett's art and practice, revealing deeper significances in the artist's work as it evolved over a decade as well as the many contexts it has inhabited since his death in 1998. Their thinking unfailingly inspired me to reflect more deeply and differently on the art and artist.

All of us benefited hugely from the openness of Lockett's immediate and extended family. His father, Short Lockett, spent a day with us recollecting his son's gifts and celebrating his character. Lockett's brother, David, joined the conversation by phone and described Ronald's creativity and gentleness of spirit. Thornton Dial and his sons Richard and Donnie remembered Lockett in the same way. Together they described a corner of the old Pipe Shop neighborhood in Bessemer where Lockett grew up surrounded by family and deeply influenced by his elders, Sarah Dial Lockett and her husband Dave. At the conclusion of our visit and interview on a warm early spring afternoon Short Lockett drove us to his son's gravesite, located in a grassy cemetery where other family members rest.

Multiple conversations with artist, poet, and musician Lonnie Holley revealed much about how Lockett sought to move his art forward and the things that inspired him. Atlanta gallerist Barbara Archer spoke of her encounters with the artist at the start of his career, and filmmaker David Seehausen shared raw video footage of an interview with the artist in 1997, the year before he succumbed to the HIV/AIDS pandemic. Seehausen's interview material recorded a rare moment where the typically reticent artist spoke openly about his work and his expressive goals.

Students and colleagues at the University of North Carolina at Chapel Hill and the University of Delaware worked on this book and the accompanying exhibition from its inception. I am indebted to many students, past and present. Although I cannot list them all by name, special thanks go to Nicholas Bell, Katy Clune, Elijah Heyward, Rachel Kirby, Kim Kutz, Trista Reis Porter, Pamela Sachant, and Cara Zimmerman. Trista and Rachel provided invaluable assistance in the last stages of preparing the manuscript for publication. Stephen Weiss,

Aaron Smithers, and Patrick Collum at the Southern Folklife Collection and Wilson Library did heroic work processing Lockett materials formerly held in the Souls Grown Deep Archive, now in the permanent collections of the University of North Carolina at Chapel Hill libraries. Friends at the Center for the Study of American South—Kenneth Jannken, Harry Watson, Jocelyn Neal, Patrick Horn, Emily Wallace, and William Ferris—provided opportunities to present and discuss Lockett's work in colloquia and seminar. My fellow travelers in Folklore and American Studies at Carolina, particularly Glenn Hinson, Patricia Sawin, Katherine Roberts, Marcie Cohen Ferris, and Joy and John Kasson, encouraged this work from the start. I owe them all a great debt.

I am grateful for the many conversations shared with friends and the perspectives they offered on Ronald Lockett's art. Brooke Davis Anderson, Sussanneh Bieber, Nicholas Cullinan, Kathleen Foster, Tom Gallivan, Charles Isaacs, Carol Nigro, Molly O'Neill, Ann Percy, Valérie Rousseau, Charles Russell, and Mark Sloan: thank you. John Powell's response to Lockett's art on a visit to Atlanta infused this project with enthusiasm and crucial support. My great teachers Henry Glassie, David Orr, and Don Yoder instilled a passion for the aesthetics of everyday life that I pursue with absolute conviction. A lifetime of thanks go to David Shields, my dearest friend. We have never conducted a conversation from which I didn't come away challenged, enlightened, and laughing.

Several collectors and museums made their Lockett materials readily accessible. James and Barbara Sellman, Ron and June Shelp, Chuck and Harvie Abney, Stephen and Susan Pitkin, Vanessa Vadim, and Jane Fonda shared images and histories of Lockett works. The Ackland Art Museum, American Folk Art Museum, High Museum of Art, and Metropolitan Museum of Art generously provided access to the Lockett works in their collections.

The contributors to this collection extend additional appreciations. Thomas Lax thanks Andrea Rosen Gallery, the Felix Gonzalez-Torres Foundation, the Dia Art Foundation, and Harvard Art Museums. Colin Rhodes particularly extends his thanks to Short Lockett, "from one father to another," and to Richard and Thornton Dial and his family for all their support. Sharon Holland thanks Wiley McDowell and DETROIT(C+PAD). Katherine Jentleson and the rest of us celebrate the extraordinary kindnesses of the Souls Grown Deep Foundation and the William S. Arnett Collection. All of us also express our gratitude to the University of North Carolina Press. Mark Simpson-Vos believed in our enterprise and encouraged it every step of the way. Lucas Church, Jad Adkins, Christi Stanforth, and Mary Caviness, along with Kim Bryant and the production team at the press, brought clarity and beauty to this book. The contributors benefited hugely from the Press's editorial process and the constructive critical readings of two anonymous external reviewers, to whom we are deeply indebted for their candor and generosity of spirit.

Support for this book and its companion exhibition came from several sources. I began the work in earnest with a fellowship from the John Solomon Guggenheim Foundation. The Chair's Discretionary Fund to Support Southern Studies created by John Powell at the University of North Carolina at Chapel Hill and a grant from the National Endowment for the Arts provided the resources that brought our collaborative project from idea to reality.

Finally, my family makes it all happen. Our daughter Lania Rebecca Herman's responses to the art of Ronald Lockett and the other artists in the Birmingham-Bessemer School make me see the work anew. Rebecca Herman, my all in all, brings an aesthetics of grace and elegance of insight to every artistic moment that marks our life. There is no art without her presence.

FEVER WITHIN

Plate 1
Untitled (Elephant)
1988
30 × 54 × 9 in.
Wood sawhorse, metal wire, plastic vacuum-cleaner hose,
industrial sealing compound, and enamel
William S. Arnett Collection of the Souls Grown Deep Foundation
Photograph by Stephen Pitkin / Pitkin Studio, HELIOTRACK
automated lighting

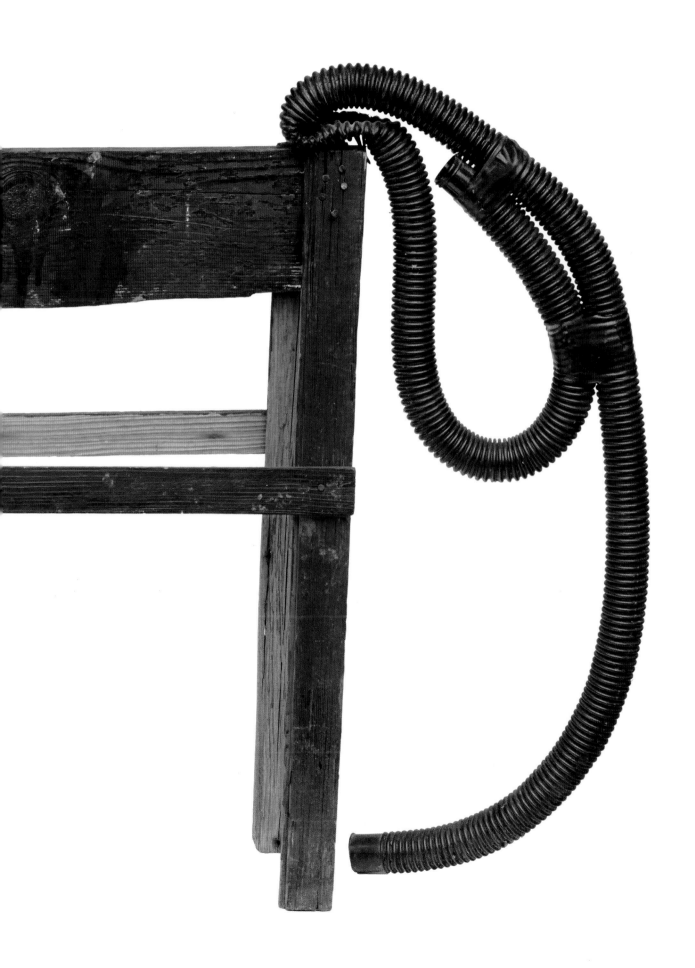

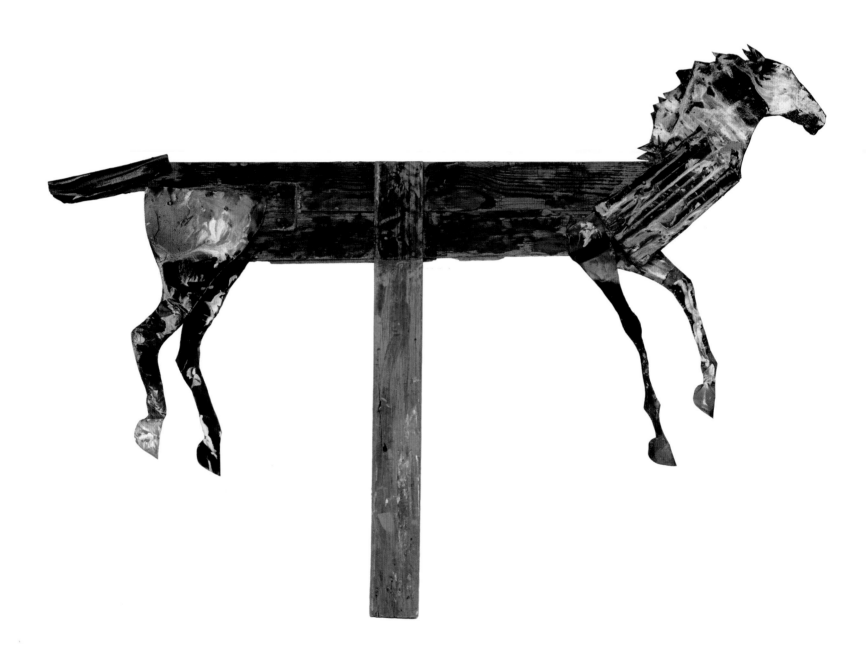

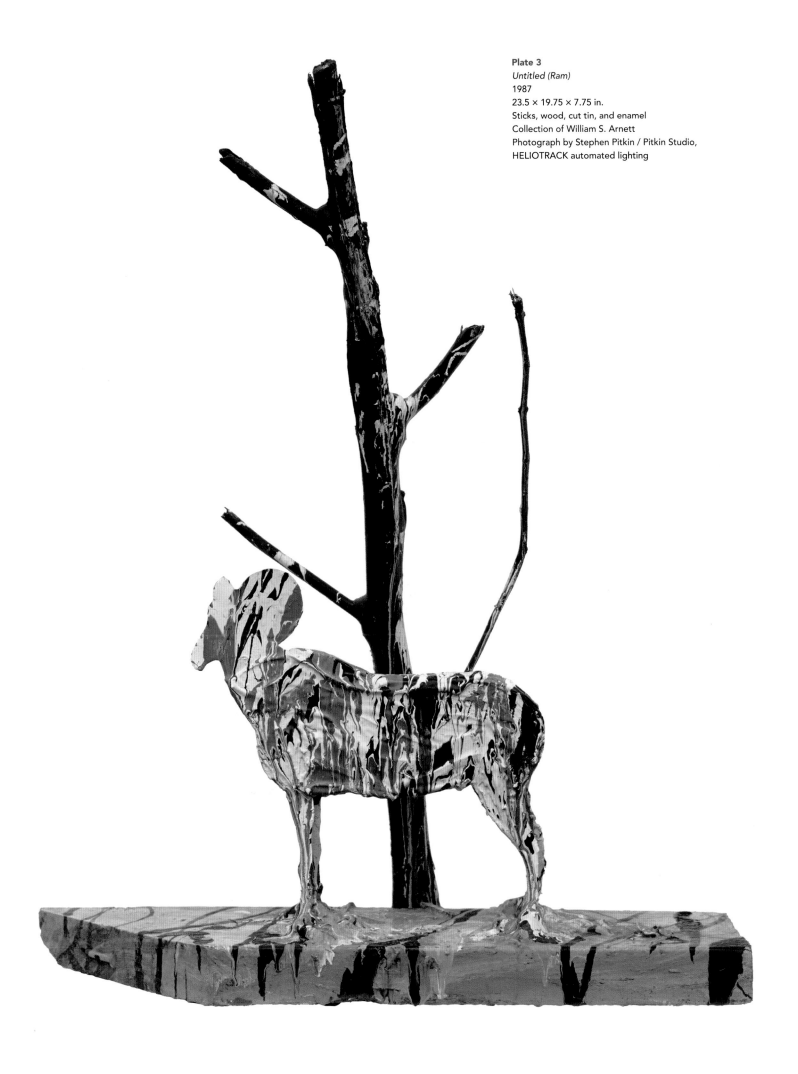

Plate 3
Untitled (Ram)
1987
23.5 × 19.75 × 7.75 in.
Sticks, wood, cut tin, and enamel
Collection of William S. Arnett
Photograph by Stephen Pitkin / Pitkin Studio,
HELIOTRACK automated lighting

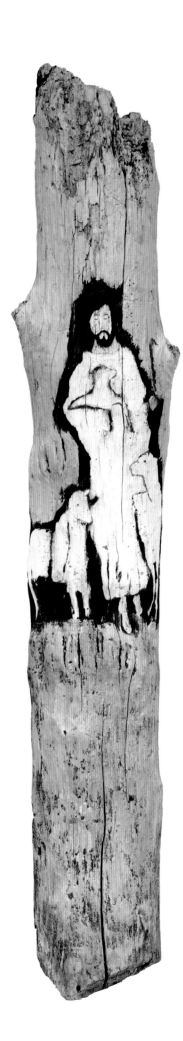

Plate 4
The Good Shepherd
1987
54.5 × 12 × 9 in.
Log and enamel
Collection of William S. Arnett
Photograph by Stephen Pitkin / Pitkin Studio,
HELIOTRACK automated lighting

Plate 5
The Last Supper
1987
16.25 × 45.5 × 1 in.
Enamel, wire, and found wood on plywood
Collection of William S. Arnett
Photograph by Stephen Pitkin / Pitkin Studio,
HELIOTRACK automated lighting

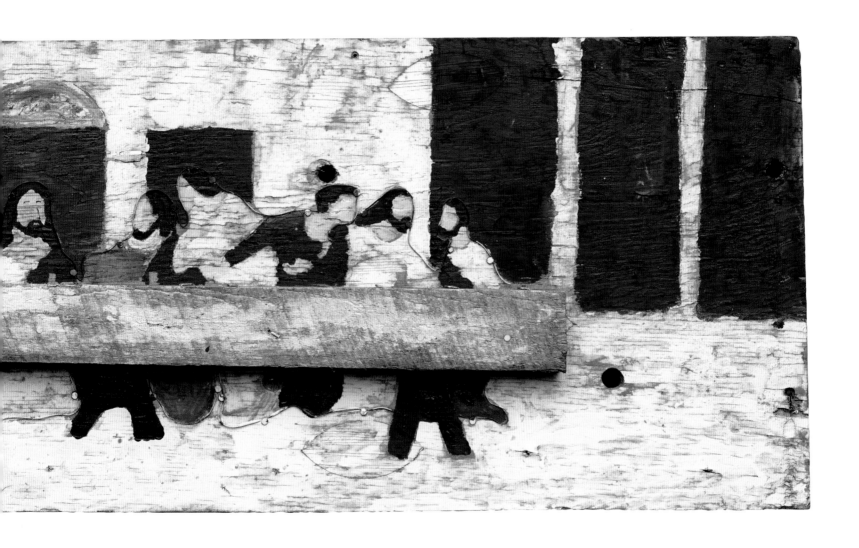

Plate 6
Morning of Peace
1988
48 × 47 × 1.5 in.
Chicken wire, wood, rope, and enamel on wood
William S. Arnett Collection of the Souls Grown Deep Foundation
Photograph by Stephen Pitkin / Pitkin Studio, HELIOTRACK
automated lighting

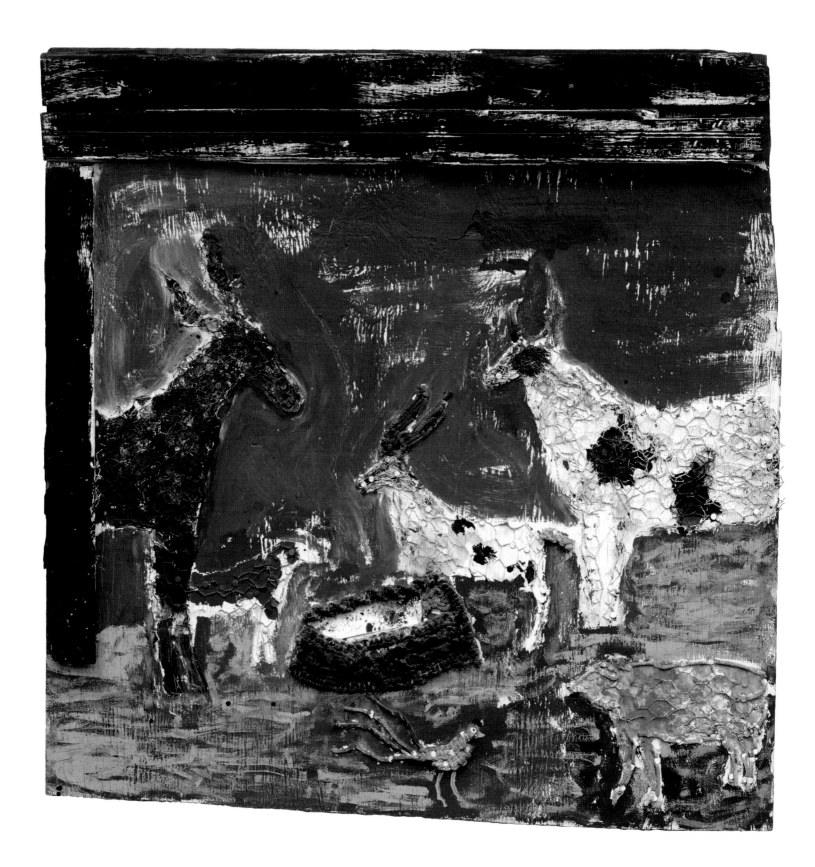

Plate 7
Untitled
1988
36 × 39 in.
Enamel on fiberboard
Collection of William S. Arnett
Photograph by Stephen Pitkin / Pitkin Studio,
HELIOTRACK automated lighting

Plate 9
Soul Mates
1989
48 × 48 in.
Wire, enamel, and industrial sealing compound on wood
Collection of William S. Arnett
Photograph by Stephen Pitkin / Pitkin Studio,
HELIOTRACK automated lighting

Plate 10
Untitled
1989
52.375 × 28.5 × 6.5 in.
Found wood, sticks, glass jug, and
enamel on fiberboard siding
Collection of William S. Arnett
Photograph by Stephen Pitkin /
Pitkin Studio, HELIOTRACK
automated lighting

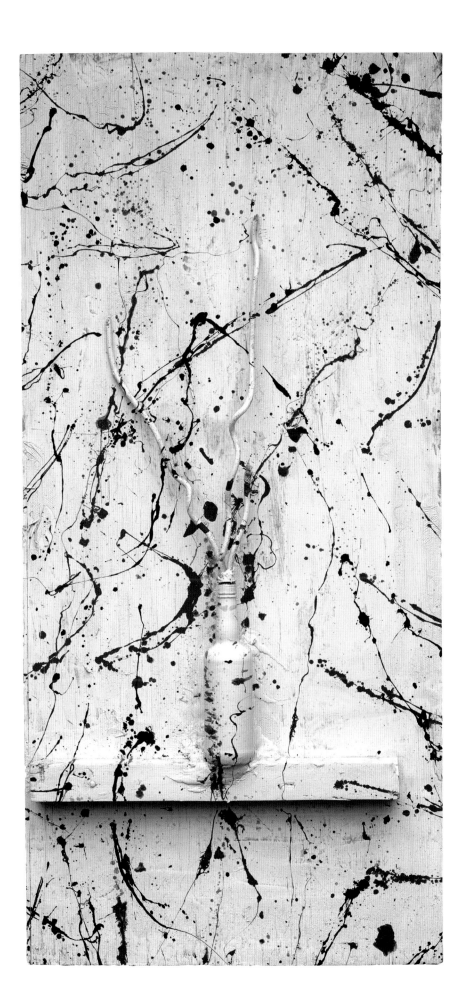

Plate 11
Untitled
1989
58.5 × 27.75 × 3 in.
Found wood, sticks, glass jug, and enamel
on plywood
Collection of William S. Arnett
Photograph by Stephen Pitkin / Pitkin Studio,
HELIOTRACK automated lighting

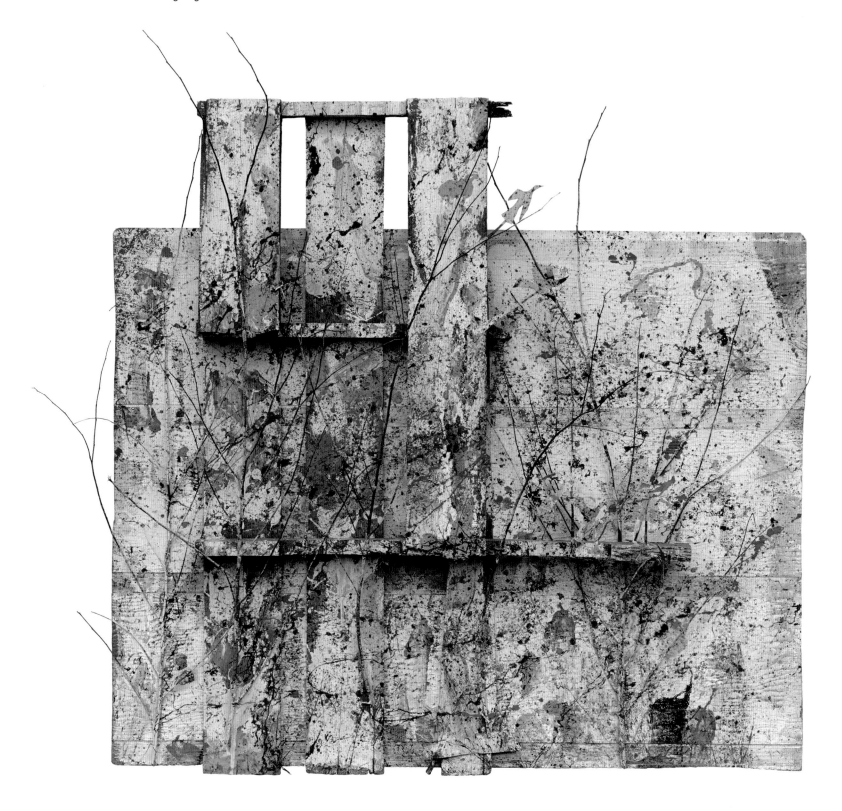

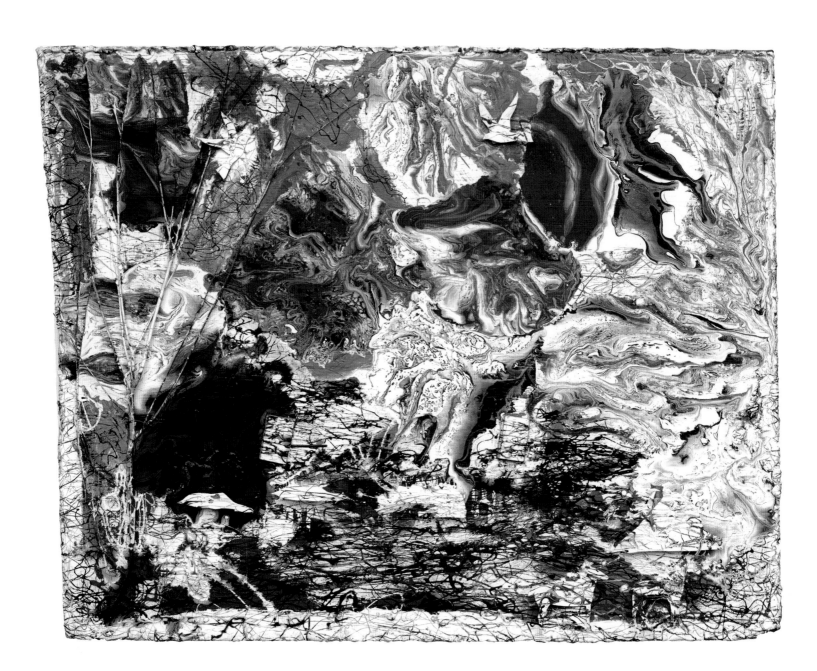

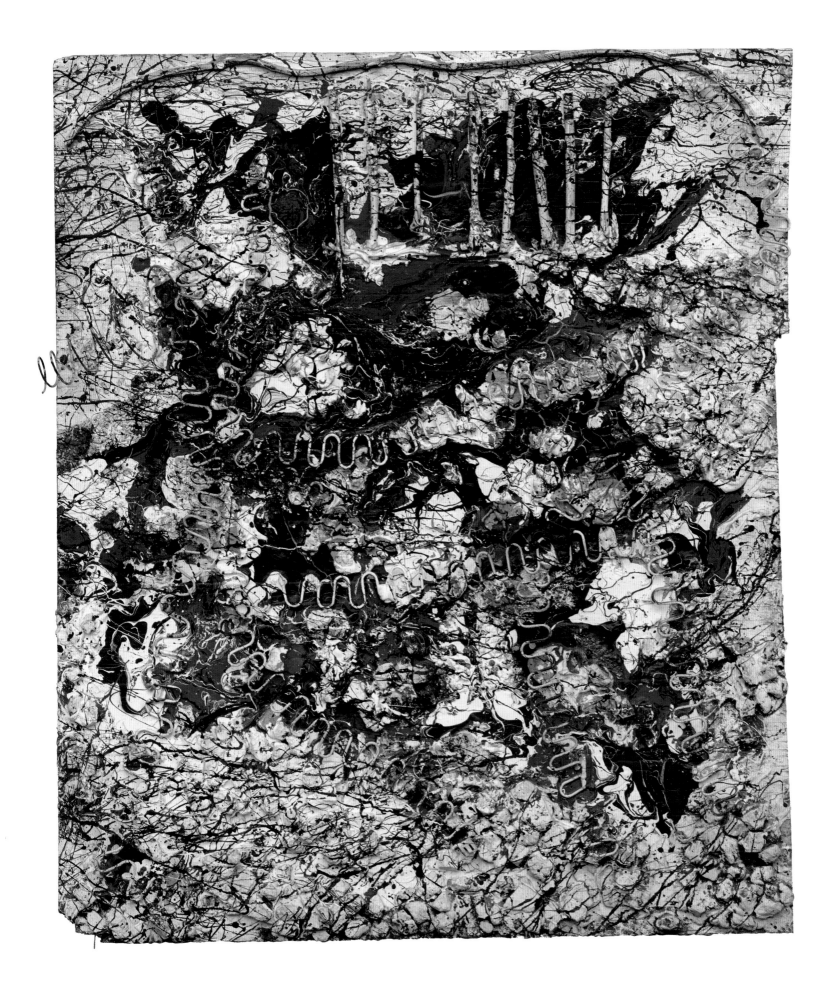

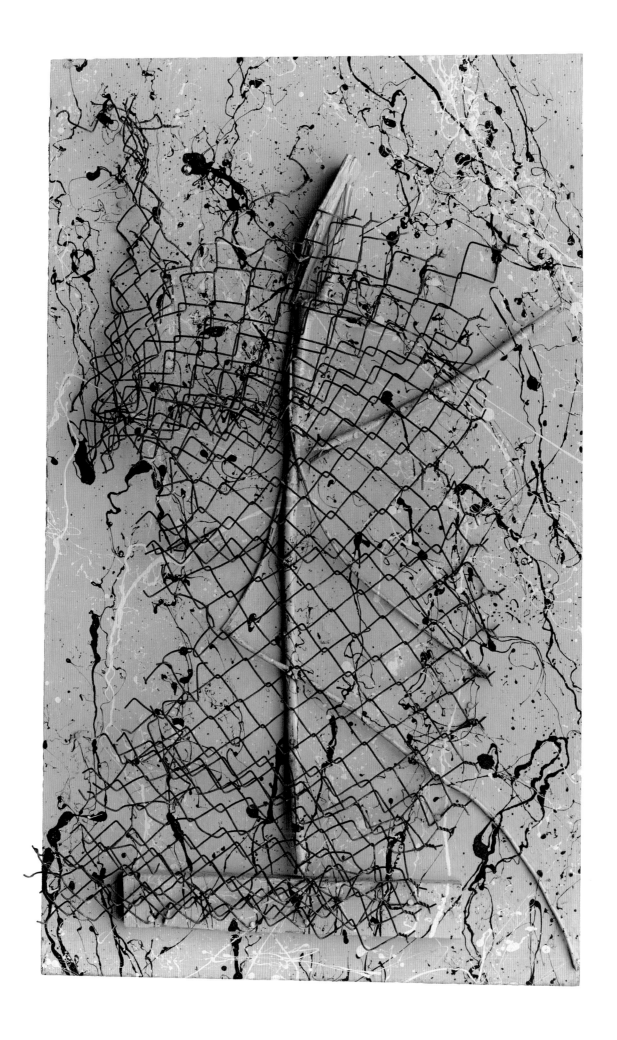

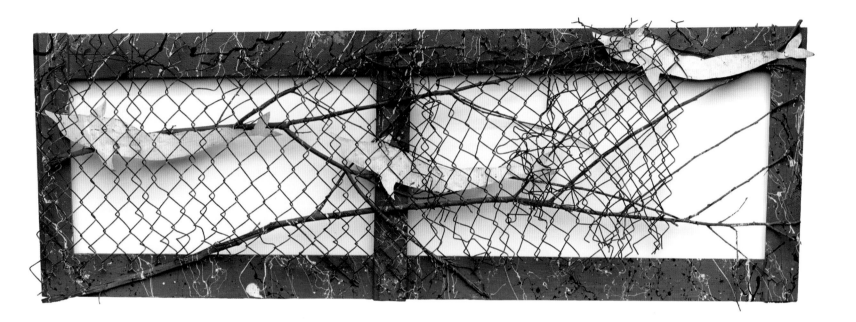

Plate 18
Driven from My Homeland
1988
48 × 267.5 × 5 in.
Chicken wire, cut tin, sticks, and enamel on plywood
Collection of William S. Arnett
Photograph by Stephen Pitkin / Pitkin Studio,
HELIOTRACK automated lighting

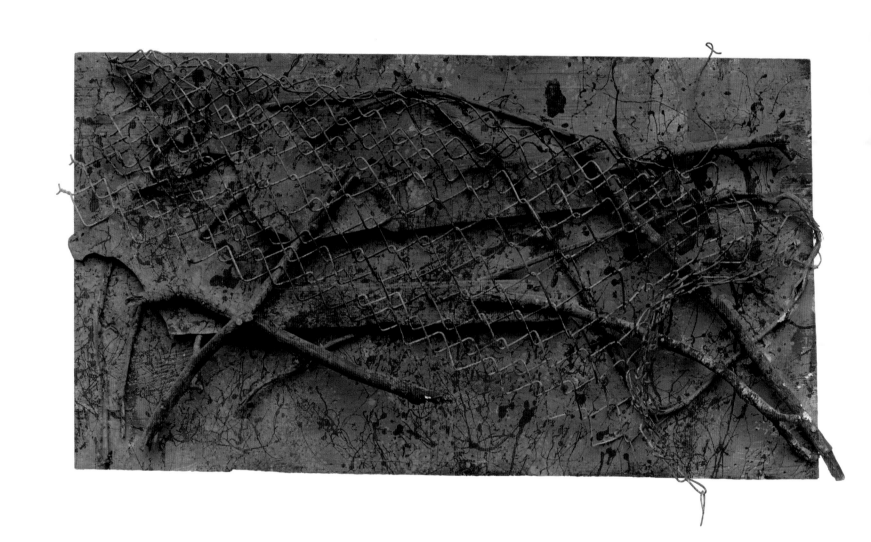

Plate 19
Traps
c. 1989
48 × 48 × 3 in.
Found metal, wire, wood, chain-link fence, and paint
Ackland Art Museum, The University of North Carolina
at Chapel Hill. Gift of the William S. Arnett Collection
and Ackland Fund, 2010.51.3

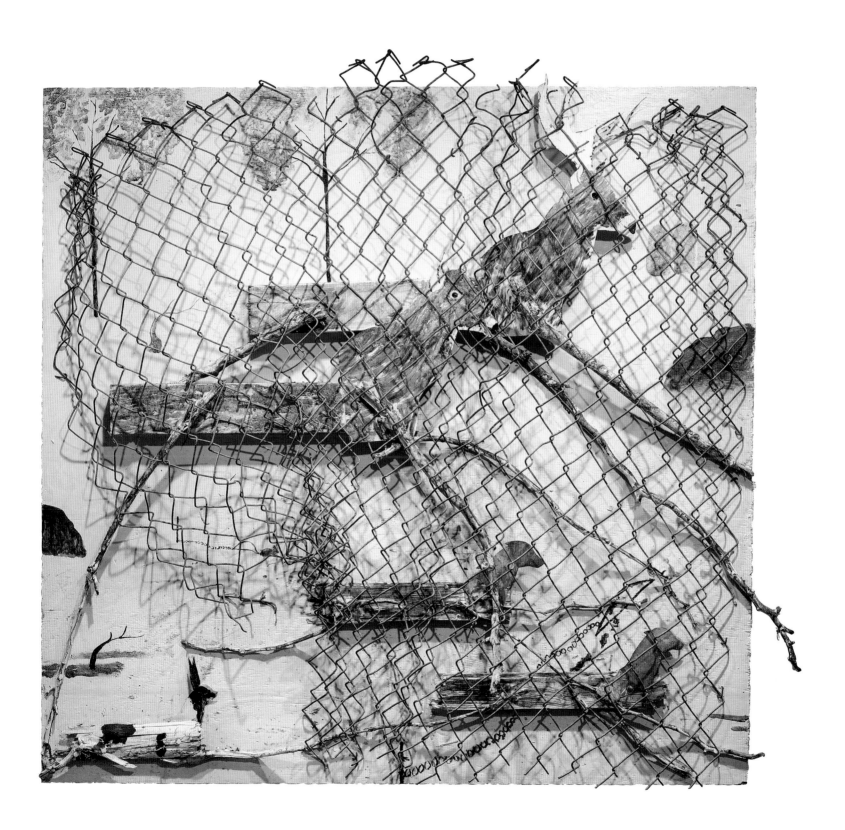

Plate 20
A Place in Time
1989
48 × 79.5 × 5 in.
Wood, cloth, plastic netting, cut tin, industrial sealing compound,
oil, and enamel on plywood
William S. Arnett Collection of the Souls Grown Deep Foundation
Photograph by Stephen Pitkin / Pitkin Studio, HELIOTRACK
automated lighting

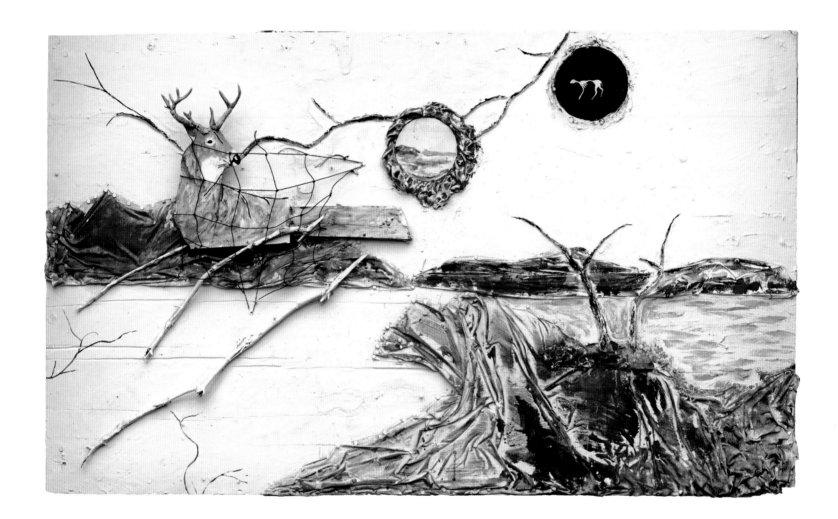

Plate 21
Crossing Over
1989
55 × 72 in.
Wood, cloth, cut tin, industrial sealing
compound, oil, and enamel on plywood
Collection of William S. Arnett
Photograph by Stephen Pitkin / Pitkin Studio,
HELIOTRACK automated lighting

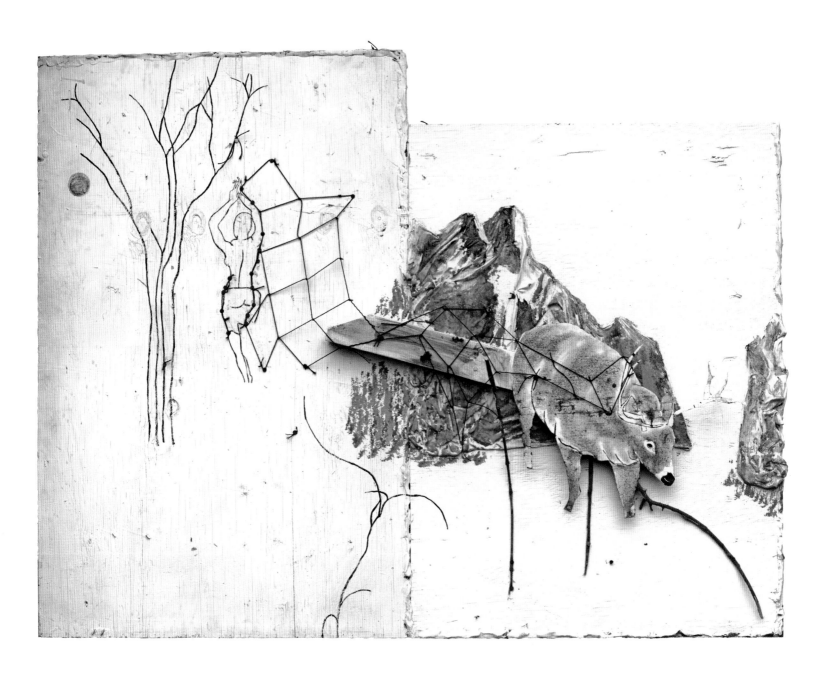

Plate 22
Traps (Golden Bird)
1990
48 × 48 × 4 in.
Chicken wire, cut tin, sticks, found plastic bird figurine,
and enamel on plywood
Collection of William S. Arnett
Photograph by Stephen Pitkin / Pitkin Studio,
HELIOTRACK automated lighting

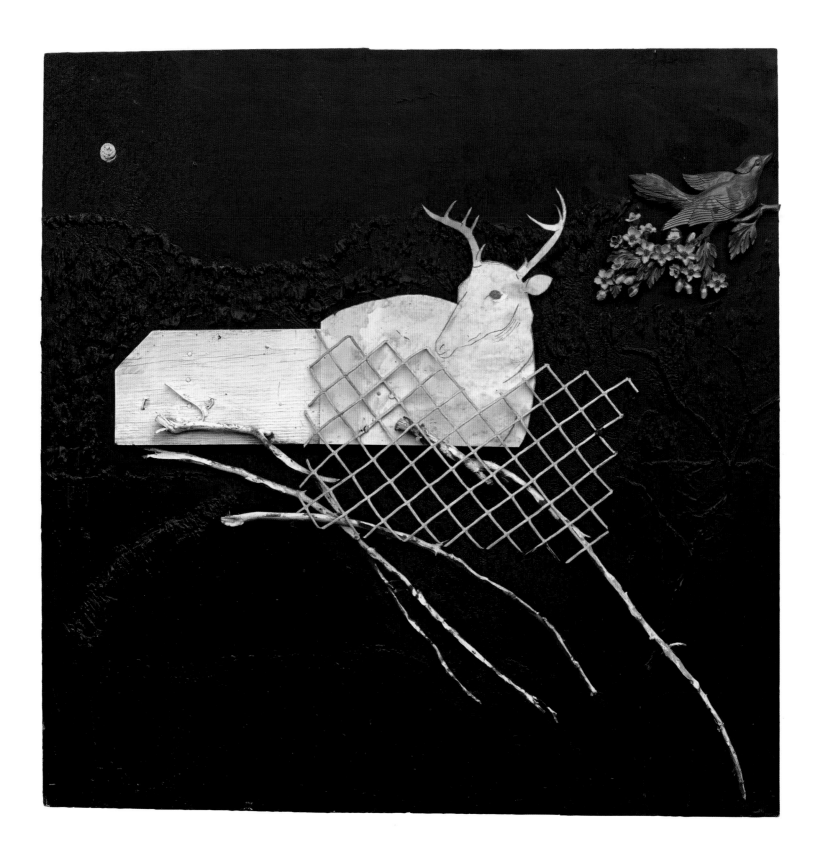

Plate 23
Cry Heard across the World
1991
25 × 66 in.
Enamel on Masonite
Collection of William S. Arnett
Photograph by Stephen Pitkin / Pitkin Studio,
HELIOTRACK automated lighting

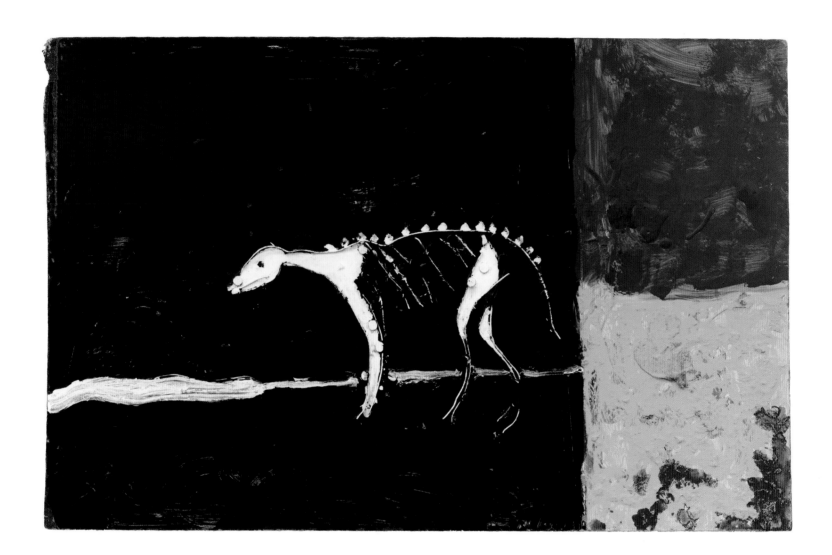

Plate 26
Holocaust
1988
48 × 72 × 5 in.
Wood, metal, nails, and enamel on plywood
William S. Arnett Collection of the Souls Grown Deep Foundation
Photograph by Stephen Pitkin / Pitkin Studio, HELIOTRACK
automated lighting

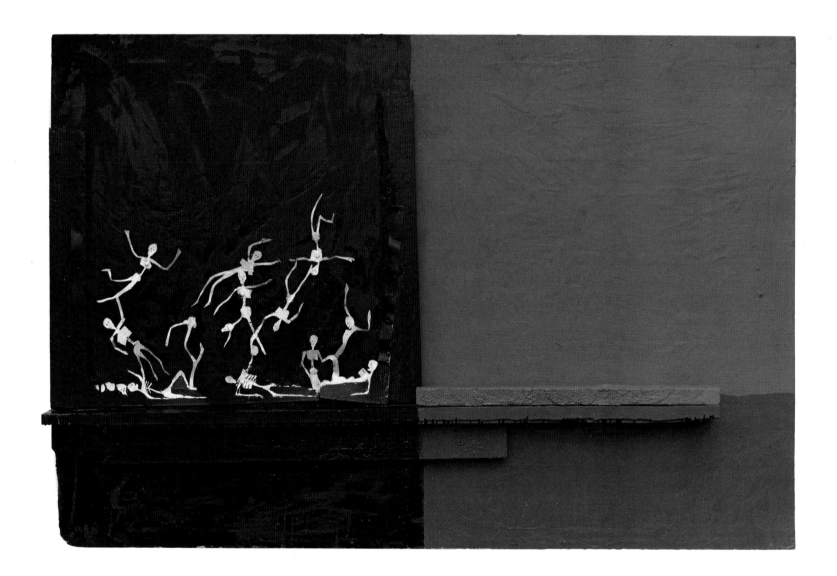

Plate 27
Hiroshima
1988
21 × 45 × 3 in.
Plastic vent, Bondo, and enamel on wood
William S. Arnett Collection of the Souls Grown Deep Foundation
Photograph by Stephen Pitkin / Pitkin Studio, HELIOTRACK
automated lighting

Plate 28
Smoke-Filled Sky (You Can Burn a Man's House but Not His Dreams)
1990
47.75 × 77 × 3 in.
Charred wood, industrial sealing compound, and enamel on wood
William S. Arnett Collection of the Souls Grown Deep Foundation
Photograph by Stephen Pitkin / Pitkin Studio, HELIOTRACK
automated lighting

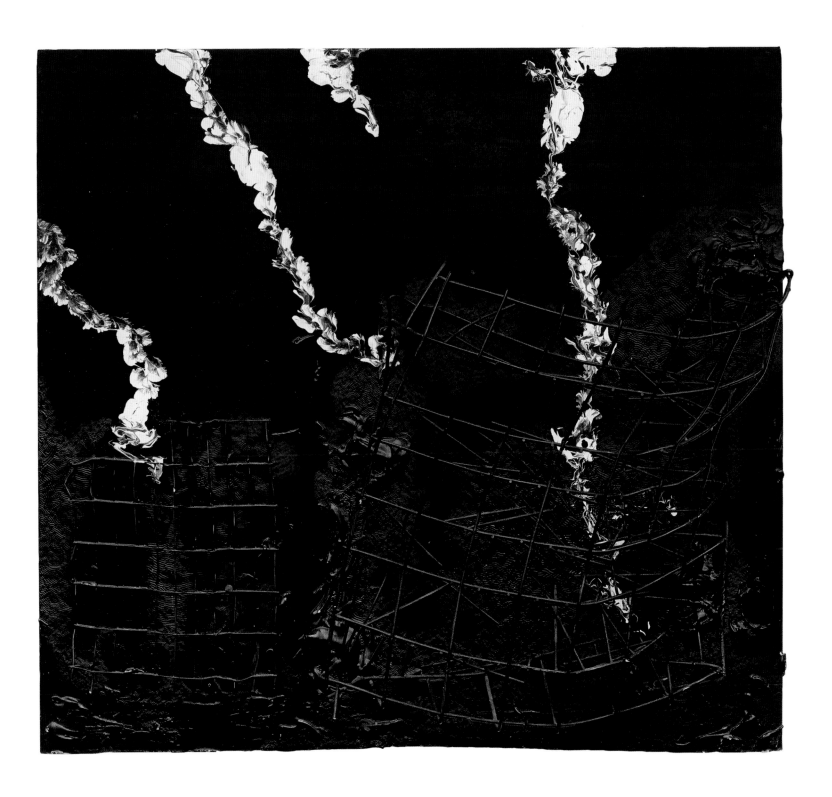

Plate 30
Instinct for Survival
1990
48 × 68 × 1.5 in.
Chicken wire, sticks, wood, industrial sealing compound, and
enamel on wood
William S. Arnett Collection of the Souls Grown Deep Foundation
Photograph by Stephen Pitkin / Pitkin Studio, HELIOTRACK
automated lighting

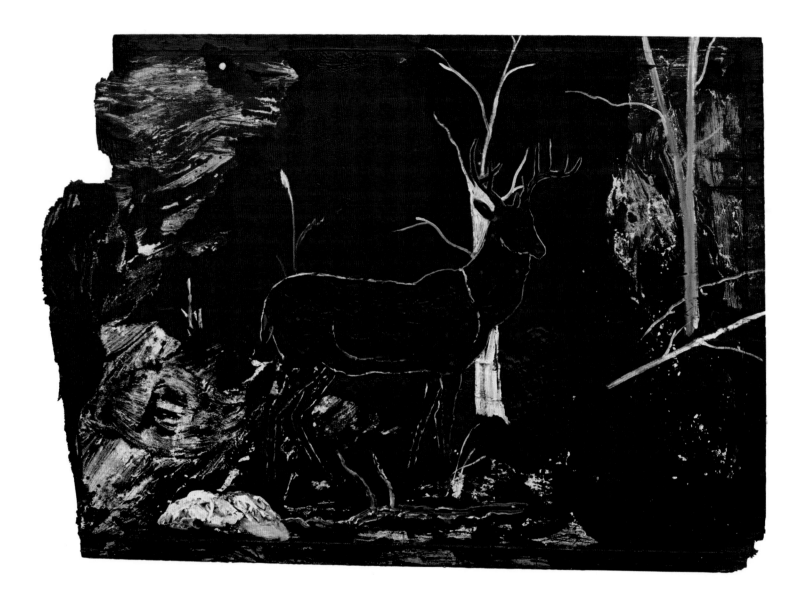

Plate 31
Deer
1990
29.25 × 40.75 in.
Collaged paper and enamel on paper
Collection of William S. Arnett
Photograph by Stephen Pitkin / Pitkin Studio,
HELIOTRACK automated lighting

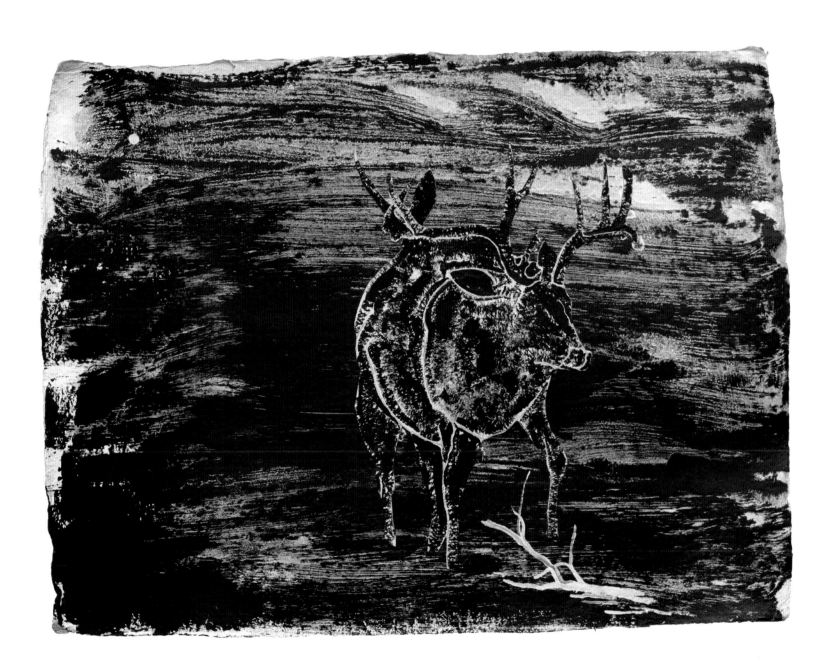

Plate 32
Cover of Night
c. 1992
47 7/8 × 40 1/8 in.
Paint, chicken wire, nails, photograph, and cellophane on plywood
High Museum of Art, Atlanta, T. Marshall Hahn Collection, 1996.94
Photograph by Michael McKelvey

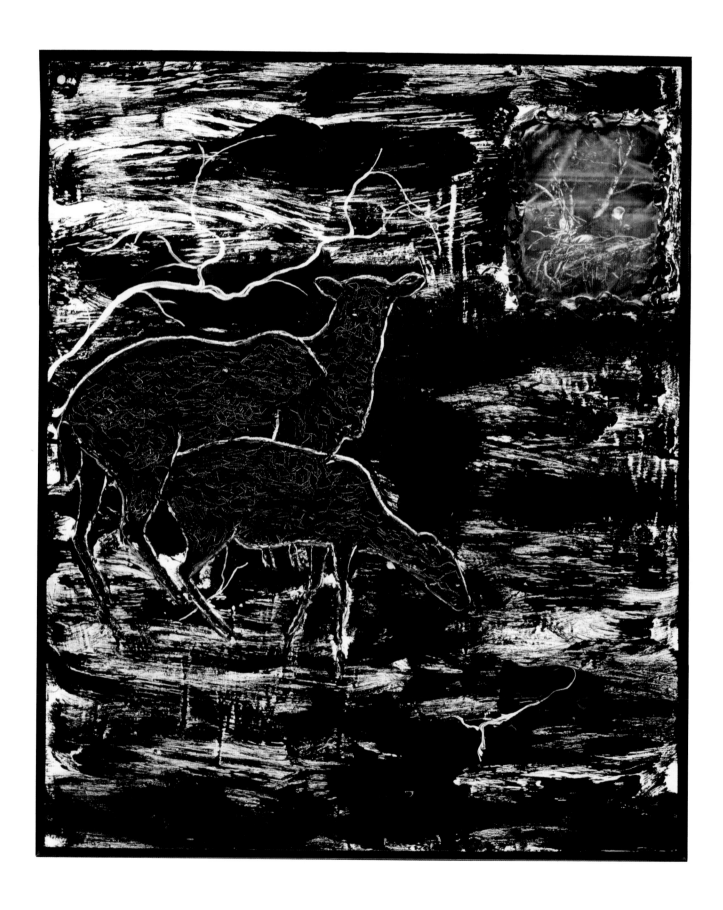

Plate 33
Natural Habitat
c. 1990
48 × 48 in.
Paint, wire, wood, nails, and wood filler on plywood
High Museum of Art, Atlanta, T. Marshall Hahn Collection, 1996.181
Photograph by Michael McKelvey

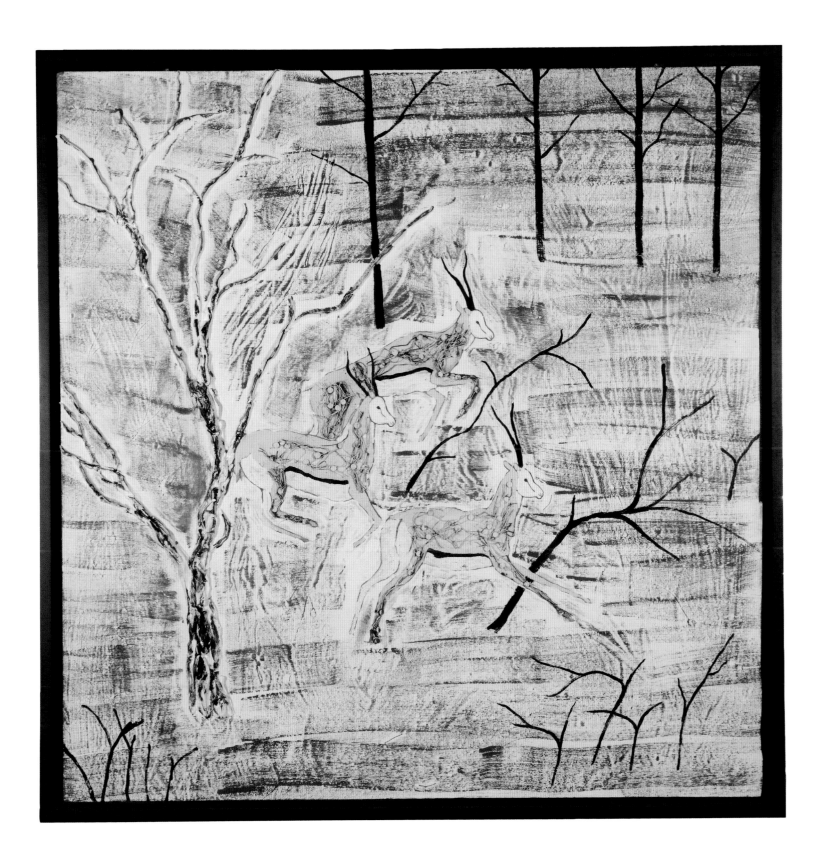

Plate 34
Homeless People
1989
48 × 48.25 in.
Paint and found wood on fiberboard
Collection of Ron and June Shelp

(opposite) Plate 35
From the Beginning of Time Our Father Watched Over Us
1988
78 × 48 × 3 in.
Found wood, cut tin, metal jar lid, and enamel on two panels of fiberboard
Collection of William S. Arnett
Photograph by the Souls Grown Deep Foundation

Plate 36
Untitled
1990
48 × 96 × 7 in.
Found wood, cut tin, found concrete statue, industrial sealing
compound, and enamel on wood
Collection of William S. Arnett
Photograph by Stephen Pitkin / Pitkin Studio, HELIOTRACK
automated lighting

(opposite) Plate 37
Homeless
1989
48 × 41.5 × 2 in.
Found wood, cut tin, industrial sealing compound, and
enamel on wood
Collection of William S. Arnett
Photograph by Stephen Pitkin / Pitkin Studio, HELIOTRACK
automated lighting

Plate 38
Untitled (Rebirth)
1989
34.75 × 27.5 in.
Enamel on Masonite
Collection of William S. Arnett
Photograph by Stephen Pitkin / Pitkin Studio,
HELIOTRACK automated lighting

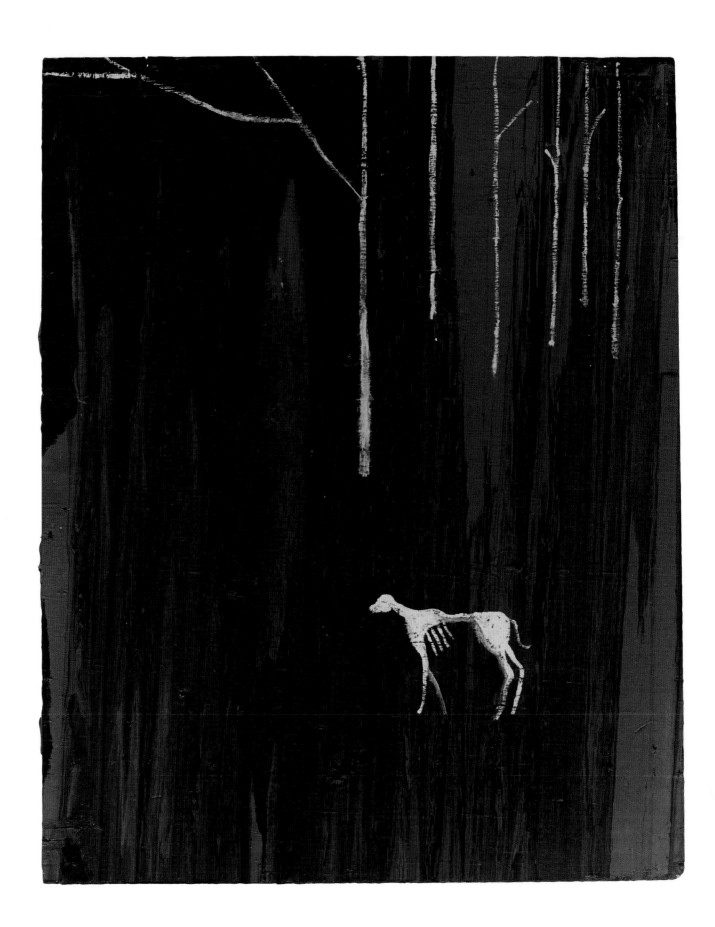

Untitled (Rebirth)
1989
34.75 × 27.5 in.

Plate 39
Once Something Has Lived It Can Never Really Die
1996
57 × 50.5 × 4 in.
Cut tin, sticks, chicken wire, industrial sealing compound,
and found steel on wood
William S. Arnett Collection of the Souls Grown Deep Foundation
Photograph by Stephen Pitkin / Pitkin Studio, HELIOTRACK
automated lighting

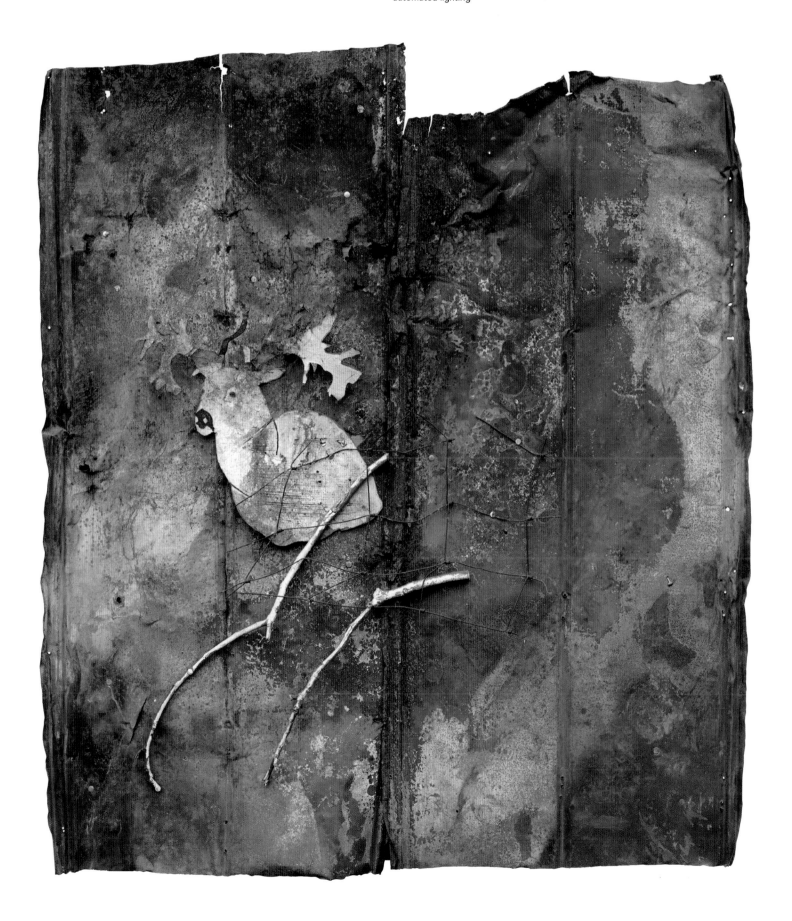

Plate 40
Traps
1992
50 × 47 × 3 in.
Cut tin, enamel, sticks, plastic netting, nails, wood stain,
and found steel on fiberboard
Collection of William S. Arnett
Photograph by Stephen Pitkin / Pitkin Studio, HELIOTRACK
automated lighting

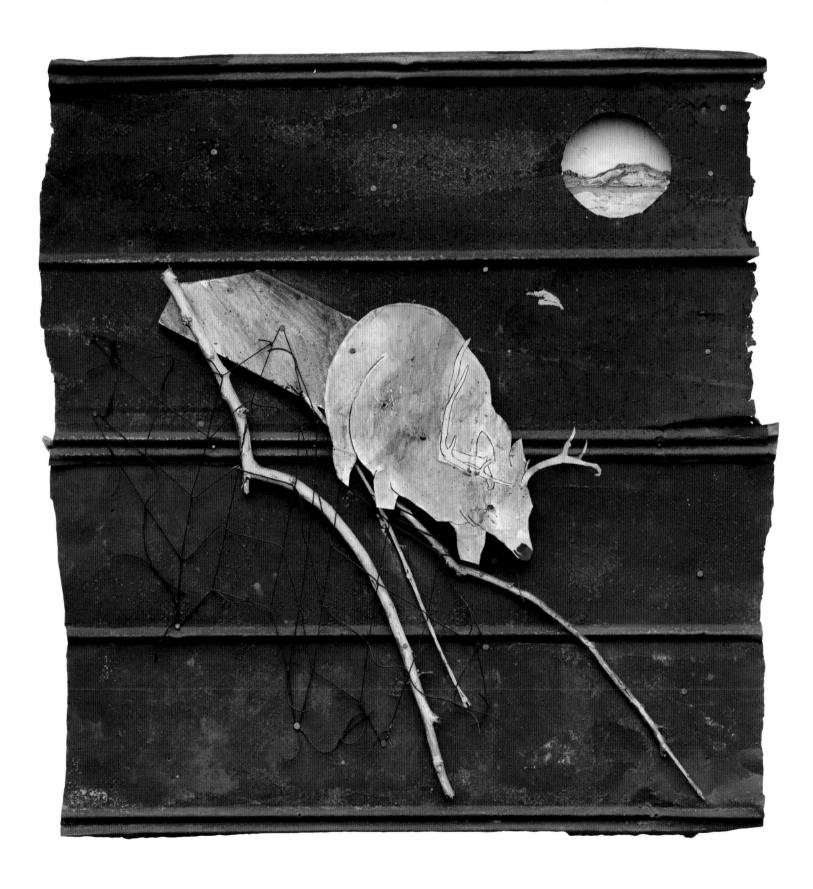

Plate 41
The Beginning
1993
42 × 47 × 2.5 in.
Nails, tin, and cut found steel on wood
William S. Arnett Collection of the Souls Grown Deep Foundation
Photograph by Stephen Pitkin / Pitkin Studio, HELIOTRACK
automated lighting

Plate 42
Drought
1994
48.5 × 51.5 × 1.75 in.
Found tin, pencil, nails, and steel on wood
William S. Arnett Collection of the Souls Grown Deep Foundation
Photograph by Stephen Pitkin / Pitkin Studio, HELIOTRACK
automated lighting

(opposite) Plate 43
Coming Out of the Haze
1994
64.5 × 51 × 7 in.
Found tin, pencils, nails, and steel on wood
William S. Arnett Collection of the Souls Grown Deep Foundation
Photograph by Stephen Pitkin / Pitkin Studio, HELIOTRACK
automated lighting

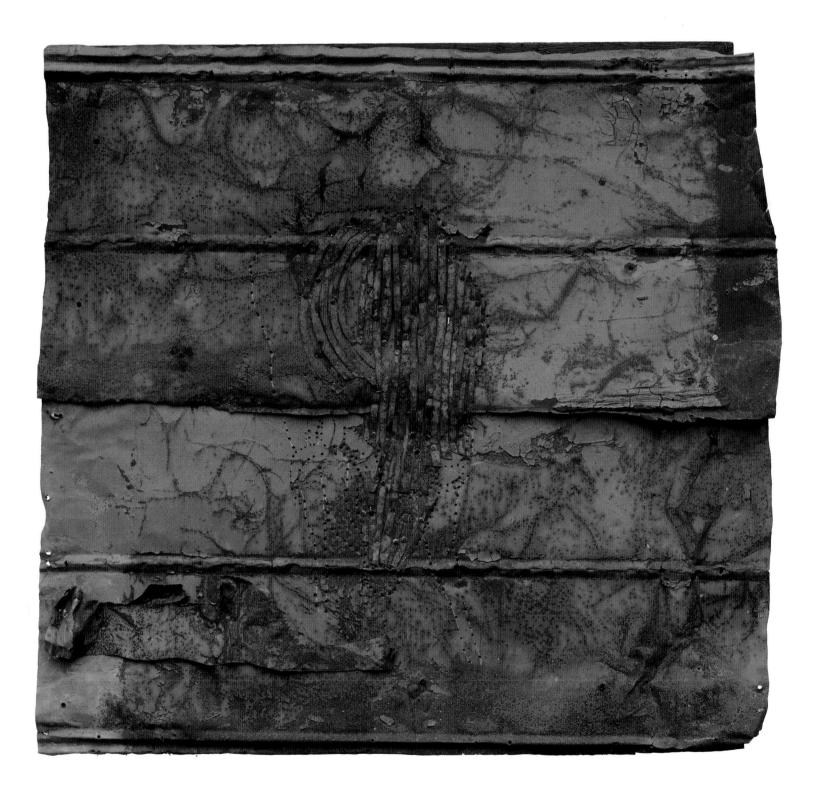

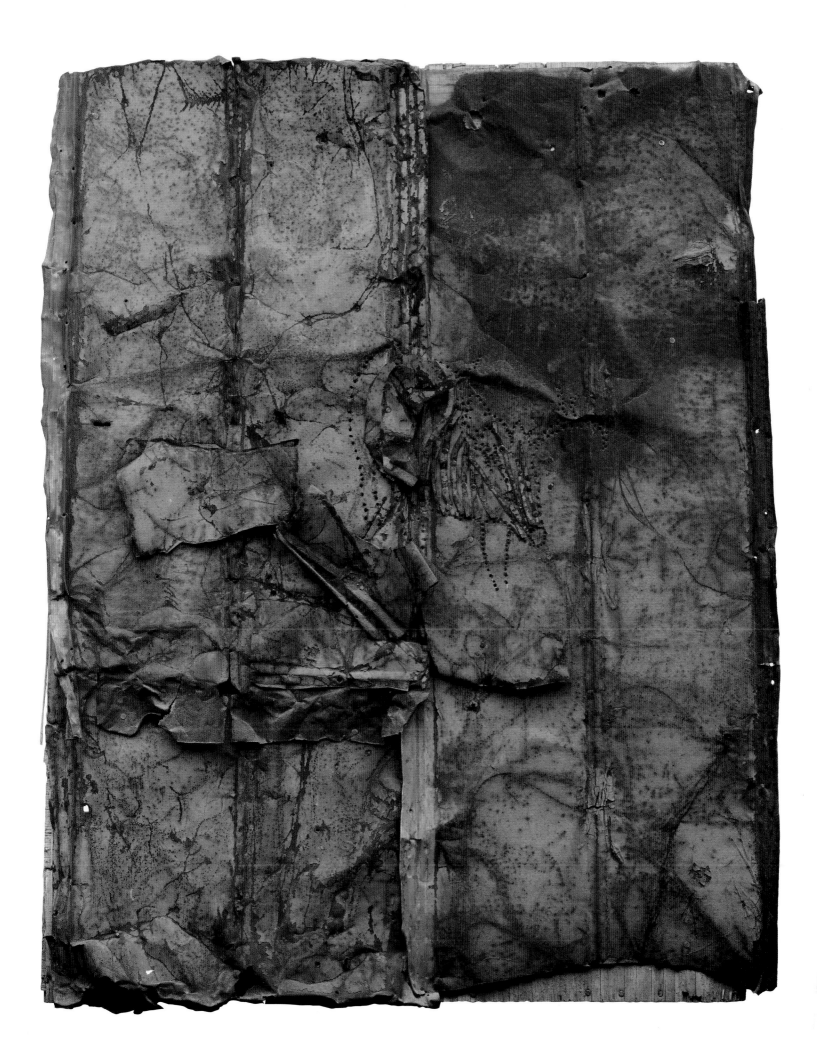

Plate 44
Untitled (Doe and Fawn)
1993
38 × 51 × 4 in.
Found tin, cut steel, and nails on fiberboard
Collection of William S. Arnett
Photograph by Stephen Pitkin / Pitkin Studio,
HELIOTRACK automated lighting

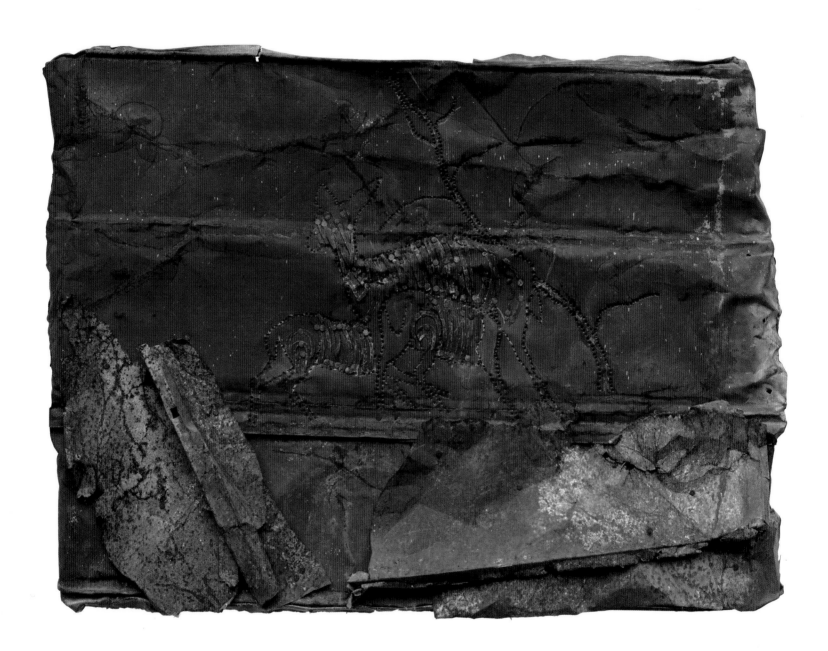

Plate 45
Ice Lands
1993
44.5 × 48 × 6 in.
Found tin, pencil, nails, and steel on wood
William S. Arnett Collection of the Souls Grown Deep Foundation
Photograph by Stephen Pitkin / Pitkin Studio, HELIOTRACK
automated lighting

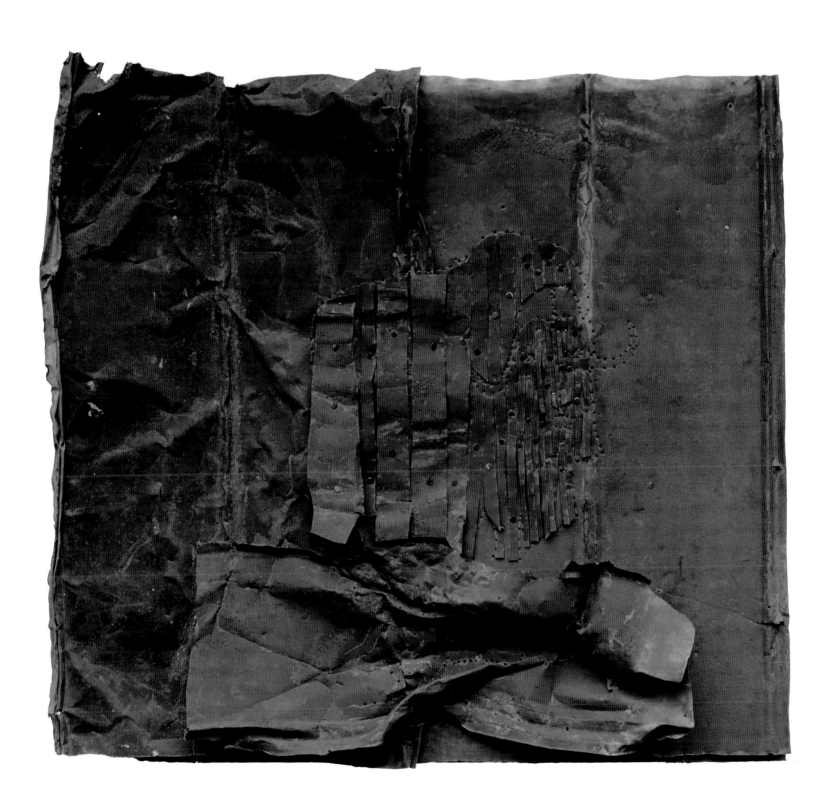

Plate 46
Verge of Extinction
1994
47.5 × 45.5 × 3.5 in.
Found tin, pencil, nails, and steel on wood
William S. Arnett Collection of the Souls Grown Deep Foundation
Photograph by Stephen Pitkin / Pitkin Studio, HELIOTRACK
automated lighting

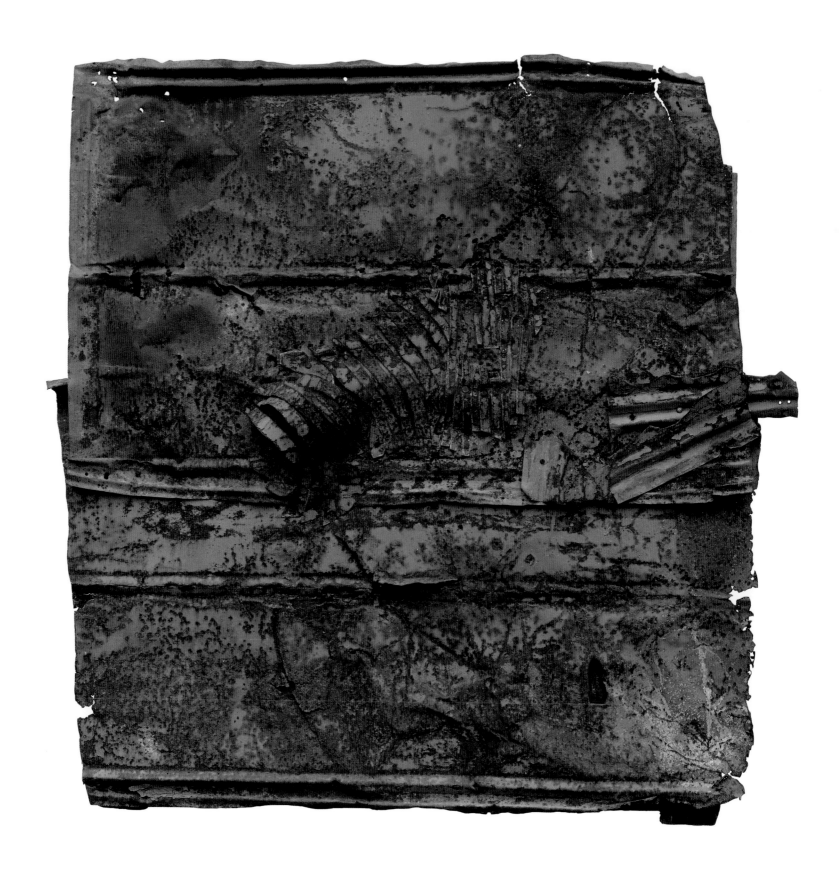

Plate 47
Untitled (Wolf)
1994
49 × 50 × 1.25 in.
Found tin, pencil, cut steel, and nails on plywood
Collection of William S. Arnett
Photograph by Stephen Pitkin / Pitkin Studio,
HELIOTRACK automated lighting

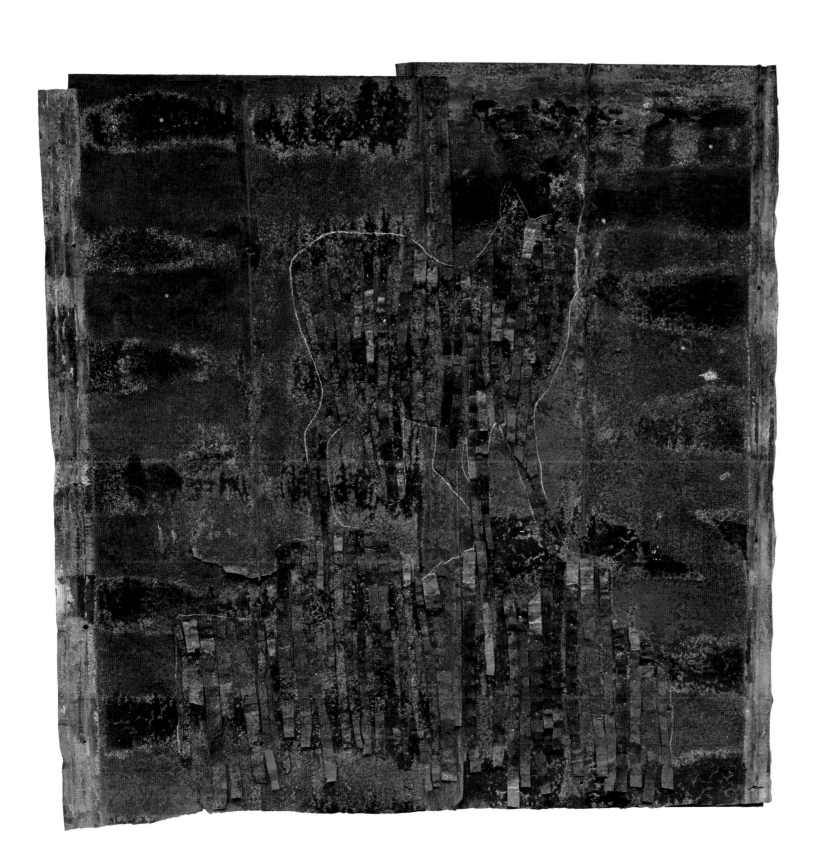

Plate 48
The Hunting Ground
1994
52 × 51 × 1.25 in.
Found tin, pencil, cut steel, and nails on plywood
Collection of William S. Arnett
Photograph by Stephen Pitkin / Pitkin Studio,
HELIOTRACK automated lighting

(opposite) Plate 49
Fever Within
1995
66.5 × 30 × 3 in.
Found and cut tin, colored pencil, and nails on wood
William S. Arnett Collection of the Souls Grown Deep Foundation
Photograph by Stephen Pitkin / Pitkin Studio, HELIOTRACK
automated lighting

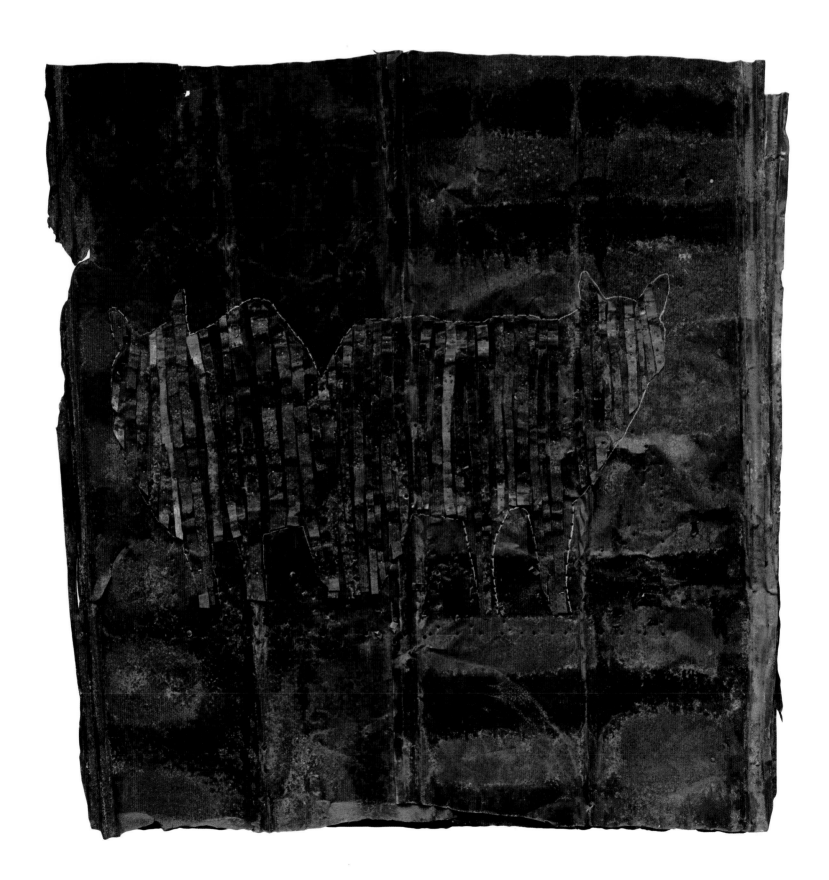

Plate 48
The Hunting Ground
1994
52 × 51 × 1.25 in.

(opposite) Plate 49
Fever Within
1995
66.5 × 30 × 3 in.

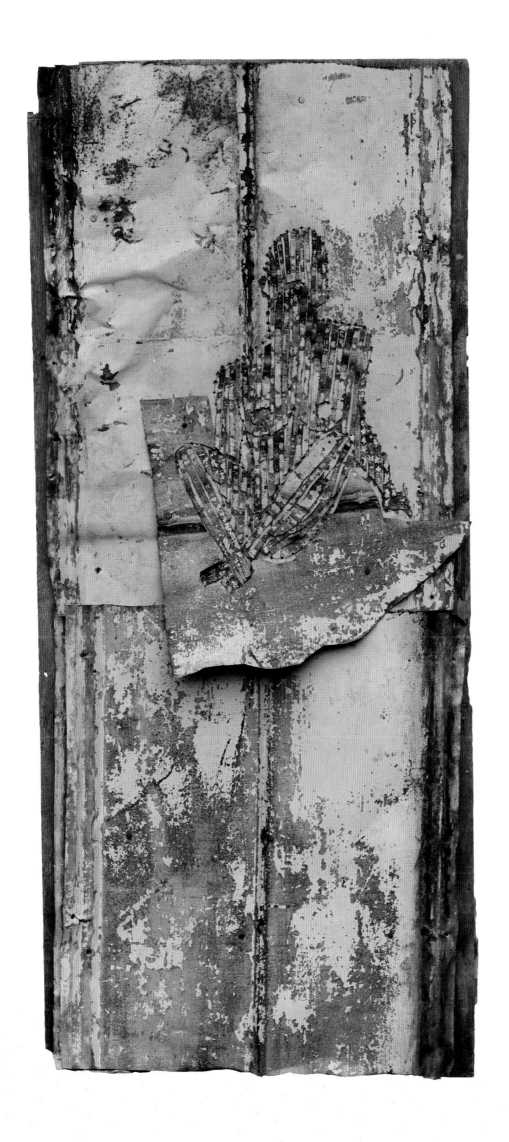

Plate 50
The Inferior Man That Proved Hitler Wrong
1995
43.75 × 42 × 4 in.
Found tin, colored pencil, and nails on wood
William S. Arnett Collection of the Souls Grown Deep Foundation
Photograph by Stephen Pitkin / Pitkin Studio, HELIOTRACK
automated lighting

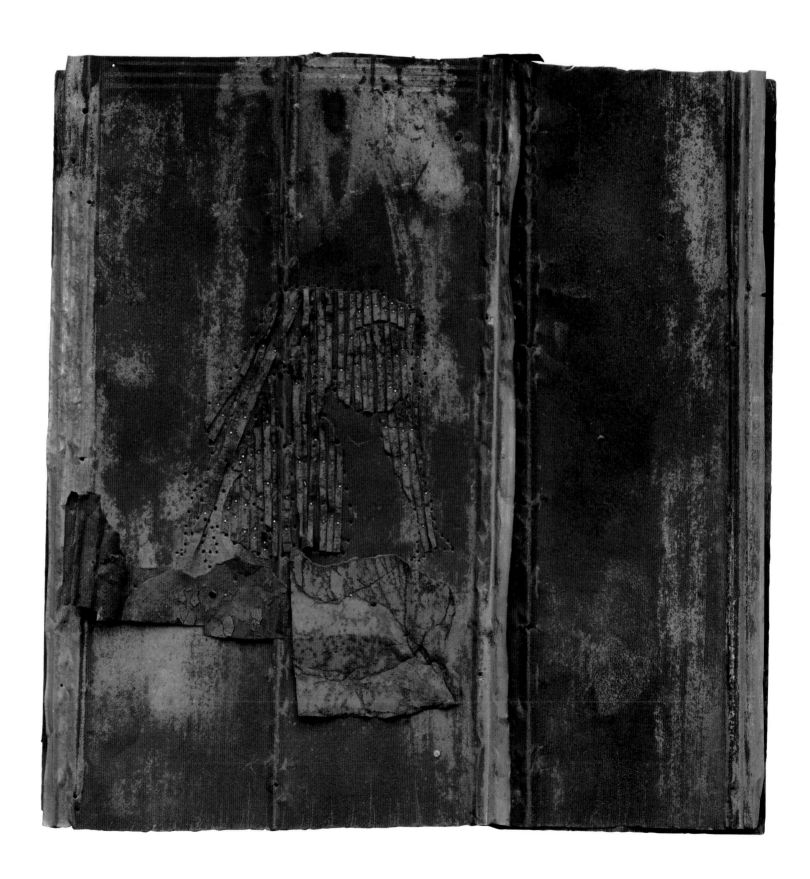

Plate 51
The Enemy amongst Us
1995
Oklahoma series
50 × 53 × 4 in.
Paint, pine straw, metal grate, tin, and nails on wood
Courtesy of the Souls Grown Deep Foundation and the
Metropolitan Museum of Art
Photograph by Stephen Pitkin / Pitkin Studio,
HELIOTRACK automated lighting

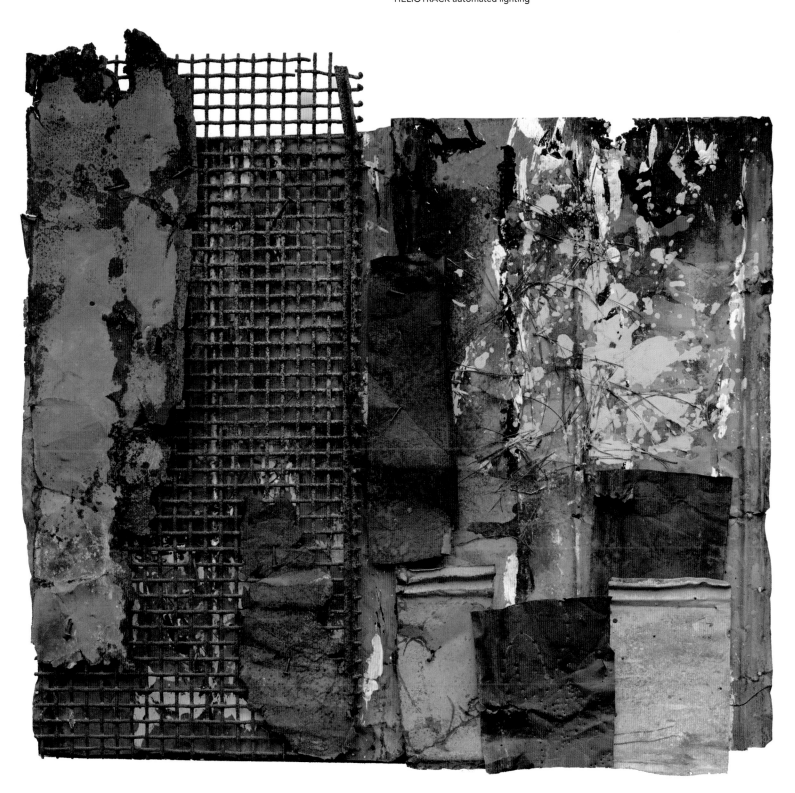

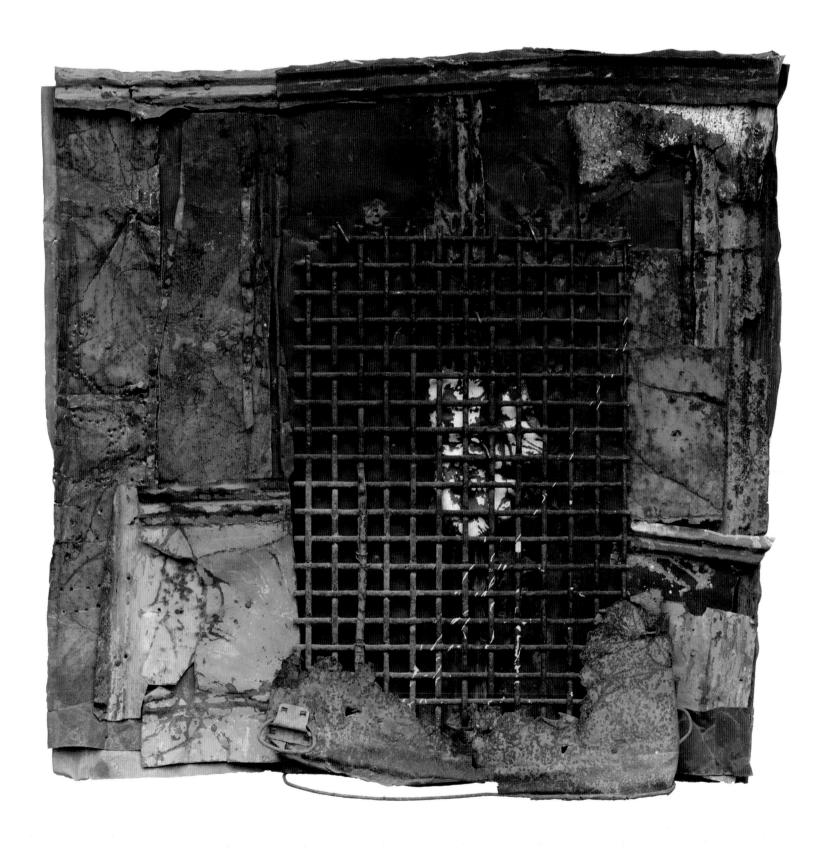

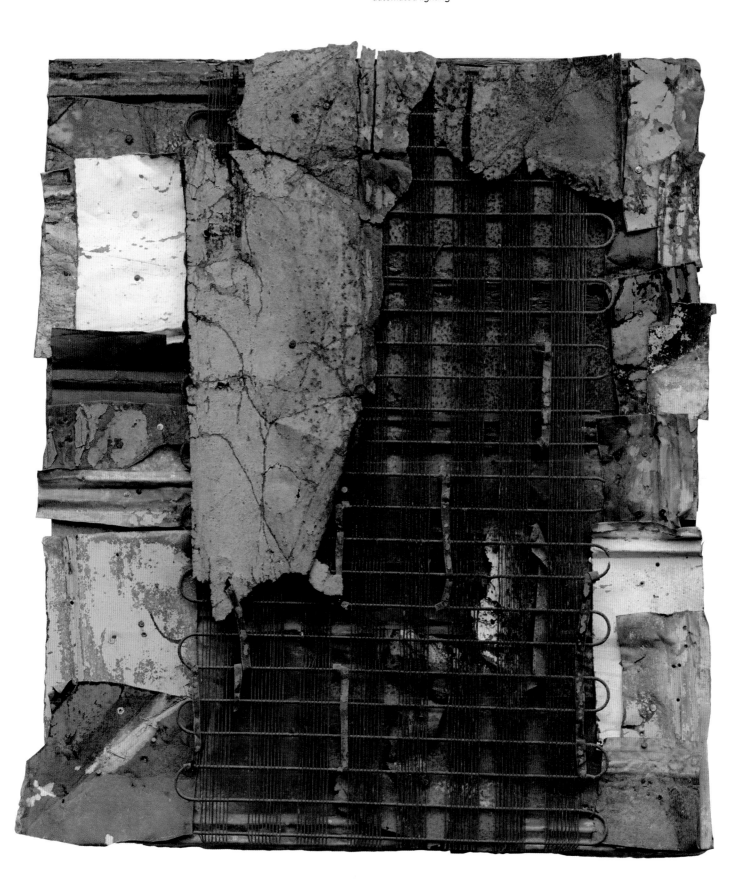

Plate 54
Timothy
1995
Oklahoma series
45 × 43.25 × 3 in.
Paint, found sheet metal, tin, wire, and nails on wood
William S. Arnett Collection of the Souls Grown Deep Foundation
Photograph by Stephen Pitkin / Pitkin Studio, HELIOTRACK
automated lighting

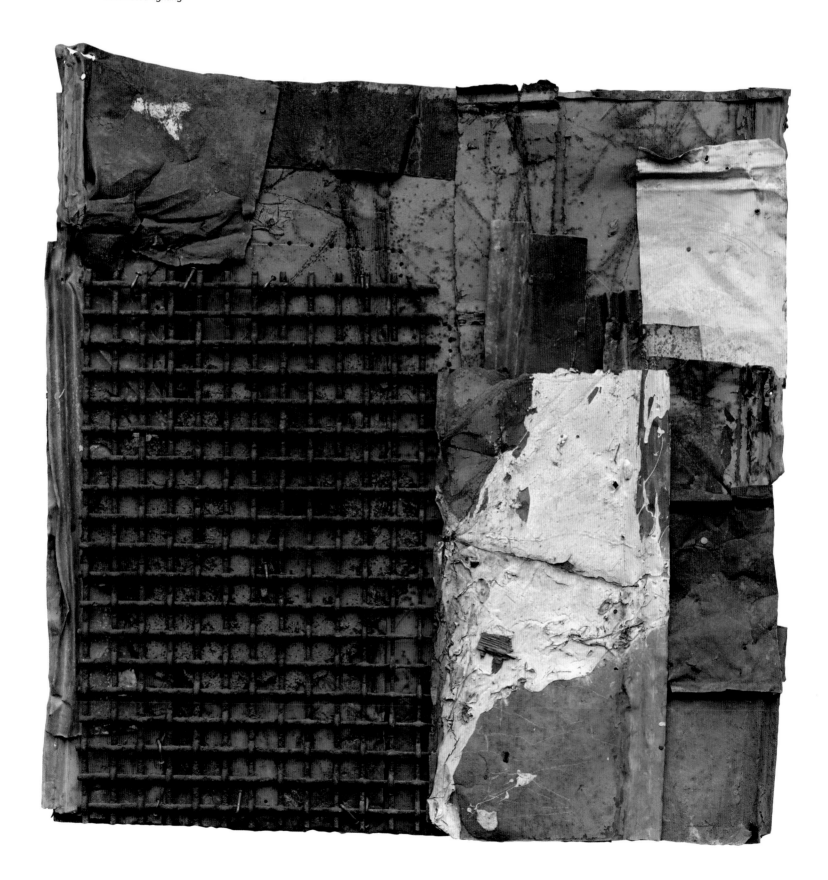

Plate 55
Awakening
1995
Oklahoma series
45 × 43 × 3 in.
William S. Arnett Collection of the Souls Grown Deep Foundation
Photograph by Stephen Pitkin / Pitkin Studio, HELIOTRACK
automated lighting

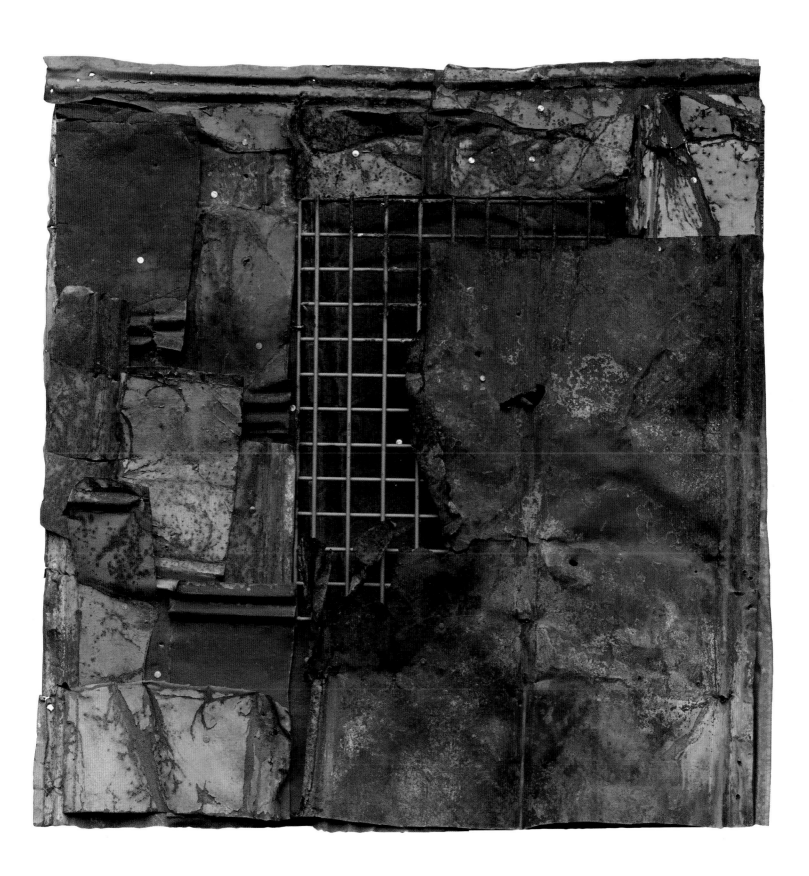

Plate 56
Remembering Sarah Lockett
c. 1997
Found metal, wire, wood, and paint
48 × 48 × 2 in.
Ackland Art Museum, The University of North Carolina at Chapel Hill
Gift of the William S. Arnett Collection and Ackland Fund, 2010.52.5

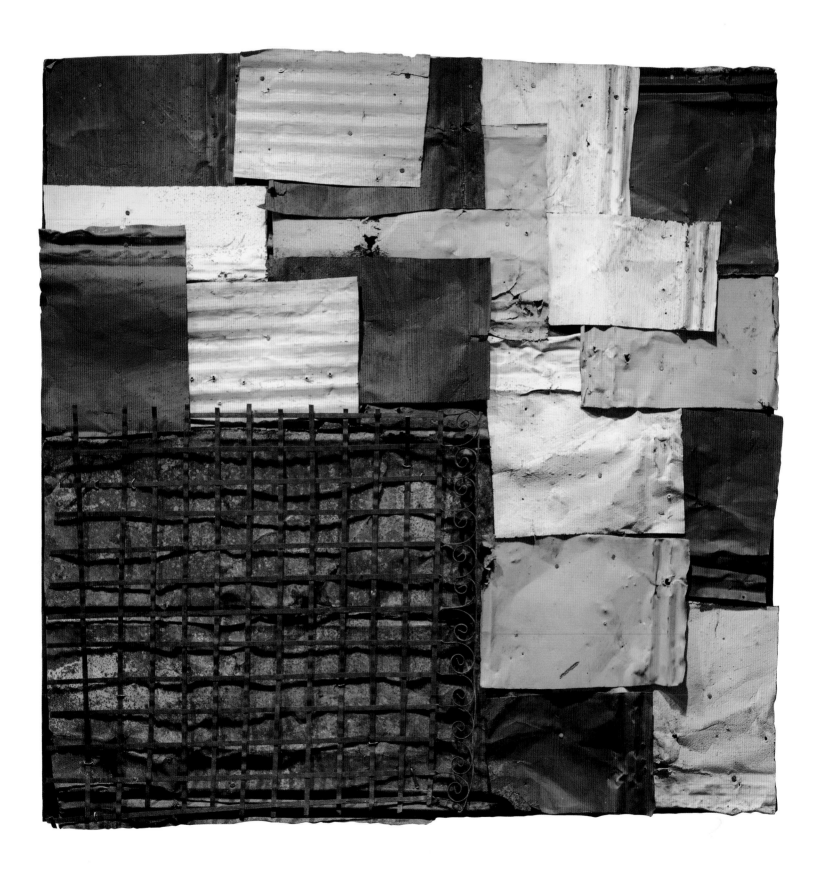

Plate 57
Sarah Lockett's Roses
1997
51 × 48.5 × 1.5 in.
Tin and cut tin, nails, and enamel on wood
William S. Arnett Collection of the Souls Grown Deep Foundation
Photograph by Stephen Pitkin / Pitkin Studio, HELIOTRACK
automated lighting

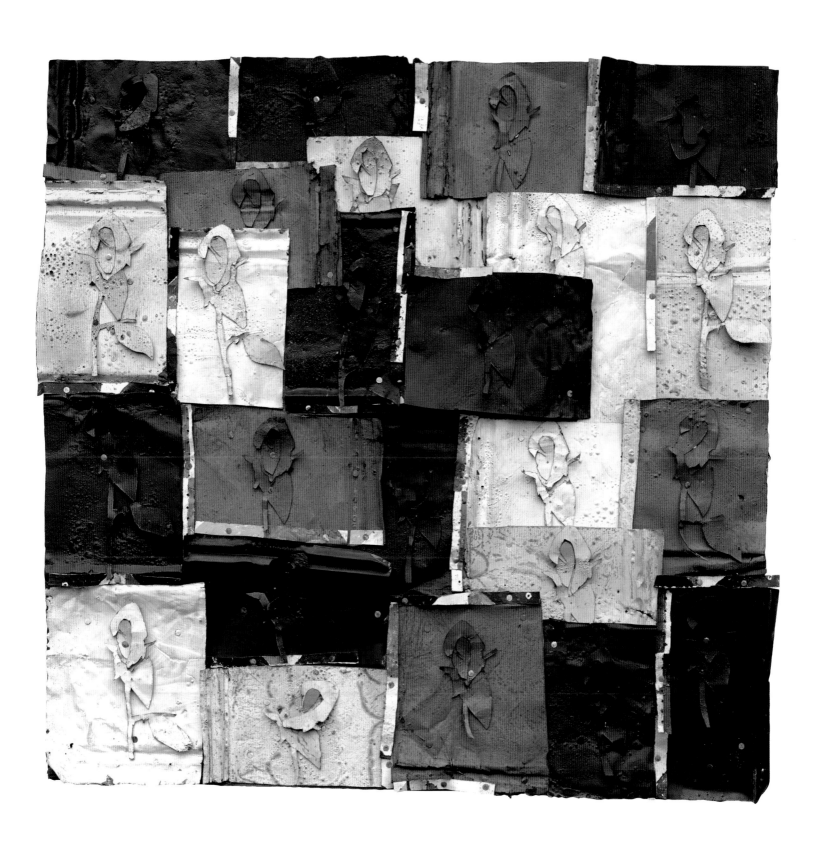

Plate 58
England's Rose
1997
48.25 × 48.25 × 1.75 in.
Tin and cut tin, nails, and enamel on wood
William S. Arnett Collection of the Souls Grown Deep Foundation
Photograph by Stephen Pitkin / Pitkin Studio, HELIOTRACK
automated lighting

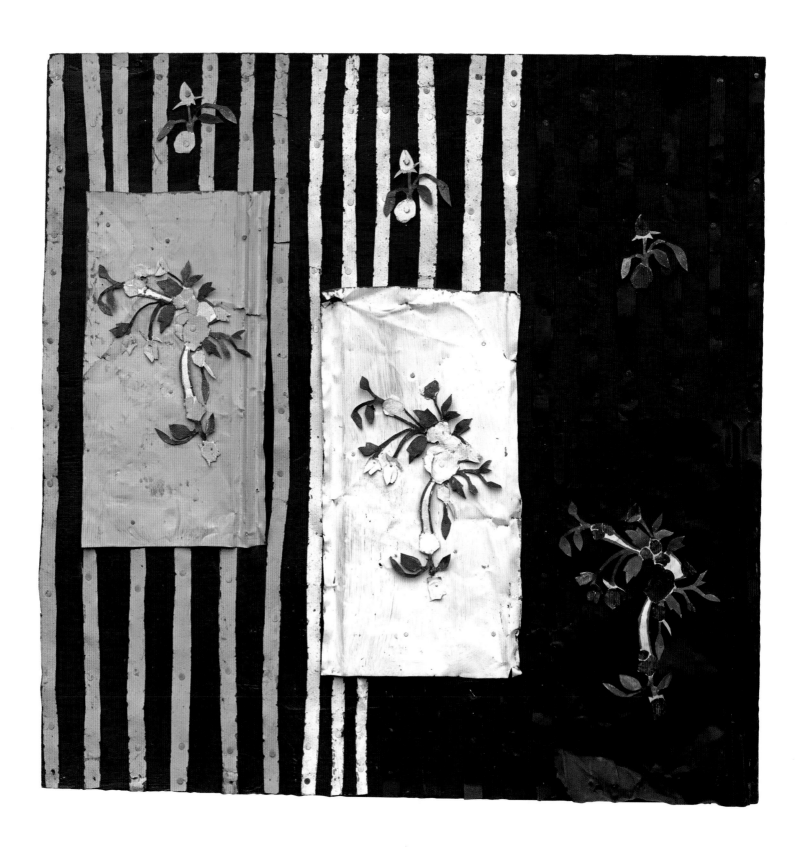

Plate 59
Traps
1988
48 × 50 in.
Cut tin, found wood, branches, nails,
metal fencing, and paint on plywood
Ron and June Shelp Collection

Plate 60
Traps (copy of original *Traps* in Ron and
June Shelp Collection [plate 59])
1997–98
48 × 50 × 4 in.
Cut tin, found wood, branches, nails, metal fencing,
and paint on plywood
Collection of William S. Arnett
Photograph by Stephen Pitkin / Pitkin Studio,
HELIOTRACK automated lighting

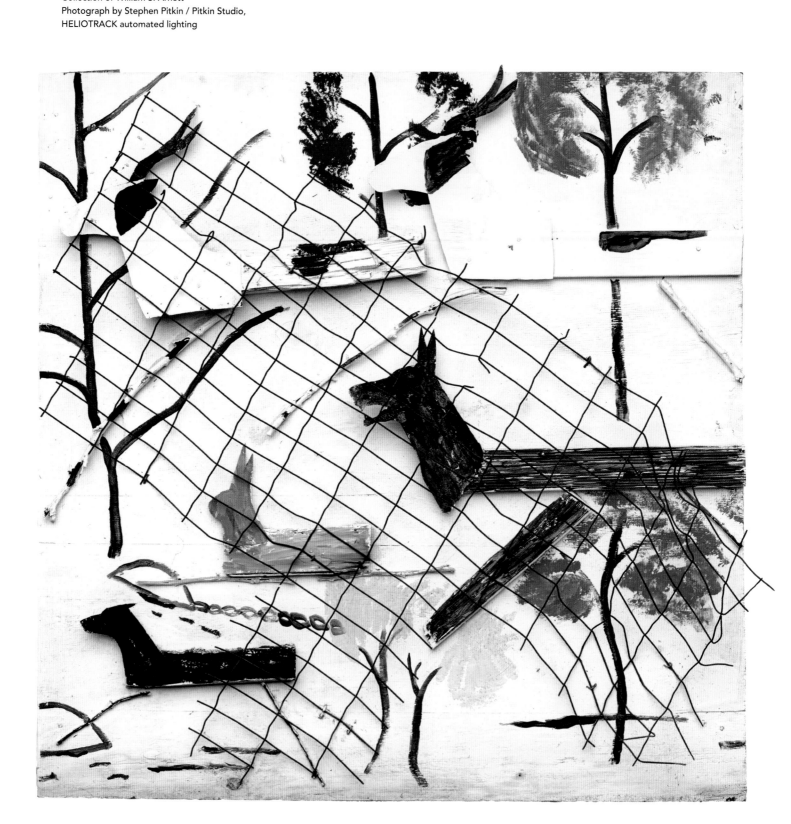

Once Something Has Lived It Can Never Really Die

RONALD LOCKETT'S CREATIVE JOURNEY

Bernard L. Herman

Ronald Lockett, hands thrust deep into the pockets of his dark slacks, studies the artwork he's tilted against the corner of his garage studio in Bessemer, Alabama.[1] His composition, roughly four feet square, consists entirely of found materials: rusted roofing and siding tin nailed to a weathered board backing (plate 52). A small vertical rectangle of metal painted white brightens and anchors the hand-cut oxidized metal panels, some crumpled, others bearing traces of worn and abraded paint. Always thoughtful in his responses, he speaks away from the camera as he assesses the work he has made. "This is called *Oklahoma*," he begins. "This is the idea I came up with to express my idea about the Oklahoma bombing. It's sort of abstract, with cut-out different shapes and stuff, with wire and old tin, and barbed wire." Lockett pauses, then continues:

> The iron has different shapes, sort of like the other buildings in the background. When the building was first destroyed, with the wire hanging down and it was all caved in, I tried to come up with the best idea I could to show that, to show the destruction. When I first got the idea to do it, I didn't really want to offend anybody so I really wanted to come up with an idea that wouldn't offend anybody, I wanted to come up with the best idea I could without offending any of those people that had families that got killed in this federal building.

For Lockett, the power of *Oklahoma* and the related pieces in the *Oklahoma* series resided in the challenge of communicating intense feeling without literal representation.

In his brief commentary, Lockett neatly offers a critical framework for the aesthetic that informs his art:

representation and affect. *Oklahoma*, created near the end of his artistic career, positions his aesthetic not as a philosophy of the beautiful, but more dynamically as the balance and proportion of being in the world. Thus Lockett's introduction to *Oklahoma* locates the work in a network of relations where the goal is to express the horror of a historical moment—the bombing of the Alfred P. Murrah Federal Building on 19 April 1995—in a way that communicates intense emotion and feeling. The aesthetic tension at the heart of his endeavor lies in how he would reconcile affect and narration, eschewing a more literal or figural representation of the bombing. To realize that vision Lockett developed a strategy that reduced the architectural elements at the scene of disaster to their schematic forms and heightened the affective work of the piece through the textures and colors of his medium. Using found roofing metal, siding tin, and rusted iron grillwork, Lockett expressed the emotional impact of the devastated blast area, depicting the eviscerated building (the grillwork) and the geometry of the surrounding environment of office buildings (the cut metal squares and rectangles). The humanity and pain of people at the scene and families left behind are communicated by evocation.

Oklahoma and Lockett's commentary on it crystallize the intent of this collection of essays. The goal is to bring Ronald Lockett's art into larger conversations about American art at the close of the twentieth century. Lockett's importance is already established within a community of internationally recognized artists in the Birmingham-Bessemer area of central Alabama, including Thornton Dial, Lonnie Holley, and Joe Minter. Their work, along with that of other Alabama creators, embracing the quilt makers of Gee's Bend, is represented in major museum collections such as the Metropolitan Museum of Art and increasingly at the center of discussions of American art writ large. But Lockett's art affords opportunities for more expansive and difficult encounters. *Fever Within* accompanies the first solo museum showing of Lockett's art in a traveling exhibition that

seeks to move the engagement and interpretation of his art beyond the ideologically marginalized positions assigned by critical default to the self-taught and vernacular and into contextually more generous political and artistic meditations. Accordingly, the writers assembled here are committed to a multifaceted discussion that looks beyond the confines of the outsider and self-taught in ways that invite provocative interpretive reflections on the contemporary turn in American art. Lockett's art offers a compelling invitation for that intervention.

Lockett created *Oklahoma* and its sister works in 1995–96 near the end of his short life at age thirty-two. Still, in the span of a little more than a decade leading up to the *Oklahoma* series, he developed visual strategies that addressed big historical themes, including the Holocaust, Hiroshima, environmental degradation, and Ku Klux Klan terrorism in the American South. And he explored intensely personal themes of ideal love, hope, frustration, and redemption. Lockett's art tapped into a deep wellspring of spiritual faith nurtured by his much beloved great-aunt Sarah Dial Lockett and the inspiring creative example of his revered cousin Thornton Dial. From his earliest work onward, Lockett remained deeply committed to questions of aesthetics, affect, and memory. He was intensely aware of rhetorical and narrative purpose in his art and frequently developed multiple works addressing a particular concept until he felt he achieved his goals.

Lockett's biography is readily summarized in a few sentences. He was born in 1965 and lived the entirety of his life in the Pipe Shop neighborhood of the old manufacturing city of Bessemer, Alabama, southwest of Birmingham. His home on Fifteenth Street stood in a row of modest working-class bungalows owned and occupied by his extended family, including two of the most influential people in his artistic life—Sarah Dial Lockett and Thornton Dial. By all accounts, Lockett was quiet and preferred the company of the older generation. A brochure for a 1992 group show, *At the Heart of Change*, held at Kennesaw State University established a foundational narra-

tive that continues to haunt his biography: "He grew up in the semi-urban environment . . . and graduated high school into a decaying industrial culture. He has been influenced in ways that reflect his own generation. This shy and self-effacing young artist has spent years watching his favorite nature programs on television, and they have been an inspiration for the mixed media constructions he started making several years ago." Some of his acquaintances described him as withdrawn, but his cousin Richard Dial offered a different perspective: "Ronald was one of the most easy-going fellows that you would ever run across. . . . He was just a calm fellow and that was his life. He just wanted to live and try to get along with everybody . . . and he got along with everybody." He added that the Dials considered Lockett very much a member of their family.

Lockett's parents separated when he was young and he turned to the Dial household, especially Thornton Dial, for guidance and mentoring. His father, Short Lockett, summed up the relationship this way: "I was his father, but he was actually more closer to Mr. Dial. I'm just being honest. He loved to stay up under him." Thornton Dial, listening to the conversation but saying little, repeatedly expressed his agreement, nodding his head, often adding the affirmation "That's right." Short Lockett continued, speaking to the close-knit nature of his son's Fifteenth Street world: "He was crazy about Sarah Lockett. That was the one who raised me, and she kept him up when he was a baby like that. And he stayed up under her, and when she was sick, he'd go up and be around with her. If he wasn't around with her, he'd be over at Buck's or with his mama, one. Most of the time, what he'd be doing, he'd be making art, cutting tin."[2] Ronald Lockett attended Bessemer public schools and completed high school. When the opportunity to attend art school was introduced, Lockett chose to remain in his neighborhood and learn from Thornton Dial as well as mining the resources of the public library and television art education programs. His art came to the attention of Thornton Dial's friend and patron William (Bill) Arnett

in the late 1980s when the aspiring artist invited Arnett's wife Judy to look at works he had created. His early efforts developed in the context of his relationship with Dial, whose studio stood in the "junk house" just down the street. Watershed moments in his life included his brother's capture by Iraqi forces during the Persian Gulf War (1990), the Dials' departure from Pipe Shop in the early 1990s, Sarah Dial Lockett's passing in 1995 at the age of 105, and his HIV diagnosis in 1994 or 1995. Lockett worked as an artist until his death from HIV/AIDS in 1998. His total known production numbers roughly between 350 and 400 works.[3] In the end, however, much about Ronald Lockett's life and art remains a mystery. The silences that surround Lockett's life render the art he made both the source and the object for interpretation.

Several series of works that Lockett undertook from the late 1980s through 1997 provide a richer biographical understanding of his artistic growth, his influences, and the continuing concerns that ran through all of his work. Although Lockett devoted the major share of his energies to more serious themes reflected in series such as *Rebirth, Traps, Smoke-Filled Sky, Oklahoma*, and a late collection of works on women (particularly Princess Diana and Sarah Dial Lockett), he could at times be playful, as seen in his sculptures of an elephant and horses (plates 1 and 2). At the same time that he developed these continuing themes, Lockett produced a variety of additional works through which he examined parallel issues and perfected his techniques through experimentation and practice.

Lockett created his first *Rebirth* piece (plate 24) in 1987. Small (12 by 18.5 inches) by Lockett's standards, *Rebirth* consists of nails, wire, and paint on a Masonite panel. Lockett's composition depicts a skeletal deer against a black background. The deer, fashioned from wire painted white and attached to the board with round-headed nails, stands in total darkness against a thin line of flowing water and facing away from the living world, rendered in a deep blue square of sky above the green earth. The deer serves as Lockett's avatar and

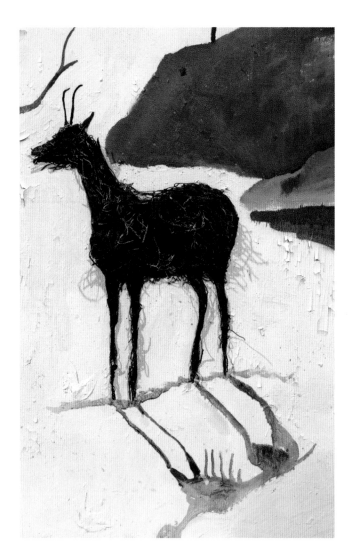

continues to appear throughout his later work in both its fleshed and spectral forms, including one work where the living animal casts a skeletal shadow (fig. 1). Lockett subsequently made several *Rebirth* variations that experimented with content and convention. In one he attached a ruched scrap of cloth, giving the green earth texture; in another he simplified the deer's bone structure. Lockett also incorporated the *Rebirth* animals into later pieces, including mixed-media landscapes where the skeleton stands beneath towering trees or in triptychs where the animal occupies a space between two landscapes: one verdant, the other sere.

Lockett's representation of death, the grave, and the afterlife as places of unrelieved blackness juxtaposed with life and the sunlit world of the living earth shaped *Holocaust* (plate 26), completed in 1988. Lockett described the inception of the four-by-six-foot work to a documentary film crew in 1997:

> When I made *Holocaust* I saw a picture about Germany. I can't think of the actor's name right now but he made a piece on it, a piece of film about it, and it just, I was, it's not that I hadn't really [known] about what the Holocaust was all about but the way they were slaughtered, and why they were slaughtered, and the way they were put on the boxcars and sent to the concentration camps and killed, their clothes were put in one boxcar, and then they were taken out and buried in massive graves.[4] So I closed my eyes that night and I said, "Well, I wonder how it would look in artwork?" and I saw this massive grave with all these skeletons in it and I thought about the boxcars that they were in, and I took this massive grave of black skeletons for blackness and put black all around them and then taking the boxcar and using the blue sky and the green grass like they were being taken off to the concentration camps, and I called it the *Holocaust*. So it kind of moved me that night, and I woke up, I painted that picture in my room and before I painted the picture, I woke up just like in a pool of sweat, like out of a nightmare. I got up that night, I went outside, cut my light on, got my board, brought my board back in that night because it was too cold for me to work outside, put it down on my floor, drew out all of my figures and just painted that picture till like maybe one o'clock until four or five o'clock that night, painted everything out. It just moved me when I had that dream. I felt like I just had to make that piece about the Holocaust.[5]

In this work Lockett demonstrates his ability to synthesize a complex narrative into an extraordinary visual moment. Boards bridge the gap between life and death, signifying the transit between boxcar, tracks, and the mass grave filling with tumbling skeletons of the dead.

Lockett drew on the symbol of the *Rebirth* animal a year later, in 1989, when he made *A Place in Time* and undertook the first of the series he titled *Traps* (plate 20). In *A Place in Time*, which is much larger (four by six and a half feet) than *Rebirth*, Lockett drew on pictorial conventions he developed there and in other early works: the use of paint-stiffened cloth to represent earth and the incorporation of scrap lumber and found branches as abstract cyphers, in this instance for the deer's body and legs. Significantly, Lockett includes two painted insets: one formed with hand-modeled and silvered auto body compound and framing a miniature landscape, the other bearing traces of a similar framing device and depicting the *Rebirth* animal.

The appearance of the *Rebirth* figure in *A Place in Time* marks a moment in Lockett's practice where he begins to quote his own creations in subsequent works. Lockett's *Traps* emerged in response to his own feelings of disillusionment and frustration in the continuing discriminatory environment of central Alabama, the loss of economic opportunity in the face of industrial collapse, and the unrealized promise of the social contract at the heart of the civil rights movement. Lonnie Holley offers his own insights into Lockett's *Traps* series:

> You know he didn't really explain a lot of his works. But his works were environmental. His works was all about creatures and animals. Entrapment. Or opportunities that were fenced around away from the animals. Or all the way to barbed wire or different little things that animals could run into that had been put there by humans. But a lot of us, we don't understand what we put up a lot of times, we don't tear them down. So some animals that is trying to get away in the forest—just think about it if an an-imal runs into barbed wire. That animal could get infected. You don't know he's been infected, you go out hunting this animal and you shoot this animal and you kill him and you eat his meat. So the infection that this animal has within—these are the kind of things that Ronald talked about.[6]

The first of the *Traps* works, *Driven from My Homeland* (plate 18), constructed in 1988, established Lockett's framework for the series. Two deer, a buck and doe with abstracted wood bodies and legs formed from branches, leap against a dark green, splatter-painted background. A net or trap of found chain-link fencing impedes their progress or flight. As avatars, the buck and doe resonate with Adam and Eve on the brink of expulsion from the Garden of Eden—a theme Lockett explored in several early works that addressed stories from the Bible in more or less visually literal terms. The two deer—a doe led by a buck whose muzzle breaks the picture frame—offer a nuanced commentary on the protective nature of companionate love, the limits of freedom, the struggle to escape, and, in the skeletal and fleshed-out creature, the sense of mortality. The forces that constrain the deer resonate with a loss of innocence and the awakening of social knowledge. *Traps* speaks as well to the degradation of the natural world through human action, something about which Lockett felt strongly, "like the slaughter of animals, or them being killed for fur or whatever."[7] Works within the *Traps* series tackled the theme in a variety of ways. In a didactic 1989 *Traps* (plate 19), Lockett painted the two deer ensnared in the chain-link netting with one wolf depicted with its paws clamped in the jaws of sprung steel traps attached by chains to stakes driven into the ground.

Environmental collapse became a recurring theme in Lockett's art. *Poison River* (plate 14), a 1988 indictment of environmental pollution and the death of native life, offers one of Lockett's most despairing explorations into the horrors of ecological degradation. *Poison River* offers a grim meditation on the misery inflicted by human

greed and political power on the natural world (a world that Lockett often conflated with an Edenic state). A barren tree, its trunk and branches bleached white and streaked smoke black, stands adjacent to a toxic river and roiling, polluted sky. A smaller tree withers on the opposing bank, framing the view. Cut-metal porpoises struggle through the vile stew, leaping in vain to escape the killing waters; schools of smaller fish struggle similarly to the left. Two deer, a doe on the heels of a buck, attempt to flee in the lower right corner. The depiction of their flight links *Poison River* to the motifs and themes of *Traps*. A bird tries to escape, fluttering and ensnared in the dead tree's branches; another floats upside down in the chemical tide; a third, a desperate survivor, flies free, but its beating wings are already stained with the slime of blood and fouled with waste. Although the fish, birds, and trees in *Poison River* speak to environmental loss, the presence of Lockett's avatar, the deer, links his apocalyptic vision to the human realm and to his own troubled sense of self and the diminished world he inhabited. Thornton Dial captured those anxieties in a circa 1990 drawing that depicts Lockett with hands worriedly clasped together and distracted eyes looking away from the artist.

Lockett addressed his concerns about social collapse directly in *Revelation* (fig. 2), a didactic early work that speaks to his perceptions of place and self. In *Revelation* he addresses the degradation of human experience and its relationship to biblical portent in an effort that lacks the subtlety and nuance of later creations. *Revelation* is more important for what it says about Lockett than as a work of art. A composition in two parts, *Revelation* comprises paint and found objects applied to a repurposed signboard. To the left a winged angel hovers against a swirling background of marbled red and black paint, gesturing toward a circle of light against a similar field of color. Six figures cut from metal and grouped in pairs occupy a projecting plinth at the base of the turbulent heavens. One figure in each pair holds a pistol; the other figure gestures in surrender and pleading. Trails of black paint suggest the souls of the slain rising heavenward

while red blood drips down. An angel hovers against an explosive sky, its arm extended toward a circle of white light. Lockett's *Revelation* captures key aspects of Revelation 8–10, in which the seven angels sound their trumpets and each blast heralds a divine torment, including "hail and fire mingled with blood" (Rev. 8:8). Lockett's *Revelation* evokes the climactic moment when the seventh angel, "which I saw stand upon the sea and upon the earth lifted up his hand to heaven: And swore by Him that liveth for ever and ever, who created heaven, and the things that therein are, and the earth, and the things that therein are, and the sea, and the things which are therein, that there should be time no longer" (10:5–6). Lockett links the visitation of the seven angels and the sounding of their trumpets to the rise of street violence and unraveling of the social covenant around him and abroad in the world.

The right side of the composition consists of a separate panel of plywood painted in green, blue, and black with hints of red and gray. The colors and the suggestion of a ground line connect the panel to the same palette that Lockett deploys in works such as *Rebirth* and *Holocaust*. Affixed to this ground, though, is a cross, fashioned from two pieces of deeply scored wood taken from a sawhorse or workbench. The elements in the cross resonate both with Christ's identity as a carpenter in the context of the *New Testament* and with Lockett's own experience as a young boy working for a neighborhood contractor, who introduced him to basic building skills that would shape his technique. Richard Dial, Lockett's cousin and Thornton Dial's son, described the relationship with Melvin Craver, the builder who lived next door to the Dials:

He was a carpenter and he would go around and he would work on people's houses and stuff, and when we were like kids, and I'm talking about, say, seven, eight years old, he would take us to the construction site with him and we would work and learn how to drive nails and stuff. And he would walk by and look at it and he'd tell you, "Nail it now," and he'd throw

Figure 2
Ronald Lockett
Revelation
1988–89
48 × 72 × 4 in.
Paint, cut metal, and scrap wood on board
Collection of William S. Arnett

a plank up there, "Nail it in place." . . . He'd line you up, "It's your time to run the Skilsaw," so you'd be like seven years old trying to run that Skilsaw. . . . It came to me four, five years ago that he was trying to teach all those guys the trade that he knew, and like I said, that's a part of me now. And a lot of the guys that was in that particular neighborhood, they were able to pick up on some of those things. . . . And I appreciate that today, which, you know it just dawned on me that he really truly was trying to teach us something that would, you know, that we might be able to depend on one day. . . . I have a lot of appreciation for him.[8]

Lockett, Richard Dial remembers, learned from Melvin Craver on these informal work crews and applied those skills to making art. His choice of the saw-scarred crosspiece taken from a sawhorse to make the cross in *Revelation* extends the associations in the work beyond its biblical referents and commentary on a changing postindustrial urban social landscape to include the revelation that comes with acquiring knowledge and skills. Thus Lockett's *Revelation* plays with the ambiguity of language, alluding to biblical judgment and artistic learning, and in that juxtaposition discovers salvation through faith and art.

In 1990 Lockett undertook a series of works with the general title *Smoke-Filled Sky: You Can Burn a Man's House but Not His Dreams* (plate 28). He produced at least seven variations in this body of work as he wrestled with the challenge of depicting the violence of the Klan at the height of the civil rights movement in central Alabama and beyond. Lockett, born in the mid-1960s, grew up with the history of the struggle and its unresolved legacies—but it was a received history rather than one born of experience. All of Lockett's *Smoke-Filled Sky* works, despite variations in size and depth, adhere to a shared composition that presents a burned-out building (almost always a house) positioned in a moonless stygian landscape. The charred timbers of the structure glow with smoldering embers and white trails of smoke drift into the night sky. One, sometimes two, scorched trees languish adjacent to the ruined dwelling. Versions of the work provide a sense of Lockett's progression in his efforts to visualize historical narrative and social concern in a synthesis of abstraction and representation. Because Lockett typically did not number or date his works, the sequence of the works is organized around the idea of progression based on the attainment of affect—to communicate pain and loss without offense—that animates his historical work.

In the earliest *Smoke-Filled Sky* works, Lockett incorporated a three-dimensional model of a burned-out house that projected from a textured black background smeared with plumes of white smoke. The house, smoking under the barren branches of a tree, is a gutted frame of charred studs and broken siding glowing with heat. Multiple threads of smoke tumble into the night sky. The chimney with its fireplace, black and cold, occupies a corner of the interior, juxtaposing the chilling of domestic warmth with the heat of racial violence. This is Lockett at his most literal. In another work, he presents several buildings in varying states of incineration. His palette for the series is definitive: heavily applied black paint, with white used for smoke and flecks for ash and red pigment for brick and radiant heat. The use of a projecting three-dimensional model has shifted to a collage-like composition crafted from reused architectural trim, flattened and incisive in its representation of violence by fire. In another *Smoke-Filled Sky* Lockett resolves the visualization of arsonous violence by using a flattened representation of the burned-out hulk pieced from bits of charred wood scrap. A single ghostly cloud billows upward. The bones of the old house pulse red; two scorched and coruscated trees alive with fire flank the old homestead. There is no ground line; the house floats eerily in its grim and hellish landscape.

Lockett's *Smoke-Filled Sky* and *Traps* series set the stage for a profound shift in his art in 1993. As he continued to experiment and reflect on the expressive goals

of his art, however, his attention shifted to the uncertain fate of his brother David, who was taken prisoner in the opening days of the Persian Gulf War, a concern Lockett rendered visible (plate 30):

> *Instinct for Survival* was a picture about my brother. It was during the time of the Persian Gulf War. He was lost and we thought he was dead over there. My mother, she had a nervous breakdown. . . . Once we got word that he was alive then I began to make this picture called *Instinct for Survival*. Later on, we got some bad news, that they hadn't really found him over there, they made a mistake and later on they found him at a POW camp. Later on, when the war was over with, they freed him and he came home. That is basically where I got the idea.[9]

With its black ground painted on board and the outline of an antlered buck standing in a blasted landscape, *Instinct for Survival* continued the stylistic direction achieved in the *Smoke-Filled Sky* works, extending the avatar of the deer from *Traps* to embrace his brother. Erect and vigilant, the buck radiates strength and confidence tempered with wariness—and with it Lockett's hopefulness that his brother's inner strength would pull him through his ordeal.

Lockett's experiments with painting and mixed-media collage continued through the early 1990s. His father described how Lockett would paint: "Mostly I stayed out there with him, when he was taking his hand in the paint. He was mixing up all of this paint in his hands and going around." He also marveled at the hand strength required to cut the animal forms: "He'd be making art, cutting tin. I don't see how he could take his hand and cut all that tin like that."[10] Lockett continued to elaborate on the motifs of deer as well as wolves, bison, and other animals that he saw as at once vulnerable and resistant to the threats around them: *Vanishing Territory*, he explained, has "three wolves on a mountain with a white background in the back symbolizing that people are pushing them out of their natural habitat and they don't really have anywhere else to go so I came up with the idea of just like this white background with three wolves up on the front on the mountain on the middle with nothing on the back of them and they are just being pushed out of their natural habitat."[11]

In a spectral variation on *Traps* he delineated a ghostly white buck ensnared against an intensely black and ruggedly textured landscape lit by the rising moon (plate 22). The buck's motion is thwarted. The animal struggles. A golden bird on a golden branch alive with flowers is poised to take flight; a characteristically barren tree stands in blackness in the lower right. There is resignation and restlessness here, hope and hopelessness, the possibility of a spiritual life that sloughs the shackles of this one. Lockett reacted strongly to what he saw as the indiscriminant slaughter of animals, whether for fur or sport, and linked that loss to larger histories of environmental destruction carried out by unseen human agents in concert with the denial of opportunity and respect to historically oppressed peoples, specifically American Indians and African Americans.[12] Ultimately, his art came to rest around his own struggles and sense of purpose.

Ronald Lockett's art underwent a major transformation in 1993 and 1994, when he largely abandoned paint and collage on board and made a dramatic shift to metal assemblages that effectively synthesized sculpture and painting. Paul Arnett vividly captures the moment of this transition:

> In the early 1990s he had discovered some weathered barnlike buildings once owned by the Dials, and he scavenged the rusty tin siding that had been covered with now oxidized paint by Thornton Dial in the 1950s and 1960s (before Lockett's birth). That old tin, the tough skin of black rural survival (and literally the roof over its head), as well as the oxidized paint brushed on it by Dial before Ronald's time, offered the younger artist his best means of trans-

lating feelings about a generalized sense of the past (including his mentor, Dial) into meaningful assertions of self. . . . Rust and oxidation immediately became his voice. Thereafter, nearly everything is rusty, muddy, opaque—neither light nor dark, neither white nor black, but an in-between brown. In an earlier period, he had tackled the struggle between positive and negative forces in terms of the colors black and white (and occasionally red). Rust—the oxidized paint—resolved battles between light and dark, a dualism that had seesawed before in his work. Oxidation's color is that of earth or dirt, yet it isn't pure or originary, and it isn't final, either; it's a lengthy, almost endlessly transitory stage.[13]

Lockett described the sources for the metal he used, linking it to the old work structures that stood on the deep lots behind the Fifteenth Street houses where he, his family, Sarah Dial Lockett, and the Dial household resided: "Well, you have to find it, you know, you find stuff, like I found that, as I go. Buck [Thornton Dial] had a barn, I guess he must have painted it red, red tin. . . . Hog pens, old sheds, off of my dog pen, I have a big dog pen out in the back. So I just happened to go by there and I was looking and I built it you know at the time I was making it I wasn't paying attention, so I went back there and found a whole lot of tin."[14] The transformation in Lockett's art came when he began to explore the possibilities of scavenged metal, not as a ground for painting and collage, but as the sole medium: "Red tin. And I would gesso over it. And I looked at it and I said, maybe I could do something with it. So I started doing what I did, I'd use some strips on tin. I wasn't sure about the idea so I put one of them off to the side. Mr. Arnett saw it and he told me to just keep the idea going. . . . That's how it came about. I'm always trying to keep something, some kind of different idea going."[15]

William Arnett described the transformation of Lockett's practice, recalling:

Well, he started using metal and not painting, and it was a sort of sudden break. . . . He started doing things with no painting on them. They would just be basically collages of metal. It would have been about maybe not until '94 or '5 that he gave up painting entirely. But once he did, he never went back. So the last few years of his life, they were all assemblages made of metal. He might have some paint on it . . . but the paint he didn't apply. It was accidental paint. He would find pieces of metal that had paint on them and incorporate them. One of the most interesting of those . . . had to do with the Oklahoma City bombing. So this piece has the paint on there. But this is a piece of metal that had paint splashed on it. It was something that Dial had at his place where he did his work. The paint that's on there came from Dial just slopping paint on things to splash it and make an effect on it, and it just carried over on a piece of metal, so it's a thing that he picked up off the ground and incorporated in his piece. Because it looked like chaos. I mean, it *was* the bombing in Oklahoma City.[16]

The gallerist Barbara Archer, who knew Lockett early in his career, summarized the impact of the shift to works with metal: "He really hit his stride with the rusty metal pieces, and he was doing something that no one had done, and he knew that."[17]

Lockett's first works with scavenged building tin projected his established motifs and themes in new directions that moved with an increasing sense of purpose toward a visual poetics of affect. The metal works incorporated figural elements, some of them drawn from earlier painted and mixed-media work, but Lockett increasingly relied on the "organic" surface of environmentally distressed metal to visually texture and nuance his work. Because he mined his neighborhood for the metal he used, the medium intrinsically bore deep associations with family, community, and place. Fellow artist Lonnie

Holley described how he and Lockett encountered the possibilities of found materials early in Lockett's artistic arc:

I think what he learned from himself by just me showing him the type of materials that [we were] developing to use in our art. . . . We went for a walk one day and he took me down back of the house where he was staying, I think his great-grandmama's or grandmama's, and we went walking down a road and I told him I preferred to walk down a ditch or a creek, did he know where one was? And he said yes he did, and we went walking down the ditch, or maybe a little creek. . . . And it was where people sneaked and just throw their trash away. . . . So me and Ronald was just walking and looking at all this stuff. And I was showing him how some of these things could be used in the forming of his art. So I think that's really what he locked onto or latched onto, and he started using it.[18]

The Beginning (plate 41), undertaken in 1993 at the outset of Lockett's metal works, incorporates elements from earlier painted and mixed-media series, including *Smoke-Filled Sky* and *Traps*. Here the deer is created as a negative image in the form of a metal cutout. Crumpled metal buckles around the animal, lending the figure depth. The shape and physical attitude of the buck echoes other works, including an untitled *Traps* work. Additional metal shapes nailed to the surface of the work cut from weathered metal siding give the animal a suggestion of modeled musculature. The lower right contains the abstraction of a house with smoke and flame rising from the roof, evoking the burning buildings of *Smoke-Filled Sky*. A massive tree with broad trunk and crown occupies the lower left corner. The tree brings together the family tree, the tree of knowledge, and the tree of life, speaking in one gesture both to Lockett's sense of rootedness and to the vital role that Sarah Dial Lockett

played in communicating genealogy, faith, and understanding. A hill looming behind the tree and burning house rises beneath the buck's feet. Thus, *The Beginning* links themes ranging across a number of works in a vivid and subtle synthetic composition that combines Lockett's engagement with his narrative interests, his family and its history, his own identity, and the larger struggle for survival in a hostile world.

Many of Lockett's first metal works incorporate punchwork outlines and thin strips of metal manipulated into animal forms including wolves, bison, yaks, mastodons, and deer. *Verge of Extinction* (plate 46), from 1994, resonates with his themes of nature in crisis. Lockett depicts a wolf fashioned from strips of hand-cut recycled metal and punched ears, muzzle, and eyes as it peers directly at the viewer against an abstracted barren landscape evoked by the rusted, rain-streaked siding. The recycled metal, pitted, scratched, and textured by weather and hard use, speaks to the forces that drive even predators to their end. Power, which takes the form of the predatory wolf here and in other works by Lockett, ultimately becomes an agent of its own destruction. Similarly, *Drought* (plate 42), from the same year, stands out as one of Lockett's most powerful and affecting pieces. The background is fashioned from two strips of salvaged metal siding and nailed to recycled plywood. A deer stands in the center, its head lowered to a drying pool or stream represented by torn metal nailed horizontally to the lower left. Lockett fashioned the deer from individually snipped strips of metal, hand-cut to form the animal's contours and give it depth. Lockett added punchwork detail for the eyes and in the area around the deer. The metal, incorporated into the work with its traces of scabbed and flaking paint, communicates an arid and barren landscape that offers no succor to the desperate living.

Lockett relieved the dark meditative mood of his work in tin with occasional historical pieces that celebrated the accomplishments of African Americans. Certainly, all of his work pays homage to the inspiration and mentor-

ing provided by Thornton Dial, but Lockett also looked to other exemplars, such as Jackie Robinson and Jesse Owens. His 1995 tribute to Owens, *The Inferior Man That Proved Hitler Wrong* (plate 50), freezes the sprinter in the moment where he crouches in the starting blocks at the 1936 Berlin Olympic summer games, seconds away from besting the field, including his Nazi competitors. Similarly, he depicts Jackie Robinson at bat. In both works Lockett shows his protagonists in the triumphant instant of upending the status quo of racial inequality. The works on Owens and Robinson, however, are exceptions in Lockett's works with metal.

In 1995 Lockett undertook a series of works that presented the figure of a female nude seated cross-legged on a small carpet or barren floor. He titled the pieces *Fever Within* (plate 49), referring most immediately to the HIV with which he had been diagnosed in 1994 or 1995. Lockett made at least half a dozen iterations of *Fever Within*, including several roughly four-foot-square variations and a rectangular composition fashioned from two salvaged metal panels stacked vertically and nailed to a recycled wood support (fig. 3).[19] By early 1995 both Lockett and his girlfriend knew that they had been infected with HIV, and each blamed the other for the transmission of the disease. Betrayed by love, exchanging accusations of who communicated the disease to whom, Lockett spoke to the fate he shared with his partner through the lone feminine figure visually isolated against a ruined and indefinite metal background.

Reflecting on his art in 1997, Ronald Lockett spoke to an earlier 1994 work titled *Coming Out of the Haze* (plate 43), which bridged the frustration and darkness of another 1994 work, *Drought* (plate 42), and the confusion and pain of *Fever Within* (plate 49) the following year: "I'm not sure, but it's a picture about me and some dark periods in my life where I was trying to come out of a deep depression. That's something I've been battling with for a while, and I have had things go against me in my personal life, but that's a particular picture that I made, *Coming out of the Haze*."[20]

With the inauguration of the *Oklahoma* series in 1995 Lockett began to draw on the quilt-making traditions he associated with Sarah Dial Lockett, who, well past her hundredth birthday, would die that summer. Barbara Archer neatly summarized the importance of that connection: "There were some buildings, metal barns or something, being torn down, and he was captivated by the metal, but to me that was a bigger leap than any— that he saw these rusty parts and he actually saw them as quilts. And of course quilting was a tradition that he totally understood, because [Sarah Dial Lockett] who he lived with, she was a quilter. He saw quilters around him and to me that was his real brilliance, that he assembled those rusty pieces into quilts. That was a big step, that was a big period, a big shift."[21] The *Oklahoma* series also owes a debt to the earlier *Smoke-Filled Sky* work. The motif of the grid as an architectural cypher and the heavily daubed clouds of smoke seen in *Oklahoma* and *Timothy*, for example, are foreshadowed by a *Smoke-Filled Sky* variant from 1990, *A Dream of Nuclear Destruction* (plate 29). Still, although serious politically charged narrative purpose informs much of Lockett's early work, it is important to remember his sometimes playful and even celebratory engagements with paint, composition, and abstract qualities that occasionally surfaced in later works and spoke to historical moments.

Lockett achieved the moment of the *Oklahoma* series through an array of influences that had always been in play for his creative process. Those influences ranged from an art class taken during high school to how-to painting shows broadcast on public television, from pictures he saw in books during his hours at the public library to the Pipe Shop community where he lived, and from his association with his patrons Bill and Judy Arnett and their sons, particularly Paul Arnett. Visual elements drawn from pictorial sources, for example, are

Figure 3
Ronald Lockett
Fever Within
1996
53 ¼ × 51 × 5 ½ in.
Rusted sheet metal, with nails
Collection American Folk Art Museum, New York
Gift of Ron and June Shelp, 2012.18.3
Photograph by Gavin Ashworth

readily identifiable in works including *Cry Heard across the World* (plate 23) and *Natural Habitat* (plate 33), from 1991 and c. 1990, respectively. The most significant forces shaping Lockett's art, however, were those closest to home: Thornton Dial and Sarah Dial Lockett. Dial's bold narrative strategies, steeped in visual signifying, metaphor, and indirection, inspired Lockett's own sense of purpose and visual strategy. So, too, did his older cousin's extraordinary ability to repurpose found and industrial-grade materials for art making. Sarah Dial Lockett's influence was more nuanced and subtle. Certainly Lockett tapped into the artistic registers of quilt making, gardening, and cooking that his great-aunt pursued, but it was her sense of family and community history, Bible instruction, and the virtue of good works that inspired her grandnephew's desire to create art that was simultaneously deeply affecting, ideologically sensitive to the plight of the unempowered, and keenly rhetorical in its objectives.

Sarah Dial Lockett was surely Ronald Lockett's earliest influence. Where Thornton Dial inspired him to create art, Sarah Lockett schooled him in the histories of family and place, the beauty cultivated in everyday things including quilts and gardens, and the sustaining comfort of faith. Sarah Dial Lockett and her husband Dave Lockett brought their grandnephew up in a world of love and good works. When Lockett was born, his father Short Lockett remembered that Sarah Dial Lockett "carried a Bible and put him on top of the Bible and walked him around the house. She had a prediction that said that the firstborn was given back to God. . . . She was giving him back to God. She took him around the house and as she took him around the house she was praying over him." Lockett's father concluded that as his son grew older, his "model was Sarah Lockett, it really was."[22]

Short Lockett then described the place quilts held in Lockett's experience:

He took time to sit down with her and there wouldn't be nobody there but her and him. . . .

She used to quilt, she had quilts, she used to make quilts . . . and that's why he come up maybe with that in there. But the old pieces that what she had, was clothes that folks now was making quilts out of. . . . And there was real value for a person just to take a needle and sit there, sew, and make a quilt for to cover a bed. There used to be a time when I was coming on when people would be a house, two or three women come together . . . and they'd sit up and make quilts together.

Richard Dial added, "It was just for peace of mind and focusing, they just got together. I guess that was just a pastime thing to do, to sit there and see what they could create out of old materials and stuff. And it had a purpose." Their purpose, Short Lockett concluded, extended beyond creative work and into an act of gifting the finished quilt in a gesture of bodily comfort and spiritual grace.[23]

Sarah Dial Lockett was a religious woman: "They were really, really deep Christian-hearted people, and I don't know of no one . . . that really, really was more Christian than they were. That was a part of their life."[24] And Lockett's as well. Lockett's brother David remembered, "When we was kids, our auntie always used to, as far as going to Sunday school, the stories she would tell us were always biblical stuff. She always said the best stories are in the Bible. . . . I think he liked them all."[25] Those stories appear in Ronald Lockett's art—for example, in the form of *The Last Supper*, based on a photograph of Leonardo da Vinci's fresco; Daniel in the lions' den, constructed in the form of a found-metal tableaux; David triumphing over Goliath; the Crucifixion; and varying aspects of Eden and the Fall (plates 4 and 5). The theme of an Edenic state was of particular interest to Lockett, and he incorporated references to what he described as "when the world was pure" in tension with "how things in this world are now."[26] An untitled work depicts a reclining nude figure gesturing toward brightly feathered birds fluttering above while a pair of loons swim and preen

below (plate 7). The image combines the story of Creation with longing for an untainted state of being where Christian love and wistful desire coincide.

Most of all, though, Short Lockett remembered, Sarah Lockett "was teaching Ronnie about the past." Richard Dial expanded on this point: "She was always doing that. Now that could be it. Because even with me, you sit out there in the evening time, the sun goes down, they had this swing, you'd sit there. I didn't know anything about Daddy's side, his people. But I think that was one of the things that kind of [drew] you into sitting there, because she didn't have a boring conversation. She would always try to explain the family tree to us coming up. How so-and-so fit in." Ronald Lockett's engagement with the past extended to the larger Pipe Shop community and its aging residents: "Ronnie, he was kind of laid back, and the elderly people were like his close friends. He could sit and talk with them, just like an average teenager would hang with another teenager—and that was his comfort zone, just being around older people." Ronald Lockett was, his father and the Dials agreed, a young old man.[27]

Richard Dial described how Lockett sat with and listened to his neighbors:

He had a certain time that he was going to dedicate out of his life, because you know people get up in age, eighties and nineties, they kind of decide to push you out of the way, rush you on out. When you look at Ronald, his personality, he was always going to take that time regardless of what was going on. . . . There was a certain time he wasn't going to let anything, I mean anything, interfere with the time that he had set aside to sit with them and try to comfort them, or talk to them, or wait on them or whatever. . . . I think he did that better than anybody. Certain time of day, certain time of morning, certain time of night, if he was going to sit there for two hours and have a conversation with them and see what they needed or did they need any help . . . and that just was written in stone. It didn't make

any difference—rain, sleet, or snow, he was going to have that little isolated time with them. He was going to sit on that porch and give them that time.

Still, Sarah Dial Lockett occupied the center of his affections. He looked after her in her last months, setting aside time to sit with her, nurse her, and address her needs. Her death devastated him. Following the funeral, "he went back to the house where she was. He wouldn't eat. It took a lot from him when she left, because she loved him. He missed her a whole lot. . . . He started making pictures of whatever she had taught him. His whole mind really was on her."[28]

In 1997, two years after Sarah Lockett's death in early July 1995 and Princess Diana's passing the next month, Lockett began a series of works in their remembrance. The first pieces for Sarah Lockett evolved out of his *Oklahoma* series. In *Remembering Sarah Lockett* (plate 56), he created a patchwork of salvaged metal painted yellow, orange, and dark red. The quiltlike composition framed a section of battered grillwork mounted on a rusted tin panel in the lower left corner. Given Lockett's ongoing and stated effort to express emotion through evocation, *Remembering Sarah Lockett* invokes the metaphor of the quilt to celebrate the legacy of her love, faith, and art. The somber grillwork panel, however, speaks both to Lockett's loss and to his increasing sense of isolation, made more acute by his awareness of the HIV/AIDS that increasingly sapped the strength of his mind and body.

Sarah Lockett's Roses (plate 57) extended Lockett's celebration of the life and lessons of his great-aunt. Roses and lilies still bloom in front of Sarah Lockett's old house in Pipe Shop in Bessemer (fig. 4). In this work, he moves beyond Sarah Lockett's art as a quilt maker to embrace her creativity as a gardener. But the roses in the commemorative work are specific to Lockett's mourning, where each panel contains a single long-stemmed rose. These are a florist's roses laid on casket and grave and not those of Sarah Lockett's garden. The flowers Sarah Lockett nurtured in her dooryard more closely resemble those

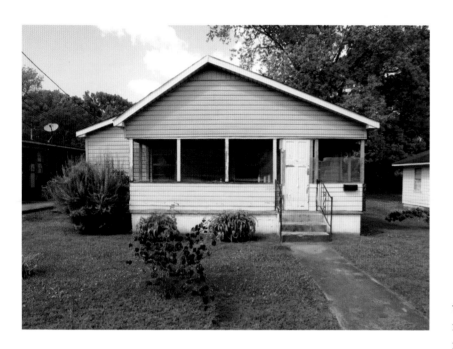

in the Princess Diana works, such as *England's Rose*
(plate 58). A plywood ground painted black supports
three sections of hand-cut metal strips in yellow, white,
and black. Three metal panels ascend from right to left,
each one bearing a trailing cluster of painted metal roses.
A second pair of blooms floats above each of the floral
panels. Lockett's choice of flowers creates a link between
two women who never met but who loomed large in his
life: Sarah Lockett, who nurtured her grandnephew from
birth, and Princess Diana, who stood among the first ad-
vocates for AIDS victims and their care.

Thornton Dial, by Lockett's own account, offered the
enduring encouragement that gave direction to his cous-
in's creative ambitions. Lockett spoke in 1997 about the
importance of Dial, his "Uncle Buck," in his art: "I always
wanted to do artwork or whatever, but he was a big inspi-
ration to me." He continued:

> But my uncle was the kind of like driving force of
> my artwork. I told him I wanted to go to art school
> and he told me I had the best school of all just mak-

ing artwork or whatever. He was a big influence
on my artwork. I mean, he helped me to kind of
find out that you could take tin or barbed wire or
different small little metals and make things out of
them. So he was kind of like a big inspiration for
me. All the pieces that I made are primarily because
of him because he helped me to keep going on even
when I couldn't afford to buy paint, he had paint
and would pour me out blue paint, red paint, when
I couldn't really afford paint until I started making
some money off of it. But he was kind of a big driv-
ing force to you know where I am today to keep me
making my artwork or whatever.[29]

Lockett then spoke to the reciprocity of respect be-
tween the two artists. Just as he admired the art of his
mentor, Dial lauded the younger man's work. Lockett
recalled:

> I remember one time I made a piece called . . .
> *Vanishing Territory*. I remember when I made it
> he was standing behind me when I was drawing it,
> and I never really erased or anything on my paint-
> ing of the wolves and he was looking surprised at
> what I was doing, but then I was just amazed at
> what he was doing, so I was kind of proud of myself
> that he had some kind of mutual respect for my art-
> work just like I had for his. So I had drew out some
> deer one time and he sit behind me and watched
> me draw the figures out and stuff and be amazed
> you know that I could do it. But I was just amazed
> at what he could do.[30]

Richard Dial elaborated on the relationship:

> If you track Ronnie from the time he came out of
> school to the end of his life, now Ronnie always
> would do artwork. He just did it. . . . All my life,
> Daddy [Thornton Dial] was always just trying to
> create something. So Ronnie didn't just pick this up

out of midair—and maybe because he was raised so close to Daddy, watching Daddy do creative things, Ronnie came up as a child doing creative things. I think that is something that has kind of been left out, too. So don't think that he just all of a sudden picked this up.[31]

Lockett's and Dial's conversation about art school is significant not just for speaking to Lockett's influences but also for the recognition that they situated themselves within a structured network of artistic relationships. Because their conversations over time embraced other artists, including Lonnie Holley and Joe Minter, they define what might be understood as the Birmingham-Bessemer School. Theirs was a school defined by a context of shared knowledge and experience, creative and critical observation, and an open exchange of ideas, often through visits. There was neither institutional framework nor formal curriculum; instead there was a rich multigenerational practice of demonstration and conversation. Through the 1980s and 1990s Thornton Dial sat with Ronald Lockett; Lockett followed Dial; together they visited Joe Minter; Lonnie Holley and Lockett walked and talked together; their friend and patron Bill Arnett brought them to exhibitions from Atlanta to New York City. Underlying those later exchanges, however, was a deeper array of artistic exchange. Lonnie Holley, for example, described how he grew up in a world of artistic endeavor (although he never stated it in that language), where found media and coded meaning enriched the too often grinding labor and disenfranchisement in everyday life. Lockett and his cousins found inspiration in the quilts and roses of Sarah Dial Lockett; Lonnie Holley drew on the colorful paper constructions the women in his family crafted from discarded cigarette packs.[32] What defines and distinguishes the Birmingham-Bessemer School is more than the sophisticated aesthetic rendering of found materials that included rusted metal, weathered wood, stone and slag, animal bones, ripped and stained cloth, and much more. The artists were also linked by

a larger rhetorical engagement with sweeping historical themes—most importantly those connected to civil rights, political critique, resistance to power, environmental degradation, and the struggle for human equality and dignity on a global scale. They also engaged themes of joy, hopefulness, and pleasure: Ronald Lockett's visual idealizations of the strength and fragility of true love speak intimately to his own yearning. Thus, unified by practice (mining the found and achieving expression through the manipulation of discarded materials), purpose (historical, political, and personal), and affect (the communication of feeling through shared sensibilities), the Birmingham-Bessemer School cultivated a dynamic artistic presence exemplified in the totality of Lockett's art and the creations of his contemporaries.

The relationship between Lockett and Dial as artists was complex and more one of creative stance than of visual content or technique. David Lockett, Ronald's brother, recalled, "He'd been drawing pictures ever since we was really little. . . . He was always drawing something, but as far as doing the art with Uncle Buck, he started that when we was teenagers, when he'd go in the back of the garage in back of Buck's and them house and doing that."[33] William Arnett noted, "Dial influenced him a great deal, but it was Dial's personality and his work ethic that influenced Ronald, it wasn't the style of what he did or anything like that." In fact, Arnett added, "Ronald influenced Dial a great deal because Dial would get ideas from Ronald. Ronald is full of ideas. Ronald would come up with something new every few months and do it, and Dial would see it and then Dial would do it."[34]

Late in 1997, Lockett, visibly ill and with advancing symptoms, undertook one last cycle of work. Sadly, the works in this project are all weak copies of earlier pieces, including *Smoke-Filled Sky*, *Holocaust*, *Rebirth*, and *Traps*. A comparison between two versions of *Traps*, one executed in 1988 and the other in 1997, show the extent to which Lockett rushed through these last efforts (plates 59 and 60). Hurriedly produced, they are characterized by thinly painted surfaces, roughly cut and fashioned ele-

ments, and minimally schematic pictorial motifs. All lack the detail and care of the early works they intend to copy. Lockett's reasons for making these pieces are unclear, although family members recollect a commission linked to the unrealized promise of a solo exhibition and book. To meet the demand of the project deadline, Lockett labored at an unaccustomed pace that compromised the thoughtfulness and complexity he invested in his earlier work. Richard Dial saw Lockett at work on these pieces: "I do remember him like out there in the rain. It's definite he shouldn't have been out there. Just working and stuff, and probably right after that he probably got sick, so I don't know what museum gave him that motivation or why he felt this certain urgency to be out there in the weather. . . . Lot of times I'd be passing through and I'd stop and stay there with him awhile and watched him work a little bit."[35] David Lockett placed his brother's last works in a larger framework: "He's seen the pain. He's seen the joy, and a lot of things. For him, his ultimate goal was that he just wanted people to care about each other—and then he really didn't see that everybody did care. A lot of people talk, but then he's seen that they didn't [care], so that was his escape, like he used to tell me, to feel like everything is right."[36] The emptiness of the last works speaks to that contradictory sensibility of hopefulness and despair.

The essays that follow provide multiple perspectives for framing the reception of Ronald Lockett's art. Importantly, the mystery of Lockett remains, inspiring an array of interpretations about his art. The open-ended quality of his creations and his limited commentary reveal only a tantalizing outline of Lockett's thoughts on affect, representation, history, and personal pain and love. The rest is up to us. Colin Rhodes explores the connections between Lockett and artists linked to an expansive view of the relationships between the modern and the contemporary, the vernacular and the academy, the local and the global. Sharon Holland extends contextual medita-

tions on Lockett's art and life with particular reference to the gender and race politics of the 1980s and 1990s. Her essay offers insights on Lockett's art as an evocative commentary on the times in which he lived—and, autobiographically, on his own struggle and ultimately the plague that struck him down. Katherine Jentleson and Thomas Lax collaborate on unpacking the artist and his work in two historical moments: the rise of "folk" art and the highly charged *Black Folk Art in America* exhibition in 1982, on the one hand, and retrospective engagement with contemporary works that address issues of identity through creative expression, on the other. Paul Arnett, Lockett's friend, speaks to the artist's family connections (particularly his great-aunt Sarah Dial Lockett) and the critical mentoring he received from his cousin Thornton Dial. Lockett, he argues, occupied all of these contexts and yet always stood outside them. He was an artist who emerged, as Paul Arnett noted in correspondence, within "a post-industrial, post-migration, post–civil rights, and post-folkloric generation of black American men struggling with all senses of place."[37] Together their contributions map the complex terrain of Ronald Lockett's art and challenge us to rethink histories of American art in more generous and inclusive terms.

Still, it is a map without borders.

Ronald Lockett died in 1998 from complications resulting from AIDS. His obituary in the *Birmingham News* quoted the praise of collectors, curators, and art historians:

"In the field of African-American vernacular art, Ronald Lockett was certainly among the best," said Atlanta-based collector William Arnett. . . . "His work was consistently good," Arnett said of Mr. Lockett. "Every piece he made was right on target." . . . Robert Hobbs, art history professor at Virginia Commonwealth University . . . agreed. . . . Mr. Lockett was "part of an extended family of artists that have made amazing contributions to art," Hobbs said Sunday. He added that the Birmingham area

boasts "some of the strongest artists in the country. . . . For Ronald Lockett, one of the things that was so very important is that, coming from the Birmingham area, he was able to see the kind of transitions that have occurred from rural to industrial to post-industrial." . . . Hobbs said Mr. Lockett's "illness allowed him to really focus on the fragility of existence." His use of rusted found materials and images of threatened native American animal species, such as the buffalo and elk, emphasizes that fragility, Hobbs said.[38]

Ronald Lockett expressed his eulogists' sentiments in his own words in the year prior to his passing:

Well, my artwork, ever since I been a kid, has always been my strength—you know, something positive about me. Lately I've been going through a lot of hard times, where I've kind of lost my way, but any time I kind of want to regain myself when I lose myself I go back to my artwork, my drawings, painting, drawing, creating. Like I said, nobody was very supportive of me in my family and I realized that when I was back then in the past my mother and my father weren't that supportive of me but I was determined to do something, and now when I feel kind of lost in my life I always turn to my artwork and that is how I kind of get back in touch with myself. My artwork is a part of me, whether it's good or bad, whether people like it, it's a part of what I do from the heart. I care about my artwork and you know, like I say, it's a way of getting back in touch with myself when I seem to lose my way. I always, either I draw or paint, or I come out here and I draw, and it seems to kind of like, I regain who I am. That's all I ever did since I been a kid, is draw, and that's a part of me and that's who I am whether people like it or not. That will always be a part of me no matter what.[39]

Fifteen years later the artist Lonnie Holley looked back on his friend's life and art, reflecting: "To me Ronald was talking about that freedom, whether it was humans or whether it was creatures that he saw fenced away from opportunities, or animals that once roamed free now had fences around them and I don't think he was just talking about the values of America. . . . He had ideas and thoughts about the rain, the mountains, the forces of nature and all these other things that affect the human way of living."[40] "He was," Holley observed, "an artist of hope. And new hope! . . . I learned from his works, even now in the warehouse there in Atlanta, Georgia, when I see them. I learn from them. I learn. I learn, we all must learn patience. And Ronald had a lot, a lot of patience. Ronald, in a sense, he learned focus . . . and he learned patience." Holley concluded, "The whole thing about a brain such as the brain that Ronald had, how do we disciple, or how do we learn from him, or how do we try to take it to this greatest value for other humans by way of education. I can only say that a person like Ronald has left the evidence of his works. And most of it is having to be deciphered, or having to be worked out and unpuzzleized, where people can understand it better."[41]

When Lockett died, Dial created two tributes to his younger relative. In one composition a large heavily antlered buck rests confident and at peace in an explosively flowering garden beneath a blue sky (fig. 5). Arnett recalls the genesis of the second work: "When Ronald Lockett died, Dial went to his garage. Ronald did all of his work in his garage when the weather was okay, which was most of the time, and the floor of his garage which was made of some kind of concrete long, long ago, was cracking and falling apart so Dial picked up pieces of that garage floor and made this big abstraction as a sort of tribute to Ronald and his work" (fig. 6). The flooring Dial peeled up consisted of thick layers of dried paint, dirt, and grime—the accidental residue of Lockett's creative life.[42]

Figure 5
Thornton Dial
Untitled (Tribute to Ronald Lockett)
1998
48 × 60 × 5.5 in.
Carpet, rope carpet, clothing, artificial flowers, artificial
vegetables, artificial leaves, Splash Zone compound, enamel,
and spray paint on canvas on wood
Collection of William S. Arnett
Photograph by Stephen Pitkin / Pitkin Studio, HELIOTRACK
automated lighting

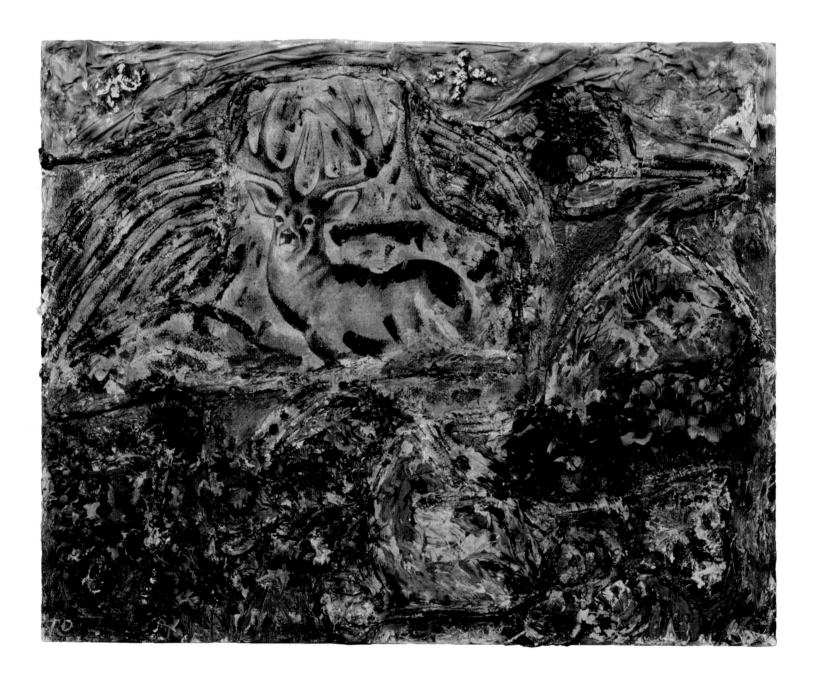

Figure 6
Thornton Dial
Ronnie's Floor
1998
60 × 96 × 1 in.
Concrete, Splash Zone compound, enamel,
and spray paint on canvas on wood
Collection of William S. Arnett
Photograph by Stephen Pitkin / Pitkin Studio,
HELIOTRACK automated lighting

NOTES

1. The film footage recorded in 1997 by David Seehausen was part of the larger Souls Grown Deep project to record the works and makers of the South's African American vernacular art; in these essays it is cited as "Ronald Lockett, interview with David Seehausen, 1997," or a "Lockett, interview with Seehausen." Paul Arnett's essay on Ronald Lockett's art remains the starting point for any conversation on the artist's work and life. The text is available online and in print: Paul Arnett, "Ronald Lockett: Improvising in a New Key," in *Souls Grown Deep: African American Vernacular Art*, vol. 2, ed. William Arnett and Paul Arnett (Atlanta: Tinwood Books, 2001), 516–27.

2. Short Lockett and Richard Dial, interview with the author, Bessemer, Alabama, 13 May 2014. Also present: Thornton Dial, Dial family members, Colin Rhodes, and Scott Browning.

3. *At the Heart of Change: Cross-Cultural Currents in Southern Contemporary Art* (Kennesaw, Ga.: Kennesaw State College, 1992), 3. Brochure published in conjunction with an exhibition that ran 30 January–14 March 1992, courtesy Morris Museum of Art, Augusta, Georgia.

4. Although Lockett does not remember the movie title, the likely candidate is the made-for-television film *Escape from Sobibor* (1987). The film opens with the arrival of a train at the extermination camp and the selection of those destined for the gas chambers. The abandoned possessions of the doomed Jews litter the ground beside the boxcars.

5. Ronald Lockett, interview with Seehausen.

6. Lonnie Holley, interview with the author, 4 October 2014.

7. Ronald Lockett, interview with Seehausen.

8. Short Lockett and Richard Dial, interview.

9. Ibid.

10. Ibid.

11. Ronald Lockett, interview with William Arnett, Bessemer, Alabama, c. 1992–93.

12. Arnett, "Ronald Lockett: Improvising in a New Key," 516–27.

13. Ibid., 523.

14. Ronald Lockett, interview with Robert Hobbes and William Arnett, Bessemer, Alabama, c. 1994.

15. Ibid.

16. William Arnett, interview with the author, Atlanta, Georgia, 1 April 2013.

17. Barbara Archer, interview with the author, 1 May 2014.

18. Holley, interview, 4 October 2014.

19. Valérie Rousseau of the American Folk Art Museum identifies a possible source for the feminine figure in Giorgione's *The Tempest* (1506–8), a canonical painting Lockett could easily have encountered as a published reproduction in his visits to the local library: Valérie Rousseau, "Fever Within," exhibition label for *Self-Taught Genius: Treasures from the American Folk Art Museum* (New York: American Folk Art Museum, 2014), http://selftaughtgenius.org/artworks/fever-within-ronald-lockett.

20. Ronald Lockett, interview with Seehausen.

21. Archer, interview.

22. Short Lockett and Richard Dial, interview.

23. Ibid.

24. Ibid.

25. David Lockett, Ronald Lockett's brother, joined the conversation between Short Lockett, Richard Dial, and Bernard L. Herman through a phone call placed by his father, Short Lockett: Short Lockett, Richard Dial, and David Lockett, interview with the author, Bessemer, Alabama, 13 May 2014.

26. Ronald Lockett, interview with unidentified party, Bessemer, Alabama, n.d., video, Souls Grown Deep Archive, Southern Folklife Collection, University of North Carolina at Chapel Hill.

27. Short Lockett and Richard Dial, interview.

28. Ibid.

29. Ronald Lockett, interview with Seehausen.

30. Ibid.

31. Short Lockett and Richard Dial, interview.

32. Holley, interview, 4 October 2014.

33. Short Lockett, Richard Dial, and David Lockett, interview.

34. William Arnett, interview.

35. Richard Dial, interview with the author, Atlanta, Georgia, 26 October 2013.

36. David Lockett, interview with the author, Bessemer, Alabama, 13 May 2014.

37. Paul Arnett, personal correspondence to author, 9 December 2013.

38. Ronald Lockett, obituary, *Birmingham News*, 24 August 1998.

39. Ronald Lockett, interview with Seehausen.

40. Lonnie Holley, interview with the author, Atlanta, Georgia, 25 October 2013.

41. Holley, interview, 4 October 2014.

42. William Arnett, interview with the author and Scott Browning, 2014.

Cross-Cultural Tendencies, Intellectual Echoes, and the Intersections of Practice

RONALD LOCKETT IN THE ART WORLD

Colin Rhodes

In the spring of 2014 I was taken by Ronald Lockett's father to a number of places that are important in the artist's story. Most obvious was the street where Ronald spent just about his whole life; a good part of the interlocking extended families of Locketts and Dials had lived there, and many still do. I was privileged to see the house in which he was raised and the now abandoned, though still erect, wooden and sheet tin workshop where Thornton Dial made art when he still lived in the neighborhood. Lockett, we know, spent hours on end with the much older man, watching and learning. Neither one is famous for his verbosity, and there are few reports of what passed between them. From what we know of their characters, though, we can be sure that much of what transpired was communicated without words—by watching and sharing the physical act of making, and by the silent exchange that seems possible between creative souls in tune with each other.

I saw, as well, the small square of concrete floor, still paint-encrusted in places, which is all that is left of the tin and wood structure Lockett used as a studio. This was a father's journey, though, not so much about art as about Short Lockett's boy—the son who had been taken from him before he had really realized the extent of what he was losing. So he drove me past the hospital in which Lockett had succumbed to AIDS-related pneumonia on 23 August 1998, at just thirty-three years old, and to his son's grave, situated in death, as the man was in life, in the company of others from the Dial and Lockett families.

Ronald Lockett left little behind in terms of verbalization about his practice, and those who knew him best offer few clues. The Dial and Lockett men present a picture of a deeply introspective but genuinely likeable and kindhearted person, though someone who did not hang out with those relatives of a similar age; he preferred in-

stead the company of an older generation, and especially women, like Sarah Lockett (1890–1995), the matriarch of the two families. They mention also that there were times when Ronald would go off—to a girlfriend, perhaps, or somewhere else? No one seems to know, exactly. All agree that there is an air of mystery to these absences (and tacitly suggest in their silence that this ought to remain the case).

So Lockett remains an enigmatic figure. I had known his work for some time, but I had never really gotten it intellectually. As recently as the day before my visit with his father in Bessemer, Alabama, I had been looking at the encyclopedic collection of Lockett's work at the Souls Grown Deep Foundation in Atlanta, Georgia, still feeling there was something missing in my understanding. The particularities of that journey changed something. I began to understand him, not as an academic might, but as one practicing artist to another. My subsequent response to Lockett is driven by the subjectivities of artistic method, his and mine, and the nonlinear peculiarities of knowledge accumulation as an aspect of practice and its deployment in the work.

Ronald Lockett was a supremely contemplative artist. His work is at once content-laden and aesthetic, metacritical and in conversation with other art. His extant oeuvre, which is relatively small only in part because he died at a young age, does not adequately reflect the extent of his practice, which, it seems to me, was overwhelmingly and primarily one based in interiority.

Everybody who knew him talks about how much watching he did. Barbara Archer, for example, describes Lockett as being "extremely quiet, almost to the point of being shut down," to the extent that "anyone who knew him felt they knew him through his work and what he was trying to express [visually]."[1] Birmingham artist and musician Lonnie Holley interprets his friend's quietness as evidence of intense focus. He became interested in Lockett, he says, precisely because "he always watched things." He was "somebody with their eyes watching every move that somebody else is making and they're re-

ally observing and pulling in a lot of knowledge that is not written about."[2] Lockett also spent a lot of time looking at and being with his works in progress—more time, in fact, than he spent in the physical act of making. As Bill Arnett, the primary collector of Lockett's work, put it, the artist "was very slow. He didn't make a lot of pieces. He wasn't prolific. But he would work all the time."[3] Lockett himself simply insisted that the process of making art defined him as a person: "Anytime I want to regain myself, when I lose myself, I go back to my artwork. . . . That's all I ever did since I was a kid, is draw, and that's part of me and that's who I am. Whether people like it or not, that will always be a part of me no matter what."[4] And in words, he doesn't reveal much more than that.

Everyone who knew him comments about how much time Lockett spent in the company of the artist Thornton Dial, watching him intensely and (to a much lesser extent) engaging in conversation. For example, Dial's artist son Richard says, "Ronald enjoyed watching Dad work a lot, and he spent a lot of time just hanging around Daddy and watching him work."[5] Before Thornton Dial moved out of Pipe Shop, the industrial suburb of Bessemer, Alabama, in which he had lived among his extended family for four decades, and where Lockett was born and grew up, the two artists were constant companions. Bill Arnett argues and Dial confirms that at that time "Dial was really the father in Lockett's life, and they lived close to each other, and he would go down to Dial's every day, say. So they had a close relationship."[6] My suspicion, though, is that their relationship was more akin to the old master and apprentice in the medieval guild system. This, of course, makes sense of Barbara Archer's suggestion that Lockett was "enormously influenced [artistically] by Dial," and most agree that it worked both ways. There was, she says, "an exchange . . . and their sort of back-and-forth was very influential for both of them."[7]

Arnett describes a complex creative relationship, which places Lockett more often as the innovator and Dial as the developer and (perhaps) perfecter of ideas and techniques: "It was Dial's personality and work ethic

that influenced Ronald, it wasn't the style of what he did or anything like that. And as I've told everybody, Ronald influenced Dial a great deal because Dial would get ideas from Ronald. . . . Ronald would come up with something every few months and do it, and Dial would do it."[8] This is perhaps because Lockett was looking at other art in his search for a method, whereas Dial was not. In any case, it is possible that the most important communication between the two of them was nonverbal—a kind of embodied visual learning, much like that described by Herman Hesse for the artist character Goldmund and the carver Master Nicholas in his novel *Narziss and Goldmund*: "Goldmund, full of wondering delight, sat watching these inspired, well-graced hands. . . . He never let him out of his thoughts, forced his way with eagerness and mistrust, alert and thirsty after knowledge, into the secret places of his life."[9] Nicholas, for his part, felt "a kind of spiritual love and kinship," born of watching the other, who worked "by fits and starts, slowly and moodily, yet insistently."[10]

It is this watching, this scrutinizing—Lockett's deeply contemplative approach to art making—that I want to emphasize here. It is what makes him slow and, in this sense, comparable with other, more widely known contemplative American artists like Mark Rothko, Mark Tobey, or Eva Hesse.[11] I also want to emphasize that this introspection is not primarily, nor even very much, about learning how to be an artist; that, I think, is something Lockett picked up rather quickly, judging from the way in which his practice developed in a remarkably short oeuvre. Like many significant visual artists, he took what he needed and employed techniques accordingly, from wherever he found them (whether that was in Dial's company, watching television, going to the library, or looking at the visual forms around his neighborhood).[12] In that sense his practice was a process of development of techniques (though not necessarily manifest content) that were mostly consecutively employed rather than built on and merged. Thus early works such as *The Last Supper* (plate 5) are comparable to vernacular carved painted relief pictures, often with a votive function—a technique that was developed and transformed to great effect by self-taught artists well known to many, such as Leroy Almon, Elijah Pierce, and Missionary Mary Proctor. At another moment, Lockett's style is clearly derived from popular paint-by-numbers techniques, as in pieces like *A Summer Day*, where a large dog rests on a green lawn beneath a deep red sky.[13]

He tries these approaches and moves on, incorporating some of the lessons learned—such as a more assured handling of paint through to *Holocaust* (plate 26) or *Cry Heard across the World* (plate 23), and the addition of functional relief elements in pieces like *Homeless* (plate 37), from 1989. Emphatic shifts of gear take place periodically, though—the use of a splattering technique in a pair of untitled still lifes and a reflection on the John F. Kennedy assassination that is inevitably impossible not to compare with Jackson Pollock for the art-savvy viewer, although any direct influence (which is possible, according to Paul Arnett in his essay here) would be an expressivist practitioner's borrowing, rather than an intellectualized one. Further, the swirling oleaginous finger-painting technique in works such as *Out of the Ashes* (plate 13; see also plates 10 and 11) was inspired by experiments being conducted by Thornton Dial at the same time. Finally, the adoption of tin-sheet construction in *The Enemy amongst Us* (plate 51), which was in part Lockett's artistic response to a renewed interest in, and knowledge of, traditional quilting techniques. Ultimately, the means of production was dictated primarily for Lockett by the need each time, as he put it, to "express yourself" and to "try to be honest about what you are trying to say through that piece."[14]

A constant in Lockett's art is the use of fairly schematic representational techniques. He clearly never learned about the various conventions for perspective rendering, for example, and was content to trace the outlines of figures and animals in his mature work—see, for example, the young buck in *Crossing Over* (plate 21) and the female figure, back to the viewer and striking a dance

pose, who may be retreating from the captured animal, or even operating the trap. Lockett was perfectly capable of learning figure-drawing techniques, though; early paintings of human figures show a deft if still untrained hand at work, as in the three silhouettes in *Homeless People* (plate 34) or the six nudes in *Cry Heard across the World* (plate 23), which are reminiscent of examples from drawing manuals or popular periodicals, perhaps seen in the public library.[15] Paul Arnett, among others, has suggested that Lockett "learned to paint by watching Dial and watching TV, especially those kitsch-laden how-to-paint shows that teach formulaic, motel-art landscape and still-life techniques."[16] Interestingly, Lockett once said that he'd confided in Thornton Dial a desire to attend art school, to which Dial replied that Lockett already "had the best school of all just making artwork."[17] The primary impetus, in any case, was to produce visual statement, and this was a constant. As Lockett said, "I'll just kind of stay on common ground, so my artwork never really changed. I just like to try and stay who I am, what I'm about, like I was in high school, or whatever."[18] This is, of course, a loaded statement. On one level it can be read as a confident belief that Lockett had all that he needed in Pipe Shop to pursue his vocation. On another level, it might be read as a fearful position, for although most agree that Lockett never really fit in in Bessemer, he was apparently easily convinced by others around him to stay, and not least by his mentor, Thornton Dial.

In Lockett's oeuvre representation was primarily dealt with as sign (as it is in the later work of Thornton Dial or Joe Minter). What was most important to Lockett was not that things were represented mimetically through technical skill or emotionally through expressive handling of materials, but that things in the works stood metonymically for things in the world: thus fragments of actual fence represent "traps," a found piece of wood fixed to an image denotes a table, or the folds of glued-on fabrics reproduce the contours of a landscape. Such a

practice is very much in tune with, though not led by, much modernist and postmodern art: used fairly literally in the synthetic cubism of artists like Pablo Picasso, Georges Braque, and Jean Gris, and more symbolically in the Dadaism of Kurt Schwitters and neo-Dadaist works of Robert Rauschenberg and Jasper Johns. It is also a common characteristic in contemporary art, from Joseph Beuys and Anselm Kiefer to Rosalie Gascoigne and Fiona Hall, where objects characteristically perform a more self-consciously hermeneutical function.

Similarly, it is enough for Lockett even when making a representational image—the figure in *The Inferior Man That Proved Hitler Wrong* (plate 50), or the deer in *Once Something Has Lived It Can Never Really Die* (plate 39), for example—to employ visual synecdoche, whereby the fragment, or the individual stands for a greater whole. Again, this was employed as a strategy in much twentieth-century art, notably in the paintings and sculpture of late modern and postmodern artists like Johns, James Rosenquist, Larry Rivers, and David Salle. The whole adds up in Lockett's work to a kind of poetic melding of literalist and nonliteralist impulses.

All of this demonstrates an urge to experiment with and to learn technique, it is true, but it also, more importantly, signals Lockett's restless search to speak clearly and strongly about issues and feelings that were enormously important to him. So, outside most of the time he spent with Thornton Dial, if it is not primarily about learning how to be an artist, what is Lockett's looking about? It seems to me that it is performative; that is, Lockett performs the work over and over internally, making it and undoing it and remaking it conceptually. The performance of that transfer from individual psychology to constructed object is a key creative work in itself, in many ways commensurate with the practices of artists as superficially different as Joseph Beuys, Leandro Soto, and Lonnie Holley. The crucial difference between the performative practice of these latter three and Lockett is that they created public arenas for their liminal works, while Lockett's was almost exclusively a private affair,

conducted in the small garage space at the side of the family house in Pipe Shop that he used as a studio. In this sense Lockett takes his place with important minimalist and conceptualist artists: those, like Brice Marden, Eva Hesse, Agnes Martin, and the later Richard Serra, who are supremely contemplative, but who communicate artistically exclusively through objects.

The object is, of course, in no way unimportant to Lockett, and it is the only intended tangible, public outcome of his art practice. There are traces in memory, to be sure, of that liminal performative process, in those who knew him well and who were witnesses, especially other artists like Richard Dial, Thornton Dial, and Lonnie Holley. The coming-into-being of each work can also be read in the objects themselves. Ultimately, then, Lockett was both artist and audience for these essentially interior dialogues.

Lockett's art shares with people like Thornton Dial, Holley, Joe Minter, Bessie Harvey, and others in the South the belief in objects as vessels capable of containing human experience and history through use (and abuse). It is, in part, a basis of the once-common yard show, characteristic of southern African American properties. At one level things are seen to have "conjural potential," inanimate at first but apparently "awaiting activation in performances of worship, incantation, or rootwork."[19] More prosaically, perhaps, it might be said that in the art of Dial and Lockett there exists an embodied telling of history through material objects that are capable of speaking their message through skilled (that is, creative) interlocutors. Holley is eloquent on this point:

The way I saw Ronald as a observer, he was real inquisitive, he was always interested in reducing things down to the lowest terms, as I would say, when I'm looking at a piece of material I try to get an understanding of it all the way from the time it began to exist—if man made it—to the time that it no longer exists in the midst of human-kind. Ronald was pretty well the same way with the materials

that he used, for me to see him take just sheets of tin and clip them up with his tin shears, the scissors that you use on tin, and all these other pieces of material that someone else would just kick around and disregard it out of their brain-set because if it couldn't do them no good at the junkyard by scrap—its hustling and loading up scrap to take it to the junkyard or to be recycled, then it didn't really mean nothing to nobody. But everything every little bit of pieces of tin even the bent cans that was rusting away, they meant something to Ronald, and I saw that in him.[20]

It is not, then, so much in seeing importance and use in the things people throw away as seeing things that people have used as imbued with their own experiences and desires, as well as those of their particular social and cultural contexts—a trait evident in the work of trained African American artists like Faith Ringgold, Renée Stout, and Juan Logan, as well as contemporary West African artists like Victoria Udondian and Romuald Hazoumè.

This really brings into sharp focus Lockett's choice of materials, which is not in the least led by any lack of access to putatively "proper" art materials. Sure, there are times when he could not afford good quality paints, canvas, and so on, but from early on he knew that he could access these through the artist Thornton Dial or the collector and patron William Arnett, at the very least. No, Lockett's use of what might be called "poor" (that is, *not-art-type*) materials is driven by a belief that they already have affective force. The lump of rough-hewn lumber that serves as a table in the early *Last Supper* (plate 5), for example, is both metonym and metaphor; it is simple and unaffected, pointing to both the candor and the directness of Christ's ministry, his profession as a carpenter, and the humbleness of his origins. Similarly, the cross, fashioned from the crossbar of a sawhorse, with its deep-scored work surface, in *Revelation* (fig. 2), is at once real and metaphoric—the wood bears the incisions and scars of time and use, and bears witness to the celes-

tial judgment of humanity much in the way that Franz Kafka's "apparatus" goes to work in his short story "In the Penal Settlement."[21] Similar scored boards are employed infinitely more subtly in Lockett's *Holocaust*.

In the *Traps* pictures Lockett employs fragments of metal fencing to overlay and entangle deer, utilizing (in art) that which has already been used (in life) to segregate and entrap the other, while protecting or feeding the ones in the position of power. There is, to be sure, a long tradition of using found, reengineered, and poor (or inartistic) materials in modern and contemporary art: once the stuff of disciplinary critique, and now the common materiality of issue-based critical artistic conversations, from Schwitters and Jean Arp through Rauschenberg, Bruce Connor, Kiefer, Beuys, and Mikala Dwyer.

Turning to the ways in which Lockett pictured the world, we are presented with an intriguing set of strategies. The ground is immensely important to him, especially after his tentative first works. In this sense he shares something with color field painters like Rothko and Barnett Newman, as well as other Americans like Louise Nevelson. It is perhaps more to neo-expressionists, personified by Anselm Kiefer and Julian Schnabel, or contemporary sculptors, including Rosalie Gascoigne, that he shares an aesthetic, for the ground is not merely the place on which to enact painting but rather the territory on which the work is built.

The breakthrough painting *Rebirth* (plate 24), from 1987, escorts the viewer and skeletal creature from a simply stated Edenic blue-and-green ground into an overwhelmingly deep black section of the picture—Paul Arnett has described it as the announcement of "Lockett's lifelong search, as fervid as religion, for new beginnings amid the nonlife of urban black male existence that had been his starting point in the world"[22]—thereby establishing the traumatic field of engagement for all his subsequent work. From at least 1989's *Homeless People*, Lockett establishes the landscape that will hold everything else in place—in which everything will live and struggle. At times this was an eternally nascent pea soup world made of fluid, poured paint, moved around with the artist's fingers and hands—*Out of the Ashes* (plate 13) and *Poison River* (plate 14). For his existentially darkest subjects—the Holocaust, the bombing of Hiroshima, and the atrocities perpetrated by the Ku Klux Klan—Lockett chose unremitting blackness as his ground, so that paintings like *Smoke-Filled Sky (You Can Burn a Man's House but Not His Dreams)* (plate 28) and *Traps (Golden Bird)* (plate 22) are almost vertiginous in their simultaneous physicality and voidal spaces. Onto these grounds image is introduced (planted) literally, usually as a mixture of figurative cutouts in thin sheet tin or natural and man-made objects—wire fencing, twigs and branches, cloth sheets, and lumber.

Before around 1993, when Lockett began to employ found metal sheeting as his picture ground, his practice was something of a search for an idiom on which to locate the action of his pictures. There are somewhat realistic grounds, painted with the brush (*Adam and Eve*, *A Summer Day*, *God Watches Over Creation*), landscapes built out of paint and crumpled cloth sheets and rope (*A Place in Time*), experiments in vertical dripping (the appropriately titled *Finding the Way*), pouring and smearing (*Smoke-Filled Sky*, *Poison River*), and spattered and drip-painted grounds (the pair of untitled still lifes with bottle and jug). Significantly, Lockett was trying to say something plainly with his work—it is representational, with a lexicality that renders it subject to highly literal(istic) readings. Unlike artists such as Jackson Pollock, Arshile Gorky, or Wassily Kandinsky, he was not engaged in hiding or veiling as a means of making viewers work harder at intuiting painterly meaning. Neither was he interested in emphasizing formalist experience or readings, as some of the cubists and postcubist abstractionists were. Rather, his art was both an expressive and representational outpouring of his existential crises. As Lockett said himself, "[*Holocaust*] and *Traps*, *Rebirth*—they mean a lot to me. The things that I've felt strongly about in my artwork, like the slaughter of animals, or them being killed for fur or whatever. I kind of like try

to put a little more into my artwork, things that I felt strongly about."[23]

In the last four or so years of his life Lockett abandoned the materials (though not the métier) of painting almost completely for a kind of painterly collage and constructivist technique that utilized found sheet metals from around his neighborhood. Once parts of buildings (including an old shed built by Thornton Dial behind his house in Pipe Shop), these materials were already subtly colored through oxidation and the weathering of paint applied years before. Aptly, his new medium was of his place, both literally and metaphorically, as representative of the Rust Belt that this area of Alabama became in the 1980s, as the steel and construction industries on which it had been built faltered and failed. Sheets of tin, nailed onto sheets of weathered plywood or wooden frames, became the ground of pictures from their first use. In some pieces, like *Once Something Has Lived It Can Never Really Die* (1996), Lockett fixed the same traced, clipped-tin cutouts of deer and painted branches that are common to earlier *Traps* pictures. More often he used a new innovation: the familiar iconography of deer, bison, wolves, and human figures outlined in punched-out holes, with strips of tin overlaid and held with flathead nails to develop the forms. In works such as *The Inferior Man That Proved Hitler Wrong* (plate 50), *Fever Within* (plate 49), *Untitled (Wolf)* (plate 47), and *Coming Out of the Haze* (plate 43), Lockett achieved some of his most powerful and best-resolved statements that distill and merge both personal and universal historical experience indissolubly. In the physical collaging of reengineered materials in low relief, Lockett's technique is reminiscent of the art of postwar artists like Arman, work from the 1960s by Nancy Grossman, and many of the pieces in Rauschenberg's *Gluts* series, from the 1980s and 1990s, though the content is far from their artistic concerns. William Arnett argues that Lockett's work "is in essence about the struggle of young black people to survive. . . . It's not happy work. I don't know of anything that was happy. He wasn't happy. He was the kind of sad, morose,

quiet, shy guy. All of his work is about that struggle. But he had gone to high school, and he knew history, so he did a number of pieces that were about specific points in history that related to black culture, not necessarily one-on-one relationship."[24] Paul Arnett points further to Lockett's use of materials and obsession with an endangered natural world as evidence of the cultural rupture experienced by the artist and his generation in relation to old symbols and beliefs: "This turn in Lockett's work was a signal moment in the postmodernization of the vernacular: the older, life-affirming animal symbols of folktales were transformed by him into 'fresh' myths of decline, deracination, dilapidation, and impotence."[25]

In the end, the ground became the work, as in *Oklahoma* (plate 52), *The Enemy amongst Us* (plate 51), and *Sarah Lockett's Roses* (plate 57). Like the great abstract expressionists Mark Rothko, Clyfford Still, and Hans Hofmann, Lockett's pictorial arena became the image in itself. And in Lockett's works as in theirs, the ground-as-image retained its representational force. Here are things that begin in individual human emotion and engagement with the physical and quotidian but make of it something transcendent and universal. Lonnie Holley articulates the expressivist position with clarity and force: "The material tells the truth, so the man didn't have to lie to you. . . . He dead and gone, but he didn't have to lie to you because his material is going to tell you the truth."[26] Owing as much, in all probability, to Lockett's knowledge of quilting through his family—particularly through his great-aunt, Sarah Dial Lockett—as they do to a feel for the symbolic uses of materials—the fragmentary pieces of tin pieced together in the *Oklahoma* series speak to the lives and things laid to waste by the terrorist attack on the Alfred P. Murrah Federal Building in Oklahoma City in 1995. Fundamentally empathic in his feeling for subject matter, Lockett described how the powerful *Oklahoma* series, of which he was immensely proud, was born of an intuitive and emotional reaction to the events, as reported in the mass media: "I liked it to be some kind of way of expressing how those people might have felt

through that piece. . . . I don't think I could have asked for any more out of that piece. I hope that when people see it one day that they should feel the same way I do. That they can see something into it that I was expressing an honest emotion about it, not trying to offend anybody, but just trying to express what happened on April 19."[27] Yet these works also speak to Lockett's own despair, both personal and cultural. He discovered around 1994 that he was HIV positive. At that time little was known about the disease, and it was generally viewed as a death sentence. Moreover, in the 1990s, in Pipe Shop as in much of the rest of America, it carried a stigma that prompted Lockett to withhold confirmation of his infection for a long time.

Lockett's death in his early thirties left us with the abiding narrative of an artistic training gleaned from television, the public library, interactions with the artists working around him, the collapsing postindustrial landscape in which he lived and died, and the experience of vernacular artwork in William Arnett's collection in Atlanta. He was an artist who had, by 1998, produced a body of powerful and coherent work that speaks, we can now see, to other contemporary art of that time and to the specific conditions of his world. Lockett was not yet receiving the sort of wider art world attention that some others of his contemporaries from the various regional parts of America who had migrated to the metropolises had achieved. Instead, he was cut adrift, so to speak, in a context that problematized even posthumous mainstream attention and acceptance; he was perceived as one of a strong, peculiarly vernacular Alabama school of artists, yet he was both a part of and separate from this group.

It is perhaps poetic and apt that Lockett identified most closely with the bucks caught up in fences, threatened and segregated from the world (and, pictorially, the spectator outside the picture) in his *Traps* series. Speaking frankly about a later found-metal work with a deer at its center, *Coming Out of the Haze* (plate 43), he revealed, "It's a picture about me and some of the dark periods in my life where I was trying to come out of a deep depression. That's something I've been battling with for a while, and I have had things go against me in my personal life, but that's a particular picture that I made, *Coming Out of the Haze*."[28] This is a picture fueled by illness, self-doubt, anxiety, and—possibly—guilt. But it is not a picture about these things. It is, if we are to believe Lockett's chosen title, one about attaining clarity. The rest of Lockett's brief oeuvre confirms this. The work produced between 1994 and 1998 speaks powerfully and coherently. It is consistent and visually strong and transcendent.

The sheet tin paintings constitute Lockett's first (and only) mature style and make him unique among his generation in America. For these works alone he deserves to be embraced and studied by artists and others alike. As with so many who were taken from us at an early age, though, we can only speculate as to the greater things that would have likely come from his hands.

NOTES

1. Barbara Archer, interview with Bernard L. Herman, 1 May 2014.

2. Lonnie Holley, interview with Bernard L. Herman, Atlanta, Georgia, 25 October 2013. Much of the material from Lockett's relatives and acquaintances here is quoted from interviews conducted by my colleague Bernard L. Herman in 2013–14 as part of this book and exhibition project. Though I have been involved in many conversations over time with the same group of people and they have expressed similar opinions, I have never formally recorded these. As a result I have chosen to use Herman's verifiable interviews where possible.

3. William Arnett, interview with Bernard L. Herman, Atlanta, Georgia, 1 April 2013.

4. Ronald Lockett, interview with David Seehausen, 1997.

5. Richard Dial, interview with Bernard L. Herman, Atlanta, Georgia, 26 October 2013.

6. William Arnett, interview with Herman.

7. Archer, interview with Herman.

8. William Arnett, interview with Scott Browning, Souls Grown Deep Foundation, Atlanta, Georgia, 2013.

9. Hermann Hesse, *Narziss and Goldmund*, trans. Geoffrey Dunlop (New York: Penguin, 1977), 148, 156.

10. Ibid., 162.

11. Artists from outside what Herman terms the Birmingham-Bessemer School are mentioned throughout this text, often with very little by way of detailed unpacking of these comparisons. There are two major reasons for this. First, as one astute (anonymous) reader has pointed out, my method aims to challenge "art-savvy readers to recognize the similarity of aesthetic strategies and vocabularies apparent across cultures in the twentieth and twenty-first centuries to those Lockett discovered one way or another." And second, there is the question of space in this volume—to do justice fully to the suggestive comparisons I draw would take a book-length study in itself, something that I or another might subsequently embark on.

12. Although such an endeavor was impossible for the current project, it would be interesting to discover which art books and magazines were kept in the Bessemer Public Library during the time that Lockett was active.

13. This is in itself a technique that is not so far removed from the stitching and embroidery patterns much derided by art critics but that can have a certain legitimacy in the folk art world.

14. Lockett, interview with Seehausen.

15. I am brought to mind of one Christmas when I was very young, perhaps five or six years old. An uncle, seeing that I drew incessantly, made me a gift of a how-to-draw paperback that he'd bought for himself, wishing to unlock the secrets of art making. I was too young to read the text proficiently and, though I was fascinated by many of the exercises, never used it. I kept it for many years, though, as a kind of talisman.

16. Paul Arnett, "Ronald Lockett: Improvising in a New Key," in *Souls Grown Deep: African American Vernacular Art*, vol. 2, ed. William Arnett and Paul Arnett (Atlanta: Tinwood Books, 2001), 521. He extends further on this in his essay in the current volume.

17. Lockett, interview with Seehausen.

18. Ibid.

19. Theophus Smith, "Working the Spirits: The Will-to-Transformation in African American Vernacular Art," in *Souls Grown Deep: African American Vernacular Art*, vol. 2, ed. William Arnett and Paul Arnett (Atlanta: Tinwood Books, 2001), 46. Characteristically, Renée Stout's recent exhibition *Tales of the Conjure Woman* at the Spelman Museum of Fine Art, Atlanta, 30 January–17 May 2014, took up many of these themes of seeing both the tangible and intangible in objects of power (or at least objects that are rendered thus through practice) in the context of a university art museum.

20. Holley, interview with Herman.

21. Franz Kafka's "In der Strafkolonie" was first published in 1919.

22. Paul Arnett, "Ronald Lockett: Improvising in a New Key," 521.

23. Lockett, interview with Seehausen.

24. William Arnett, interview with Herman.

25. Paul Arnett, "Ronald Lockett: Improvising in a New Key," 522.

26. Holley, interview with Herman.

27. Lockett, interview with Seehausen.

28. Ibid.

Quotidian Remains

Sharon Patricia Holland

Too late, my time has come

Sends shivers down my spine

Body's aching all the time

Goodbye everybody, I've got to go

Gotta leave you all behind and face the truth.

—Queen, "Bohemian Rhapsody"

December 2000, Goodman Theatre, Chicago

Our seats were not all that great: we were crammed into the middle of the last row in the orchestra section of the newly renovated theater. Stuffed with a good meal and plenty of pinot, we settled into chairs smelling faintly of polybrominated diphenyl ether and sorted out our booty of sucking candy. The lights flashed, the announcements commenced, and we relaxed into a three-hour marathon of August Wilson's newest—*King Hedley II*. The ninth installment in his Pittsburgh cycle (ten plays in all), *King Hedley* tells the story of African America in the 1980s—neighborhoods in decline, drive-by shootings on the rise, and funerals all too common.[1] It is set in 1985 in Wilson's favorite fictional neighborhood, the Hill District of Pittsburgh, where "life is like an ornery lover, comforting you tonight and frustrating you tomorrow."[2] The main character, King, is a reprise of an earlier player in *Seven Guitars*, a play whose time stamp is 1948. King struggles to escape the repetition of his "father's" history but, in the end, succumbs to it by killing a man and producing a son, who will in turn do the same. Ironically, it becomes clear that King's father is in fact not his father, making patronage and biology central question marks in the Pulitzer Prize–winning playwright's repertoire.[3]

Because all of us had been born in the 1960s, we remembered what the 1980s were like for people like us—women queer and struggling to pay our way through graduate school. But what we remembered most was the onslaught of what would become HIV/AIDS. Our LGBT community sometimes divided against itself, our friends dying, sometimes forsaken by parents whose rage against their queerness only strengthened with the coming of the pestilence. It was a plague on all our houses. "What would the '80s be without HIV/AIDS?" we thought, and so we unveiled our sucking candies and watched in horror as *King Hedley II* marched across our sometimes-peripheral vision with no mention of the thing that con-

sumed us. At intermission we were perplexed, if not mildly enraged, but we sat through to the bitter end, unwrapping our candies during the second act of the play in audible unmannered protest for what seemed like a blatant disregard for the truth of our existence as a people. How could you write the story of black life in an urban city in the 1980s and forget to mention AIDS?[4] In many ways, we were about to find out. In the 1980s HIV/AIDS was considered a white gay man's disease. By 2011, 44 percent of the new cases in the United States would be among African Americans—a population that comprises only 12 percent of the country's populace.[5]

April 2006, Art Chicago, Merchandise Mart

Since coming to Chicago in 2000, my ex and I had become somewhat serious art collectors. We had established a relationship with at least two galleries (Geischiedle and GR N'Namdi) and counted a number of working artists as close friends and colleagues. In the spring of 2006, we were happy to see ourselves among those dealers, artists, and collectors descending on "Art Chicago"—a multilevel display of some of the world's most incredible art—for sale. As we made our way among the paintings, sculptures, drawings, and mixed-media pieces, we marveled at both the quality and the quantity and sometimes gasped at the prices ("Really?"). At the time I had what some would call a "good eye" for spotting skilled composition in a work, and we prided ourselves on collecting well—choosing from among those artists produced, like us, with the credible stamps of institutional belonging.

That year, the fair included installations from the category of "outsider" art. I had no idea then exactly what that was, but, intrigued, we traveled below ground (literally). The elevator opened up on an installation filled with trash and broken wire. My brother-in-law, a Princeton graduate and known for his sharp tongue, leaned over and pronounced, "You see that? I did that when I was eight!" We all laughed the comfortable laugh of the petit bourgeois, content in the fact that we purchased art

from a different quarter of the mart, that we knew what good art was and how to spot it.

This essay on Ronald Lockett begins in the interstice—somewhere between the heartbreak of a story that never got told and an ignorance so profound that to even recall it is shameful and humiliating. But to turn away from the truth of it all—one that we, in the words of the late Freddy Mercury, must face now—would be to tell a lie about my investment in this project and in an artist whose work has changed the way I see the world around me. As a theorist focusing on critical race, feminist, and queer studies, my interest concentrates itself in those areas of Lockett's art and life that bring some illumination to these prevailing themes in my own work. Although many of the categories I explore intersect one another, it is rather profound to realize that when speaking to HIV/AIDS, one is almost confined to the matter of LGBT life—a containment and dis-ease that Wilson's play speaks to on some level; the HIV/AIDs crisis rarely speaks to black heterosexuality. This is in no way to assume I know what sexual life Lockett claimed for himself, nor is it to make an assumption about how he contracted HIV/AIDS. That information, on both counts, is, as my grandmother would say, strictly none of my business. But I do want to speculate here on the possibility that somehow HIV/AIDS in the black community only belongs to discourse about black LGBT life. As I sit and make the last edits to this piece, the numbers of black heterosexual women with positive HIV status in my state (North Carolina) exceed those of all others of African American descent. In these pages I attempt to cross the chasm of what is left out and what is underacknowledged. I begin with nomenclature.

Consider the following definitions of "outsider" from the scholar/collector David Maclagan. He writes: "Whereas the careers of conventional artists show progressive shifts of style, and maybe a restless ambition to keep on 'making it new,' outsider art is often marked by

a constant returning to the same motifs and an intense elaboration of them. This is what gives it the feel of being driven by some invisible compulsion or of being coloured by motives that might be secret or perverse: something that is once fascinating and baffling for the spectator."[6] More pointedly, Maclagan continues: "Outsiders are a bit like a species that once inhabited the wild, was then declared an endangered species, and as a result was rescued and decanted into safari parks or zoos, but that may now have to face the alternative of dying in captivity or being hunted to extinction."[7] The words "perverse" and "species" jump out at me. Even though Maclagan refers to a European critical tradition in outsider art, the two words seem to represent either side of the chasm to which I speak here—the one representing the queerness of a disease that can be transmitted through sexual contact and the other indicating the exclusivity of taxonomies, marking both inside and outside. Perversity usually marks the outside of all things normative, and although its sexual connotation stands in the forefront of the average usage, its more commonplace meaning is to do a thing that is unreasonable and to care less about the consequences. On the other hand, the word "species" marks any bounded territory absolutely, as it defines the limit of reproduction itself. To tarry in the space of the outsider, therefore, is to indulge in what is wantonly unacceptable and to surrender the self to possible categorical extinction. This latter precarity calls attention to critical understandings of American outsider art as coming from populations so relegated to margins of a larger culture that their disenfranchisement is profound.[8]

Having expired of a disease that marks the body as perverse (because HIV/AIDS turns the body into a sexual object) and having created work that profoundly shifts the gaze from human to animal, Lockett's life and work suture the very categories I am attempting to put pressure on in the foregoing paragraphs. His work speaks to my project *Perishment*, on the distinction between the human and the animal, a boundary informed by Heidegger's philosophical hypothesis that animals *perish* while humans *die*.[9] Othering animal worlds is at the center of Heidegger's twentieth-century project, and interdisciplinary scholars in the new millennium have attempted to dismantle this always already clunky dichotomy. Knowing now what's at stake, for me at least, I turn to four pieces that speak to ideologies of speciation and perversion.

Species: A Wolf in Sheep's Clothing

Two wolf pieces catch my eye (plates 47 and 48). In both, a rusty brown is the predominant color. In each, the wolf-like animal figures almost blend into the background and are made of strips of the rusty metal, making the outlines of animal life look like parts of the "canvas" have imploded in long rectangular pieces—like some Pixar rendering—and magically assembled into recognizable form.[10] The artist's hand roughly stitches them back together in a collage. Barbara Archer, gallery owner and friend of Lockett's, explains, "When I was visiting with him, this was really between 1990, maybe late 1990 and '94, when those trips were happening, and these were the painted pieces and collage pieces. It was later that he started making the rusty metal pieces."[11] When I viewed them in the Souls Grown Deep Foundation warehouse, the wolf pieces spoke to one another but were not placed side by side. The distance from one to the other allows a possible narrative to take shape.

In the first, depicting a pair of wolves, the rusty background is broken by thick black stripes, helping to form a flaglike pattern. A patch of black, reminiscent of mud cloth, dotted with an indiscernible pattern stands in for where the stars of our United States should comfortably sit.[12] Liberty and justice for all, except perhaps for the animal figures superimposed upon the muddied and rusty flag, their outlines drawn in matte white—the rough cut of a crime scene's human remains. The animals—two wolves in the first or perhaps a wolf and a sheep in both—backed up to one another, their connection literally asinine. The scene's ambiguity is a perversion in itself; are

the images from similar species, or are they a perversion of both kind and prevailing understanding? Are there two wolves or two sheep, backed up to one another for the protection of kinship? It is hard to know. The chalky outline suggests perhaps that these are animal stand-ins for human remains, but I think that literalness is of the essence here—we send sheep to slaughter; we remove wolves from their natural habitats and reintro-duce them at our whim. If these animals be wolves, then the white outline marks the nature of their relationship with human endeavor. If they be sheep, then thoughts of lambs before slaughter come to mind. If these animals be mixed—displayed in all their promiscuity[13]—then ideas of wolves in sheep's clothing can be brought to bear.

Collectively all of the above avenues for interpretation point toward the insidious nature of American forms of nationalism; a jingoistic nationalism, which makes itself known through a robust masculinity, and one that all manner of peoples are drawn toward, with dire consequences. The wolf/sheep piece, like much of Lockett's art, is haunting and unnerving. There is nothing folksy about it—we are not lulled into the complacency of representation or feeling here. Human endeavor—from flags to animal ingestion—is looked upon with suspicion. Vulnerable subjects in the wake of the human are always already dead—falling prey to the potentiality of ideologies of national virility, represented by the wolf; led to slaughter by the flag's promise, but kept at bay by the realities of marginal life on this part of the globe, represented by the sheep; and finally rendered reproductively nonviable, a perversity produced by the very systems of sexual rigor and competence required to be visible to the national self.

The animals, far from representing anything comfortably, remind us of the trick of the political. As Jacques Derrida once noted, "Politics supposes livestock."[14] In other words, in order to have human endeavor, human being has to overcome animal nature, or at least be observed in the act of pretending to be interested in overcoming it. It is precisely at this moment of regulating the other (animal), turning a wild thing into livestock, that human being produces itself (or a self that can be recognized). Therefore, the philosophical conundrum proposed in Lockett's work is not whimsical in the least, but it does refer to an action so necessary to our understanding of the human self—and, more importantly, to enacting that self—that its movement is barely perceptible. In essence, the subjection of animal life to human life is so complete as to be unremarkable. In Lockett's work, the bones, the antlers, and, here, the chalky outline show up again and again to remind us of the remains of the day, of what the cost of being human truly is.

The broken dream of American individualism (lone wolf?), of the West's investment in contradiction and binaries, presents itself here.[15] Interestingly enough, Jane Kallir, a gallery owner, collector, and critic and the foremost scholar on the work of Grandma Moses, also observes that "Americans tended to lump all self-taught art together as expressions of the stereotypical rugged individualism that is so much a part of our national myth."[16] These two pieces are no homage to that "rugged individualism," but a negative celebration of its impact on the very homeland that the flag attempts to both reveal and conceal. "United we stand" has a way of concealing the always already of "divided we fall." Kallir continues her ruminations on labels such as "outsider" or "self-taught" with the following: "When the designation 'outsider' was applied to African-American artists—who because of their intrinsically marginal status were prime targets for the new trend—the label acquired covertly racist connotations. 'Outside of what?' members of the African-American community might rightly have asked. To be sure, these artists were operating outside mainstream white culture, but they were still very much within their own legitimate communities."[17] But if "outsider" or "self-taught" art is to remind us of or to retain its place as "material evidence of a particular cultural environment," then we might need to reassess Lockett's commentary on the state of the political in the United States.[18] The universality of his artistic take on life in these United

States moves through the particularity of "black" or "African American" experience to some other truth. The point of Lockett's expression at least in these two pieces seems to be to think *through* (notice how I do not say "beyond") categories and perversities that shatter black/white dichotomies so that we can recognize structures that subtend the struggle for belonging to human being that blackness and whiteness want to wage against one another.

What I am getting at here could best be described via analogy. In the world of literary criticism, we tend to see "great" artists like William Faulkner or Toni Morrison, for example, as having created their own cosmos—a cosmos that extends to the wider world around them and thus becomes our cosmos; think of Faulkner's Yoknapatawpha (Mississippi) and Morrison's Ohio. So particularity may be the wrong word, since that group of artists to which Lockett belongs use *particular* experience to get us to see something much more endemic, common, and quotidian. In essence, I am arguing that Lockett uses his experience of marginalization to dismantle a number of commonly held assumptions about national identity and belonging, understandings that his marginalization would seem to preclude his ability to broach.

In many ways these two wolf/sheep pieces could be thought of as a commentary on the outsider tradition that depends on marginalized status for its repertoire. The wolf and the sheep—I will stick to that assessment of the two figures here—exist within the rough outline of the coroner's mark, their outline determined by the dull white paint, their insides constructed from a vivisectionist's dream. The chalk outline was abandoned by medical examiners and the police long ago, but it still exists in the public imagination, and artists like Michael Carr and Keith Haring used its stark outline to mark unnecessary violent death.[19] The abandoned coroner's outline reminds us of culpability and evidentiary claims; the white outline conjures the presence of jurisprudence and possibilities of (in)justice. In both wolf/sheep pieces, strips of metal are aligned and nailed into place, the wolf/sheep/

sheep/wolf forged together in a crazy metallic EKG. In the second work focused on a lone wolf (plate 47), the flag background has disappeared and we are somewhere among the black stripes—gone are the stars-cum–mud cloth; we are somewhere between black and brown, but not black and blue. Here the wolflike figure stands on top of other forms, the possible results of a kill splayed underneath or just in front of the wolf. The lumpen forms at its feet are still constructed of rusted and burned black strips of metal. The figures in the second piece are even harder to parse—is it a wolf in the foreground looking at its prey? Or is it a wolf in the background standing in obvious protection of the progeny being foregrounded? Does the wolf glare at us, or does it look away? Does this interpretation then speak to those things/persons that need to be protected by/from the ravenous and, here, lonely wolf?

These pieces remind me of a chilling triptych by Edgar Heap of Birds that reads: "The brutality which is America raises mad dogs that were once beautiful children." I had a reproduction of that work in my office for some time years and a few states ago. But I took it down; it caused discomfort because it had no high ideals. It was a simple statement—brutally honest, like the Panther Party's 1968 *Message to White America*, also in my office, framed, a word-poem trapped in a block of blackness, breaking through from the exceptional to the everyday, struggling to get back to its quotidian life. Nevertheless, to the collector's eye, the second Lockett piece I am referring to is compositionally flawless, and as a whole the square mixed-media structures speak to one another. The first piece possibly captures, albeit briefly, the slaughter to come or the kindness that prevents it.

Potentiality is the key. Rather than depicting decisive action, the stark outlines demand our interpretive acumen. Lockett puts the ethical question on the table: with which species do you identify, and why? So what to make of these two pieces I have coupled here? My point is that Lockett's animals are not representations of people or stand-ins for something else. In these mixed-media as-

semblages, he doesn't seem to see in simile or analogy. The animal is not "like" or analogous to us; it is a being, in all of its ambiguity, unto itself. By posing the ethical questions, he has refused to demonstrate mastery—perhaps what being "outside" truly means—in exchange for something more elusive and therefore ambiguous. Refusing categories, Lockett entreats us to think about what manner of animal we might be were the world depicted in all the glorious truth of its naked ambition and overcoming.

In the wake of Lockett's ambitious refusal to limit himself to what is readily apparent, I want to travel back to Kallir's speculative comments about African Americans and the category of outsider art. She notes the "intrinsically marginal status" that African Americans have in U.S. culture, and I would like to put pressure on that assessment, with perhaps a little help. Toni Morrison once asked, "What intellectual feats had to be performed by the author or his critic to erase me from a society seething with my presence, and what effect has that performance had on the work?"[20] I was fortunate enough to be in the audience when Morrison delivered "Unspeakable Things Unspoken," her 7 October 1988 Tanner Lecture at the University of Michigan. The lecture was a game changer, as Morrison troubled the notion of black marginality in American letters and, along with scholars like Michael Rogin, encouraged us to see blackness even when it was under erasure. It became possible to think of ourselves as inside rather than outside, as capable of *informing* if not shaping the very culture in which we (female graduate students working our way into the profession one paper at a time) were considered marginal players. Despite these late twentieth-century critical interventions, critics and scholars have continued to come at blackness with a sense of its absolute marginality and therefore inability to work as a shaping force of the culture at large.

Given this problem of critical demeanor and penchant for categorization, is it possible to substitute the word "outsider" with "African American" and get to some im-

portant point about "culture," "art," or even hum/animal? In the "folk art" section in Chicago's famed Art Institute, a curator's long-ago-composed wall label describing a sculpture titled *Country Preacher* notes: "Folk sculpture, an alternative to the academic high-style tradition, was created by carvers." The carving is believed to be from 1860–90 and depicts a "solemn African American." In the folk art section is the stuff of the everyday—the country, a preacher, and a farmer and his wife. The penultimate piece in the Institute's small allotment to the folk is by a Surry County, Virginia, artist named Leslie G. Bolling. *Sister Tuesday* depicts an "African American woman at an ironing board." Black life is the stuff of the everyday—a quotidian space that Zora Neale Hurston drew from when she embarked on her literary career—one dedicated to depicting "the folk" in scholarship and in fiction. In essence, we cannot escape the connection between blackness and "the folk"—a connection sutured both by the apparatus of art history and by a community of Harlem Renaissance writers eager to make their mark on an emerging American modernism. Regardless of the source, this reference to the folk is always contentious and somewhat pejorative. The everyday is marked by the vicissitudes of pleasure and pain, discipline and punishment. The curator's comment on Leslie's sculpture continues by noting that the work "straddles the divide between fine and folk art." Too high to get over, too low to get under: blackness occupies the interstitial; it produces the boundary between one thing and another, making mastery an impossibility, as the condition of blackness is to stand as a constant symbol of *possibility*—a dream deferred, a goal never realized, raw potentiality itself.

But the question is: what is to be mastered here? The set of a line, the curve of a stroke? Sure we can recognize (American) beauty—created by human hands, right? I am reminded of the three-minute scene from Sam Mendes's film *American Beauty* (1999) of a plastic bag dancing in the wind near a storage facility. That video is mesmerizing, and the Thomas Newman score makes

it all the more poignant—a small dose of time snatched from the everyday in the service of art's endeavor to prove human (in)capability, to note human mastery's lack. How the whiteness of that plastic bag floats against the backdrop of the brick and mortar—the fragility of the ordinary plastic grocery bag made more apparent by the solidity of the wall. But given rates of decomposition and the durability of plastic, the fragile bag will last longer than the wall. Somewhere between folk and fine, we float too.

What is brilliant about Lockett's two pieces is not what they depict or attempt to depict. Rather, I am interested in—okay, fascinated by, if not obsessed with—what the pieces invoke, and not so resolutely. Is it a wolf or a sheep, is it slaughter or protection of the young, is the metal representative of industrial strength/resilience or its decline—its poked-through-with-holes-ness? It is the simultaneity of hopefulness and, yes, death that each embraces which arrests me. For a young and dying African American man, what do country and flag represent? What I am asking here is whether or not Mr. Lockett's blackness circumscribes the work at all, or is it another way to engage in our own taxonomic practice? These questions are all underdetermined in Lockett's art, and we should take critical direction from them.

When something is fine, it has been distilled for use, there is no question of its belonging. But that belonging comes with a cost, as clarity breeds a potency beyond ordinary consumption. Distillation always leads again to dilution—the cycle is vicious. That is the overdetermined nature of any museum visit. What I have come to appreciate about the vernacular is its volatility, its inability to be distilled. The moment we encounter such works, their beauty assaults us. It comes from outside what there is to know and defies nomenclature and taxonomy. The message of the indeterminate is brutal, affective, and interestingly opaque.

Leaving Pipe Shop

For years, throughout my life, death or its imminence had interrupted study, so I surrendered to the pattern once again. I researched one book by day, but by night, I scoured the columns of my memory and pressed all my fragile band of remaining kin to do the same, so that I, long the family's reader and its scribe, could piece together the history of our family, there in Pipe Shop, one story at a time.
—*Deborah E. McDowell,* Leaving Pipe Shop: Memories of Kin

Critic and scholar Deborah E. McDowell's memoir *Leaving Pipe Shop* chronicles her childhood against the dawn of civil rights in the very same place that artists like Dial, Lockett, and Holley were producing what Bernard Herman has called "the Birmingham-Bessemer School" of art. Her memoir speaks of migration in and around and mostly away from Pipe Shop, one that unsettles our sense of place, as Pipe Shop becomes a thing to leave rather than a place for grounding. She asks: "Why would I want to return to Alabama?" before recalling that her own grandmother left the same town at twenty-five in 1932. A family "reader and its scribe," McDowell's ambivalence about the place called Pipe Shop sits in juxtaposition to the kind of recuperative and searing commitment to place—and staying in it—that the group of Bessemer artists that includes Ronald Lockett reminds one of. But McDowell's painful memoir is brilliantly written and artful, marking her place among Bessemer's artists, expatriate and ghostly alike. In a section recounting the whereabouts of her siblings, McDowell notes that her rather nomadic brother Reggie (Wiley Reginald McDowell, b. 1953) lives in Detroit and "is a determined (read 'starving') artist, who makes sculptures of steel trees and carves spoons of pregnant women with featureless faces and arms cut off at the elbows."[21]

So Bessemer churns out another artist, but this time an expat; nevertheless, McDowell's cheeky characterization of her younger brother's penchant for visual over written cultural production misrepresents the artist. You

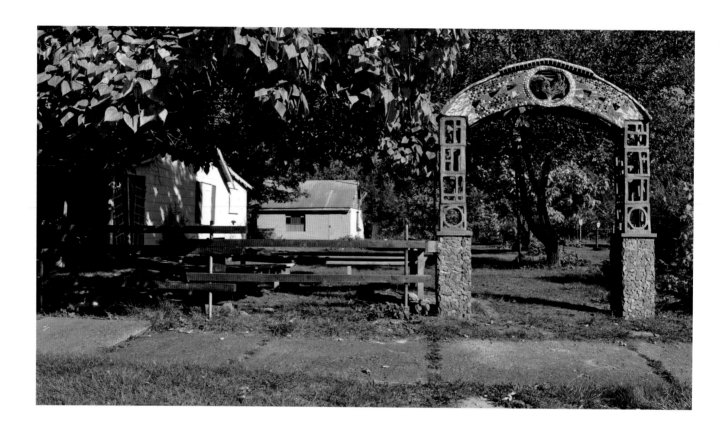

can't fight the blessings of place, as Wiley McDowell's powerful collaborative works *Talking Fence* and *Illuminated Garage* (figs. 7 and 8), both from 2012, speak to contemporary state politics and appear in the yards of abandoned buildings—which numbered in the tens of thousands in Detroit at the time Wiley produced his work.[22] Obviously, the Birmingham-Bessemer men cannot forget steel and color, light and their common place; and neither can compatriots like William Hawkins, Kentucky born but still attracted to fire and ice, as he was also a son of America's steelworks (Buckeye Steel Casting Company in Columbus, Ohio).[23] Like Thornton Dial (b. 1928) before him, "Reggie" McDowell figures women into his collaborative artwork.[24] Here he uses art to tell the story of communities that might otherwise be forgotten. In truth, one can never leave Pipe Shop; instead, the artist carves a home for himself that carries the trace of

the creative timbre of a place and time. So we now have before us the stories of three who left Pipe Shop: one black feminist, her nomadically inclined sibling, and, too soon, Ronald Lockett.

Ronald Lockett is just a year younger than I am. At his death in 1998, we were more than a decade into the HIV/AIDS panic, which quickly turned into a pandemic, which has now become a disease that disproportionately affects Afro-America, as fully half of new U.S. cases are found among us. Our generation of scholars and activists has been accused of forgetting, of turning our work away from the crisis onto more abstract and perhaps less visceral theories of the self. When I heard that Lockett died of HIV in 1998 and that he perhaps produced some of the most important artwork in the late twentieth century, I was not surprised. So many of us . . . dead and gone, no pen or brush to paper or canvas, fire to metal or

Figure 8
Wiley McDowell
Illuminated Garage (Installation corner of Keeler and Lamphere
[15376 Lamphere], Detroit, Michigan)
2012
60 × 100 feet for the site
Painted plywood, gel cell battery lead acid, copper wires, acrylic,
powder-coated steel, copper rod and bare wire, PVC conduit, plywood,
140-watt solar panel, solar panel charge controller, 15-amp breaker,
breaker box, aluminum, and acrylic paint
Photograph by Wiley McDowell and DETROIT(C+PAD)

wood. Silence. One acquaintance remembers Lockett "as someone who was extremely quiet, almost to the point of being shut down. Emotionally, intellectually, I guess perhaps physically—in every way, he was very close to being non-verbal."[25] Lockett's cousin Richard Dial offered his own, softer recollection: "Ronnie was kind of quiet, kind of kept to himself, and didn't run with a big crowd or nothing. Kind of hung around a lot of older people, more so than schoolmates."[26] Silence is perhaps the prevailing theme of early AIDS activism and LGBT letters—for poet Audre Lorde, it would not protect her; for early activists like Larry Kramer, it equaled death.

What I want to do here is remember my LGBT dead through the death of Ronald Lockett. I want to bring together a grieving for one community and then another without fear that such companionate sadness will create sexual panic. It is time to think through community silences to . . . something else. Barbara Archer speculates,

> I don't know about Ronald Lockett but I often wondered if he was heterosexual, or homosexual, not that it matters except to wonder more about what he was thinking, what was going on in his head. I know he said that he had HIV because he was in a relationship with a woman and I guess she accused him of giving it to her and vice versa, and maybe that is so. But if I hadn't heard that I would have assumed that he was homosexual and so, I don't know. He may have had—let's just say I will always wonder if perhaps he was more drawn to things feminine and his sexuality was perhaps part of that.[27]

In the end, as Archer concludes, we cannot know, and it is that kind of silence that creates the complicated pattern of dying with AIDS.

But for those of us who rely so much on the spoken work, I find that Lockett's art more than speaks justice, it screams it—the voice is reedy and high and thin. As Bill Arnett so aptly surmises: "All of his work is in essence about the struggle of young black people to survive.

. . . He did a number of pieces that were about specific points in history. . . . There are a lot of things that are an obstacle to survival, not just racism. That's not really what they're about. I mean, some are, but most of them are about something else."[28] The work that brings me to that voice, that timbre to recall by, is perhaps his simplest and most unassuming. These early pieces use a drip technique (plates 10 and 11), one that at least two crit-

ics note was abandoned by Lockett once he discovered that the famous Jackson Pollock had used it too.[29] The two still-life compositions stand out as some of the few without human or animal depictions. Prominent in the first is a jug, the ubiquitous symbol of southern hospitality and extralegal culture; prominent in the second is a paint-encrusted standard forty-ounce (beer?) bottle. Both feature a technique he would later abandon, and each is speckled with red and blue drippings (among others) that evoke patriotic celebration. Each vessel sits on a shelf, and in the first the shelf is higher and more precarious—the jug held in place by the familiar tree branches used in the representation of legs (limbs) in his *Traps* series, reminding us literally of what's at stake. In the second, the ledge is in better shape, providing the newer jug with more support, and the branches extend out of the vessel and are slightly coiled, rather than angled like so many of his deer antler–bearing works. In these two works, the days of wine and roses are behind us. The juxtaposition between the old black economy of the South (its hooch) and the new legal market in the forty-ounce points toward a black community (as do the spatters of black paint in each) sapped of its livelihood by businesses carrying liquor, sugar, and processed foods rather than sustainable products for healthy consumption.[30] In these works, you can almost hear the cork pop, almost feel the foggy spray of carbon dioxide—the three-dimensionality of the pieces is nearly overwhelmed by the sounding they require to make their collective point about the time traversed between Jim Crow (the jug, the porch, the South and its old self) and desegregation (the forty-ounce, urbanity, the new welfare state as we know it).

Here I want to ask, what do you create when you know you will be dead before you reach thirty-five? In my mind these two pieces come out of a postracial America—a black community severed from itself, celebrating accomplishment at having left the old behind, but coasting into the new in an even more precarious way. The background in the second image is cream—whiteness within it barely detectable, the bottle more centered, the objects extending from it softer and more supple.[31] But the urgency of the celebration holds the precariousness of blackness, still a speck on the canvas, held in place by a more market-savvy and therefore quotidian form of racism. This one reminds the food critic in me of "food deserts" and the perniciousness of Monsanto and of our government's compliance in our collective genetic reengineering.[32]

As I step away from the pieces and think about my earlier question—what do you create when you know you're going to die?—my mind drifts back (perhaps because the answer is too devastating) to 1988 or '89 and that first HIV test, which took more than three months, and the waiting that accompanied it. Time stood still; celebrations halted. A new order was being put in place, and most of us were too busy burying the dead or responding to their family's ire or obfuscation to take notice. Yes, this is the first sustained writing I have done about HIV/AIDS in over twenty years, and now the dead won't leave me alone. . . . I return to the bones left by Lockett's work, and for the first time I understand that the pieces are for a celebration that must be forestalled. Always. Our collective dream of inclusion has trickled down indeed, but not as Ronald Reagan forecast. Instead it has migrated to a class-based assimilation so complete that most African Americans are no better off now than they were in the years immediately after the passage of the Civil Rights Act of 1964; statistics from 2011 demonstrated that whites in this country still make twenty times more than African Americans.[33] Wow. In this day and age, being black is no cause for celebration, and many of those who can remind us of this fact or help us survive it, through print or paint, fire or sound, have died a sudden and awful death.

Why wouldn't a young man reaching the end of his rope turn to animal figures to think through the catastrophe that is racialized human being?

NOTES

1. In her moving preface to *Justice Older Than the Law*, Katie McCabe evokes the memory of civil rights attorney Dovey Johnson's eulogy for a child, Damion Dwayne Blocker, killed at fourteen by bullets intended for another person. As McCabe notes, "Damion Blocker was, after all, part of her [Roundtree's] congregation, the one she'd helped build and nurture before that thing she called 'the demon of violence' had turned the streets of her beloved Anacostia into killing fields." Rising to the podium, Roundtree begins, "The caskets . . . grow shorter and shorter." Katie McCabe, preface to *Justice Older Than the Law: The Life of Dovey Johnson* (Jackson: University Press of Mississippi, 2009), xiii–xv.

2. Charles Isherwood, "Theater Review: King Henry II: At War with Ghosts and History," *New York Times*, 12 March 2007, http://www.nytimes.com/2007/03/12/theater/reviews/12hedl.html?_r=0.

3. For an assessment of themes that permeate much of Wilson's work, see Donald A. Pease, "August Wilson's Lazarus Complex," *Criticism* 51, no. 1 (Winter 2009): 1–28.

4. Even as I ask this question, I am reminded of theater critic Harry J. Elam Jr.'s take on black performance. He writes, "A play is by no means an essentialization of blackness, but rather an articulation of how black experiences function as forms of epistemic knowledge that structure performances." Harry J. Elam, "A Black Thing," *Theatre Journal* 57, no. 4 (December 2005). What I am driving at here is this: while I am aware that *King Hedley II* doesn't have to represent the whole of black experience, I want to open the possibility that representing some and not other experiences produces knowledge. This knowledge stands in for aspects of black history and thus shapes what kinds of questions we can ask about blackness and black community. Interestingly enough, the last play in the Wilson cycle, *Radio Golf*, does not center on the HIV/AIDS crisis.

5. In her landmark 1999 study, Cathy Cohen observes, "To discuss AIDS in black communities is to discuss a multiplicity of identities, definitions of membership, locations of power, and strategies for the political, social, and economic survival of the community, because all these factors interact with a disease that divides and threatens ever-growing segments of these populations." Cathy Cohen, *The Boundaries of Blackness: AIDS and the Breakdown of Black Politics* (Chicago: University of Chicago Press, 1999), 8. Even though rates among members of the community have risen in the decade plus since Cohen published her book, evidence of shifting attitudes toward LGBT peoples in the nation as whole, and particularly in the black community, can be seen in films like Yvonne Welbon's *The New Black* (2013).

6. David Maclagan, introduction to *Outsider Art: From the Margins to the Marketplace* (London: Reaktion Books, 2009), 13. In his interview with Barbara Archer, Bernard L. Herman also surmises, "Rather than the sort of quintessential folk artist who just keeps doing the same thing he seems to have real historical periods, and I wonder if you had any thoughts on that—all in the space of ten years." Barbara Archer, interview with Bernard L. Herman, 1 May 2014.

7. Maclagan, *Outsider Art*, 21–22.

8. I thank the second anonymous reader for his or her insights here.

9. See Martin Heidegger's landmark work on phenomenology, *Being and Time* (1927). My project *Perishment* attempts to look at scholarship in animal studies, food studies, and animal rights activism and its intersection with some of the tenets of critical race theory. More to the point, when scholars in animal studies think through "race" and its intersection with the animal, the discussion often devolves into what I would call the space of the disaffective, where human life is often at odds with the animal, often brutally so. My project attempts to think through "race" in the context of animal studies work, where blackness in particular doesn't always sit in abject relation to the animal. I am interested not in the Michael Vicks of the world, or in comparisons between black subjects under enslavement and animal being, but in black jockeys and horse whisperers. In short, I am in search of an approach to blackness in animal studies and philosophical discussions of the distinction between the human and animal that privilege the affective relationship that blackness has formed with the animal. For an excellent discussion of the intersection of approaches to animal advocacy and to work on affect, see Kathy Rudy, *Loving Animals: Toward a New Animal Advocacy* (Minneapolis: University of Minnesota Press, 2011).

10. Barbara Archer maintains that these metal pieces capture the quilting culture that surrounded Lockett. She notes: "I know that there were some buildings, metal barns or something, being torn down and he was captivated by the metal but to me that was a bigger leap than any—that he saw these rusty parts and he actually saw them as quilts. And of course quilting was a tradition that he totally understood, because his grandma, or whomever the woman was that he lived with, she was a quilter. He saw quilters around him, and to me that was his real brilliance, that he assembled those rusty pieces into quilts." Herman notes that the metal structures were composed from the remains of Lockett's father's home and Dial's old barn. Archer, interview with Herman.

11. Ibid.

12. Interestingly enough, "mud cloth" comes from Malian

culture and the word *bògòlanfini*. Much like the red clay found in parts of the South, this Malian clay has a high iron content and, when painted on fabric, turns it black. See in particular the charged exchange between Sarah Brett-Smith and Tavy D. Aherne in *African Art*: Sarah Brett-Smith, "On the Origin of New Tapis Mud-Cloth," *African Art* 27, no. 4 (Autumn 1994): 16–17, and Tavy D. Aherne, "More on Tapis Mud Cloths," *African Art* 28, no. 2 (Spring 1995): 83–84. The exchange is interesting because it points to the kinds of influence that collectors and researchers can have on a traditional cultural practice. Perhaps all players, whether we like it or not, are part of the community of artists, making "outsider" art unique because claims to individualism and isolation cannot be adhered to so easily. The exchange between Herman and Archer about Herman's proposed name "the Birmingham-Bessemer School" for the collective work of Lonnie Holley, Ronald Lockett, and Thornton Dial speaks to the problem of naming that is at the heart of my inquiry. Archer, interview with Herman.

13. I use "promiscuity" here in its nineteenth-century sense—to designate a promiscuous audience was to designate one mixed by gender.

14. Jacques Derrida, *The Animal That Therefore I Am*, trans. David Wills (New York: Fordham University Press, 2008), 96.

15. In their landmark study, Temple Grandin and Catherine Johnson observe, "One other thing people probably got wrong: the 'lone wolf.' Lone wolves are usually just young wolves who've left their parents and are looking for a mate." Temple Grandin and Catherine Johnson, *Animals Make Us Human: Creating the Best Life for Animals* (Boston: Mariner Books, 2009), 28.

16. Jane Kallir, "Introduction: The Collector in Context," in *Self-Taught and Outsider Art*, ed. Anthony Petullo (Urbana: University of Illinois Press, 2001), 9. On page 17 Kallir says, "Self-taught art was equated with the individual empowerment that lies at the heart of the American Dream."

17. Ibid., 10.

18. Ibid., 13.

19. See John Marchese's assessment of Michael Carr's work and the coroner's mark: John Marchese, "Chalk Body Outlines: Grisly, Yes, but Chic," *New York Times*, 13 November 1994, http://www.nytimes.com/1994/11/13/style/chalk-body-outlines-grisly-yes-but-chic.html. For a novel discussion of the genesis of Keith Haring's work in "outsider" graffiti art, see the forthcoming book by Dagmawi Woubshet, *The Calendar of Loss: Race, Sexuality, and Mourning in the Era of AIDS* (Baltimore: Johns Hopkins University Press, 2015).

20. Toni Morrison, "Unspeakable Things Unspoken" (Tanner Lecture, University of Michigan, Ann Arbor, Michigan, 7 October 1988).

21. Deborah E. McDowell, *Leaving Pipe Shop: Memories of Kin* (New York: Scribner, 1996), 22, 39, 29. The epigraph is from p. 48.

22. The works were created in collaboration with Design 99 and members of the Brightmoor community in Detroit. The installation was created as part of the community + public arts: DETROIT initiative while Wiley was a teacher at Community High School in Detroit.

23. See Anthony Petullo, *Self-Taught and Outsider Art: The Anthony Petullo Collection* (Urbana: University of Illinois Press, 2001).

24. The best characterization to date of Dial's efforts on paper would be Bernard L. Herman, ed., *Thornton Dial: Thoughts on Paper* (Chapel Hill: University of North Carolina Press, 2011). See in particular Herman's analysis of Dial's use of women as figures in the introductory piece, "Thornton Dial, Thoughts on Paper."

25. Archer, interview with Herman.

26. Richard Dial, interview with Bernard L. Herman, Atlanta, Georgia, 26 October 2013.

27. Archer, interview with Herman.

28. William Arnett, interview with Bernard L. Herman, 1 April 2013.

29. See Kristin G. Congdon and Kara Kelley Hallmark, *American Folk Art: A Regional Reference*, vol. 1 (Santa Barbara: ABC-CLIO, 2012), 229–31.

30. Food studies work often refers to these communities as "food deserts," places where "food insecurity" can be represented by the lack of fresh produce. I have often wondered about the naming here—about how in an age of antiterrorist wars and global police forces, policy makers would choose such militaristic terms to address the growing problem of the ethical distribution of resources among communities.

31. See Richard Dyer, "The Matter of Whiteness," and "Coloured White, Not Coloured," in *White: Essays on Race and Culture* (London: Routledge, 1997).

32. In October 2013, a provision for what was commonly known as the Monsanto Protection Act was struck down to prevent a government shutdown. The Monsanto Act protects genetically modified (GMO) products and was considered a sweeping piece of legislation protecting Big Agriculture over the smaller U.S. family farms.

33. Pam Fessler, "Making It in the U.S.: More Than Just Hard Work," *National Public Radio*, 15 September 2011, http://www.npr.org/2011/09/15/140428359/making-it-in-the-u-s-more-than-just-hard-work.

Curating Lockett

AN EXHIBITION HISTORY IN TWO ACTS

Katherine L. Jentleson & Thomas J. Lax

Between 2000 and 2004, nearly a dozen Lockett works toured the country as part of *Testimony: Vernacular Art of the African-American South*, a show of seventy pieces from the Ronald and June Shelp collection. In a review that appeared in *Art in America*, critics David Ebony and Kate Wodell noted, "Until recently it has been difficult to see work by some artists in this show," and they used Lockett as an example, calling his *Smoke-Filled Sky* "one of the most striking pieces on view."[1] Although isolated works by Lockett have appeared in about fourteen group shows since 1989, prior to his retrospective in 2016, opportunities to see large cross-sections of his work had been virtually nonexistent. As for his presence in the permanent collections of American museums, which increasingly include work by self-taught artists, important southern institutions like Atlanta's High Museum of Art and the Birmingham Museum of Art were the first to acquire work by Lockett, and today his art can also be found at the Ackland Art Museum, the American Folk Art Museum (AFAM), and, most recently, the Metropolitan Museum of Art.[2] But the majority of Lockett's work remains at the Soul Grown Deep Foundation, established by Atlanta-based William Arnett, who met Lockett through his cousin Thornton Dial Sr. in the late 1980s.

Lockett's institutional presence is impressive by some standards, but it is easily eclipsed by that of many other self-taught artists. Dial, for instance, has headlined three museum shows over the past five years alone, and his work can be found in more than a dozen permanent collections. Although Dial's rise might be exceptional in its magnitude, there are other southern self-taught African Americans, such as Lonnie Holley or Royal Robertson, who were creating art at the same time as Lockett and have also achieved broader visibility than him to date.

45

What if the reconsideration of Lockett occasioned by this exhibition and catalogue was used not simply to rehearse Lockett's comparative institutional scarcity— which is related to the timing of his "discovery" as well as the marked underrepresentation of African American and self-taught artists in museum collections and exhibitions[3]—but instead to trace the contours of Lockett's prior exhibition history and imagine the kinds of affinities and differences that might have been made available had Lockett been shown in relation to his peers?

In this essay, we examine Lockett's position within the category of black vernacular art that has emerged and evolved over the last two decades of the twentieth century and then make an argument for the resonance of his work in the pluralistic field of the contemporary. After we demonstrate how Lockett's visibility has thus far depended on successive exhibitions and discursive frameworks devoted to black vernacular art, we resituate Lockett's work in relation to contemporary art of its time that dealt with the AIDS crisis that claimed Lockett's life, proposing a series of curatorial fabulations in which we juxtapose Lockett's work with exhibitions that occurred and artistic communities that worked in New York during his most active period.[4] Our intention is to think collaboratively between two interpretive vantage points—Katherine Jentleson's academic study of the reception history of self-taught artists and Thomas J. Lax's methodology as a curator of contemporary art. Through the combination of our approaches and shared conclusions about the possibility for curating Lockett in contemporary contexts without having his identification as a black vernacular artist struck from the record, we balance institutional history—something that is often denied self-taught artists as a strategy that preserves an ahistorical dimension of outsiderness—with a forward-looking curatorial perspective that disrupts the potentially self-fulfilling cycle of institutional exclusion, stereotyping, and marginalization.

Part I. From a Vernacular View

The American art world's interest in the work of self-taught artists goes back nearly a century, to the populist, cultural patrimony–seeking period that unfolded in this country between the wars.[5] But when collectors like Abby Aldrich Rockefeller and Albert C. Barnes began buying the paintings of untrained Americans in the 1930s, they were mostly interested in artists from the Northeast, a region that was widely promoted as the nation's richest cultural reservoir. Although widespread enthusiasm for self-taught artists—and specifically those of African descent—did not emerge until the last two decades of the twentieth century, there were many preludes to this shift in institutional interest. In 1937 sculptor William Edmondson became the first black artist to have a show at the Museum of Modern Art (MoMA), and in 1964 his legacy—never forgotten in his hometown of Nashville— was revived again in New York when the Stony Point Folk Art Gallery devoted an exhibition to him.[6] Minnie Evans also counted major breakthroughs in the postwar era: in the early 1960s her visionary drawings of an antediluvian world were exhibited at the Little Gallery in Wilmington, North Carolina, and several years later photographer Nina Howell Starr organized a show of her work at two Manhattan churches—an important antecedent to her solo exhibition at the Whitney Museum of American Art in 1975.[7]

These and many other events index the strong undertow of interest that began to swell around the work of untrained African American artists in the postwar period. But the Corcoran Gallery of Art's 1982 show *Black Folk Art in America: 1930–1980* is generally regarded as the watershed moment that brought the flood.[8] This highly visible exhibition, which traveled to six American cities, included almost four hundred works of art created by twenty self-taught artists, nineteen of whom were from the South.[9] Through what art historian Colin Rhodes has called a "vertical invasion" of the canon, the *Black Folk Art* exhibition generated unprecedented demand for the

work of African American self-taught artists that exceeded the exhibition's actual roster.[10] Leroy Almon Sr., a bas-relief carver who was not in the show but apprenticed with one of its stars, Elijah Pierce, recalls the new audience he encountered when he returned from Ohio to his hometown of Tallapoosa, Georgia, in 1982: "There's a family of people looking for black folk art—they'll find you, wherever you are," he said.[11] For Philadelphia collector Jill Bonovitz, enthusiasm for black folk art was indeed a family affair; the show influenced her mother, Janet Fleischer of Philadelphia's Fleisher/Ollman Gallery, as well as the personal collection she was building with her husband, Sheldon, which the couple has since partially pledged to the Philadelphia Museum of Art.[12] *Black Folk Art* may have inspired a new generation of collectors, but it also drew from seventy-eight lenders—an indication that "a small, quiet army had been at work" gathering this material under the radar for decades.[13]

Lockett was too late for the *Black Folk Art* show, as his art did not begin circulating beyond Bessemer and Birmingham until the late 1980s. His work was not shown in an art museum until 1993, which coincided with the beginning of a second wave of black vernacular art shows that took place in Winston-Salem, Atlanta, and New York throughout the 1990s and were markedly different from their Corcoran predecessor. Moreover, the lag between the art world's knowledge of Lockett's work and its appearance in a museum setting is indicative of the dual consequences of *Black Folk Art*, which was received as both groundbreaking and problematic. The exhibition's most pointed and enduring criticism came from the folklorist Eugene Metcalf Jr., who argued that the curators, Jane Livingston and John Beardsley, wrongly categorized their object as folk art. As the charged title of his essay, "Black Art, Folk Art, and Social Control," suggests, Metcalf saw the consequences of this miscategorization as highly hegemonic, insofar as classifying the objects in the show as folk art "relegates black art to categories in which it is undervalued and misunderstood" and "perpetuates the social stereotypes that afflict black artists in particu-

lar and black people in general."[14] Metcalf's critique also dovetailed with a broader objection to the art world's insistence on viewing objects as formal entities stripped of their cultural context. Just months after his article was published, scholars and critics unleashed a much more explosive firestorm on MoMA's 1984 show *Primitivism in 20th Century Art*, which considered the influence of African, Native American, Oceanic, and South American art on European and Euro-American art. Just as Beardsley and Livingston were criticized for failing to find the right terms and interpretive frameworks for their material, *Primitivism* curator William Rubin was lambasted for missing the opportunity to interrogate perishing binaries like "Western/non-Western" and revise MoMA's linear, Euro-centric narrative of modernism.[15]

Black Folk Art, *Primitivism*, and their respective critical fallout signaled the paradigm shifts that materialized in the 1980s and early 1990s, a period in which Marxist, postcolonial, and critical race theory nurtured a new consciousness of the elite, white, and Western bias that had been dominant in disciplines like art history. Amid these revisions from the left—and aggressive attempts to police culture from the right—curators who ventured into realms fraught with race, class, and sexuality were taking major risks. Therefore, as much as *Black Folk Art* gave shape to an emerging field, it did so by creating a climate of cautiousness that bounded and frustrated the reception of up-and-coming black vernacular artists like Lockett. Of course, African American self-taught artists did not disappear from the institutional landscape in the years following *Black Folk Art*. Artists whose profiles were raised by the Corcoran show, such as Sister Gertrude Morgan and Sam Doyle, enjoyed solo exhibitions in subsequent decades at mainstream institutions, including the New Orleans Museum of Art and the High Museum of Art. Also during this period, the National Museum of American Art in Washington, D.C.,[16] and the Milwaukee Art Museum acquisitioned folk and self-taught art from field-defining collectors like Herbert W. Hemphill Jr. and Michael and Julie Hall that included

some pieces by black vernacular artists.[17] However, museums avoided exhibitions that addressed black vernacular art in a categorical way for nearly a decade.

Lockett thus came of age as an artist at a moment when institutional willingness to grapple with how to address black vernacular art as a field was in retreat. His first appearance in an art museum finally occurred in 1993, when curators Tom Patterson and Brooke Davis Anderson opened *Àshe: Improvisation and Recycling in African-American Visionary Art* at Winston-Salem State University's Diggs Art Gallery, an event that indexed a second wave of institutional interest.[18] In his insightful catalogue essay, Patterson contextualized *Àshe* as descending from but breaking away from previous art world interventions with self-taught artists: "Now that we're well into the '90s and some of its novelty has worn off," he wrote, "the art world is in the process of reassessing and refining its view of this nonmainstream art, struggling with some of the difficult questions that surround it, and recognizing distinctions and common traits among the artists and their works that had earlier gone ignored."[19] The exhibition, which took its name from the Yoruba word that roughly translates to "the power to make things happen," included Lockett's *Traps (Golden Bird)* (plate 22) and *Tree of Life* (from 1990 and 1992, respectively) among the nearly one hundred works on view.[20] However, Lockett's work did not get a major billing in *Àshe*; artists like Lonnie Holley and Bessie Harvey, whose work was attracting attention from numerous curators at the time, had many more pieces in the show. The exhibition catalogue featured Holley on the cover; inside Lockett's work was barely mentioned, and *Traps (Golden Bird)* received only a black-and-white reproduction.

Holley remained a dominating figure in terms of the sheer quantity of work in an even larger exhibition of African American vernacular art, *Souls Grown Deep*, in Atlanta three years later. For this exhibition, a sprawling show of more than five hundred works from Arnett's collection, Holley transformed the entrance to City Hall East, one of the exhibition's two venues, into what cultural critic Thomas McEvilley described as a "grottolike entrance to an under-world of neglected cultural treasure."[21] Beyond Holley's mixed-media installation, which resembled the yard show of his soon-to-be-demolished Birmingham property, several of Lockett's works were on view, including six works from the *Oklahoma* series. This exhibition revealed the stylistic breadth of Lockett's practice, as it included both figurative works like *Instinct for Survival* (plate 30) and his more recent collaged metal abstractions.

This was the first time that paintings from Lockett's series based on the Oklahoma City bombing (plates 51–55) were shown. Although the eerie resonance between Lockett's monuments to the 1995 tragedy and the bombing that would take place that July in the Olympic Centennial Park received no comment in the press, the exhibition inspired many admiring reviews. The *Los Angeles Times* art critic Christopher Knight preferred *Souls Grown Deep* to the High's official contribution to the Cultural Olympiad, *Rings: Five Passions in World Art*, lauding the former for expanding on the "groundbreaking display of black American folk art that traveled the United States in the early 1980s."[22]

Months before *Souls Grown Deep* debuted in Atlanta, *The Dial Family: A Celebration of African American Self-Taught Artists* opened at the Sidney Mishkin Gallery at Baruch College in Manhattan, marking Lockett's first art museum appearance north of the Mason-Dixon Line. When this show was reprised in an expanded format as *Bearing Witness: African American Vernacular Art of the South* a year later at the Schomburg Center for Research in Black Culture, Arnett brought Lockett and four other artists to New York to see the show.[23] It was not the first time Lockett had seen his artwork on display, as Arnett had invited him to previous events in Atlanta, but the experience had a significant impact on the artist. "It just opened his eyes to bigger things," Arnett recalls.[24]

Just as *Black Folk Art* benefited from groundwork laid in preceding decades, this second wave of group shows exclusively devoted to black vernacular artists did not

materialize out of a vacuum.[25] However, the tight succession of exhibitions—four in four years—as well as the critical acclaim many of them received marked a level of art world interest that had not been seen since *Black Folk Art*.[26] Yet the venues for these shows—university museums, a research center, and a municipal building—were strikingly different from an art world inner sanctum represented by the Corcoran. Although all museums share a pedagogical mission, a study conducted by the University of Chicago in 2012 concluded that campus museums are typically more "experimental and innovative" because their direct accountability to an institution of higher learning "allows greater freedom of expression and lets campus museums be more daring in their exhibition and program choices."[27] In addition to their liberating ties to academic inquiry, which allowed them to revise the controversial category of black folk art, the venues for *Àshe* and *Bearing Witness* also possess specific allegiances to the study of black culture in the United States: the Schomburg Center has been devoted to the exhibition and study of the social and cultural achievements of African diasporic peoples for nearly a century, while the Diggs Art Gallery is the university museum of a historically black university.[28]

In addition to a shift in institutional stewards—from the canonical Corcoran to academic and alternative venues like the Diggs and Atlanta's City Hall East—the second wave of black vernacular art exhibitions that debuted Lockett's work introduced revisions to terminology and an expansion of discourse. Patterson demonstrated that he had absorbed the lessons of *Black Folk Art*, writing that the artists in *Àshe* "can't be described as 'folk' artists according to the strict definition of that term outlined by folklorists and other academic specialists" and offering "visionary" as an alternative.[29] By contrast, the organizers of *Souls Grown Deep* and *Bearing Witness* favored "vernacular" for their subtitles, a pivot that left critics unconvinced and even pessimistic. Thomas McEvilley suggested that the term "vernacular" was guilty of perpetuating "the classical modernist distinc-tion between high and low arts."[30] Michael Kimmelman doubted its ability to "catch on because it lacks the ring of avant-garde rebellion that 'outsider' had."[31] Almost twenty years later, we continue to circle within this interminable loop of labeling, criticism, and relabeling.[32] The attempts of curators in the 1990s to use more apt terms may not have produced a clear heir to "folk," but they represented an underlying effort to approach their material more critically than their 1982 predecessors had. Patterson, for instance, clearly laid out the criteria for selecting the artists in *Àshe*, which, apart from race and lack of art school training, included their use of recycled materials—a practice he relates to the survival of West African traditions on U.S. soil. Although the scholar Regenia Perry had addressed this practice in the *Black Folk Art* catalogue, by the late 1980s black vernacular artists' adaptations of African traditions had become a widely circulated assertion thanks to Yale professor Robert Farris Thompson and his followers. Many essays in *Souls Grown Deep*, the two-volume book by William and Paul Arnett that followed the 1996 exhibition, bear the mark of this Africanizing discourse, although the art is the real star in these hefty productions, which continue to serve as an unparalleled record of the breadth and depth of southern African American vernacular art.[33]

In addition to generating new interpretive frameworks and visual resources, the shows that emerged in the late 1990s renewed debate about the boundaries between insiders and outsiders. The notion that a self-taught artist could "out-modern the moderns" goes back to Henri Rousseau and, in this country, to interwar period artists like John T. Hailstalk, an African American elevator repairman whose paintings were shown in a Manhattan gallery in 1928.[34] But the degree to which self-taught artists cause a reckoning with mainstream definitions of art has reached a new magnitude in recent decades, as contemporary artists further the aesthetic anarchy set in motion by the overthrow of academic authority more than a century and a half ago. Arthur C. Danto saw how the resurgence of "outsider art" in exhibitions including

Bearing Witness was a test case for the Institutional Theory of Art that he and other philosophers had been developing since the 1960s, which holds that art is defined not by any essential characteristics but rather by the decision of societally empowered institutions and their discourse to promote it as such.[35] What astounded Danto about his visit to *Bearing Witness* was the lack of difference between what black vernacular artists were doing and what could be found in the studios of aspiring contemporary artists in premier art schools across the country. After reflecting on how he could imagine Lockett's *Homeless People* (plate 34) as the output of a Rhode Island School of Design student, Danto added, "In fact, there was probably not a single work in the Schomburg show that could not have been painted by an art-world artist, with academic credentials, rather than by an artist defined as an outsider."[36] Danto further developed his explanation for this "treachery of visual sameness" three years later in his catalogue essay for *Testimony*, which was poignantly and prematurely titled "The End of the Outsider."[37]

Danto may have been in advance of the field in sounding outsider's death knell, but he presciently predicted the ubiquity of self-taught artists in contemporary art venues that has unfolded in the 2000s.[38] Although Lockett has yet to be integrated into the contemporary mainstream, the widening knowledge of his art is bound to inspire new curatorial attention, as solo exhibitions like this one strongly assert an artist's canonical status and give expansive views of his or her work not afforded by group shows. The denouement of Lockett's institutional triumph is yet to come and, we hope, will continue not only in the context of black vernacular art but also in a specific realm of contemporary art to be discussed in part II of this essay.

Part II. Toward a Contemporary Context

Ronald Lockett's concerns are the stuff of the everyday and its disintegration. Through the roughly 250 works he made over a ten-year period, he actively developed a visual and material language for art making to intervene in social life's most basic and urgent questions—the kind of inquiries that, in broad strokes, describe the stakes of contemporary art writ large. Consider Lockett's commitment to thinking through the relationship of the industrialized, built world to the natural environment: in reusing scrap building materials and discarded signage as the supports for his depictions of figures and landscapes, he treated his materials and illusionistic image-making as contingent upon one another. Consider also his concern with notions of historical dispossession, which he understood in both grand historical and ecological terms (e.g., the Holocaust, the dropping of the atomic bomb on Hiroshima, environmental degradation) and deeply personal terms (the death of his great-aunt Sarah Dial Lockett, or his awareness of his own mortality).

Throughout his work, Lockett addressed a central contradiction of his life: his desire for freedom and the impediments to his own self-articulation. In understanding the personal stakes of this challenge, we were drawn to the reliance on muted biographical details in the existing accounts and literature on his work. We had heard about his shyness and softness, characteristics that were projected onto his symbolic figures, including his representations of trapped deer.[39] We knew of his HIV diagnosis and the fact that he eventually died of AIDS. Through our own projection, we identified with his narrative of social alienation and, as queer subjects, wanted to break through the gossip and circumspection about who Lockett was to name them as filled with innuendo and homophobia. Yet rather than claiming him as our own, we in fact recognized in him a resistance to be known and thus claimed, both during his life and now. In the absence of locating a true Lockett, might it be his own illegibility that shared an affinity with us in ways that mirror how artists have proposed a link between unknowability and queerness, if we understand "queerness" not as an identification or even a set of sexual practices but, rather, as a buffer against stable narratives of identity and cultural representation?[40]

In seeking to situate Lockett's life and the work that ensued from it, we were immediately drawn to contextualize him within the New York artistic community that organized around issues of representation and AIDS in the late 1980s and early 1990s, around the same time he was actively working in Alabama. We struggled to fit him into a dialogue of petition and protest, wondering how a cultural struggle led by interlocking communities of lesbian and gay practitioners in an urban context could be considered alongside the work of an artist working in a specific community of other artists (Thornton Dial, his sons, and Sarah Dial Lockett) in postindustrial Alabama. What would a shared topos in which Lockett might be considered alongside the cultural politics of AIDS activism of his time look like?

Following this line of inquiry, we put works that have little historic or personal affiliation with one another in dialogue, effectively curating fictional encounters to ask whether the process of situating Lockett in relationship to his contemporaries working in a different cultural context can open up shared strategies. Might we be able to locate a common articulation of loss in the face of an epidemic, a heightened relationship to sentiment and feeling, or a political project rendered in its full aesthetic terms? Insofar as we attempt to find traction in comparing works that have no historic relationship to one another beyond their contemporaneity and their relationship to the AIDS crisis, we also acknowledge the limitations of such an approach. Indeed, it risks falling into the trap of pseudomorphism on a social level, in which one thing looking like another or grappling with similar content is privileged over artistic intent or social context. Because we believe that canonical revisionism is ambivalent at best, the task of looking at incommensurable things beside one another can in fact redouble the acts of historic closure they rally against, reproducing the inequitable relations that caused one work to be favored by history at the other's expense. Despite these risks, there is a productive force in these experiments in comparison if one looks through both similarity and difference. Be-

cause of the potential errors of this kind of work, we will favor Lockett's work in our story in the hopes that even if the reader is unconvinced by the context in which we attempt to place him, we will at least have offered another method by which to explore his contribution.

FLOWERS

The 1997 work *Sarah Lockett's Roses* (plate 57) is an assemblage of red, orange, white, tan, and black rectangular pieces of metal. Affixed to each of the more than two dozen panels is a metal rose, made of the same colored material as its support and affixed to its support with nails. The title of the work references the artist's great-aunt, whose front yard in the Pipe Shop neighborhood of Bessemer contained roses and lilies. Sarah Lockett, a quilt maker and gardener, died in 1995 at the age of 105. The work carries several memorial functions: named after the elder Lockett, its depiction of flowers represents this classic object of mourning, and in its overlapping application of metal pieces, its construction also pays homage to the artist's great-aunt's quilt-making practice.

Now consider Felix Gonzalez-Torres's *"Untitled" (Alice B. Toklas' and Gertrude Stein's Grave, Paris)* (1992), a series of photographs depicting the flowers that appear below the grave of Gertrude Stein and Alice B. Toklas in the Cimetière du Père-Lachaise in Paris (fig. 9). Stein and Toklas—famed modernist art collectors, writers, a lesbian couple, and longtime residents of Paris—were buried together and share one headstone; one of their names is engraved on either side. In photographing the flowers rather than the identifying gravestone, Gonzalez-Torres reveals the significance of the images to the viewer only through the work's title. In this way, he triangulates himself and the viewer, both inserting himself and us into their private lives and rendering this public memorial intimate and on the viewer's scale. Four images were recently included in the exhibition *Macho Man Tell It to My Heart: Collected by Julie Ault*, organized by artist and curator Julie Ault at Artists Space in New York (fig. 10).[41] Installed on the white field of the gallery wall, the juxta-

Figure 9
Felix Gonzalez-Torres
"Untitled" (Alice B. Toklas' and Gertrude Stein's Grave, Paris), 1992
Framed C-print
29 ¼ × 36 ¼ in.
Image: 15 ¾ × 23 ¼ in.
Edition of 4, 1 AP
© The Felix Gonzalez-Torres Foundation
Courtesy of Andrea Rosen Gallery, New York

(below) Figure 10
Installation view of *Macho Man Tell It to My Heart*,
collected by Julie Ault. 24 November 2013–23 February 2014
Image features four pieces of additional material related to
"Untitled" (Alice B. Toklas' and Gertrude Stein's Grave, Paris), 1992
© The Felix Gonzalez-Torres Foundation
Courtesy of Andrea Rosen Gallery, New York

position of images feels happenstance, much like a group of friends or plants scattered in a garden or gallery. Their provenance, made legible in the gallery's accompanying floor plan, indicates a network and chain of possession: "Gift of the artist to Julie Ault, 1993; Collection of Roni Horn; Collection of Jim Hodges Collection of Danh Vo; Acquired by Julie Ault by descent, 1996; Gift of Julie Ault to Danh Vo, 2009."

While the depiction of flowers is a long-standing subject in the history of Western art, codified within the still-life genre since the late sixteenth century, the meaning of Lockett's and Gonzalez-Torres's works are defined by their respective contexts. While they share a memorial and mourning function, Lockett's works were made in homage to his great-aunt, while Gonzalez-Torres's are a link between multiple generations of artists and collectors. Whereas Vo's acquisition of Gonzalez-Torres's depiction of Toklas and Stein's grave brackets concerns across three generations of artists, Lockett's layering and assemblage pay homage to the structure of his great-aunt's quilt-making practice. Both are citational, coded through different logics but structured through inter-generational relationships between a set of practitioners. Finally, what we are looking at in both works is a kind of garden, with cyclical time and labor implied therein. The space of the garden is a cypher for everyday acts of care and preservation, with all the power and influence such considerations carry with them. In *My Garden (Book)*, for example, Jamaica Kincaid describes a process of un-wittingly constructing a garden in her yard that resembles a map of the Caribbean. She writes, "I marveled at the way the garden for me is an exercise in memory, a way of remembering my own immediate past, a way of getting to a past that is my own (the Caribbean Sea) and the past as it is indirectly related to me (the conquest of Mexico and its surroundings)."[42] Kincaid's garden, like Lockett's and Gonzalez-Torres's, is representational, but their representations are not figurative; instead they rely on codes and decoys. Much as Kincaid's garden depicts the Caribbean not through the intention of picturing

this place, but as an act of remembrance, Lockett's and Gonzalez-Torres's flowers are objects that memorialize others through the ongoing and personal negotiation of memory.

ARE YOU A BOY OR A GIRL?
Ronald Lockett's 1995 work *Fever Within* (plate 49) is made up of two recycled metal panels stacked verti-cally and nailed to a recycled wood support. The figure depicted is nude, with legs crossed and arms extended back. While the punchwork detail that distinguishes the figure from its ground underlines the figure's chest, its line work does not clearly identify the chest as breasts or pectorals, leaving the figure's identify as either male or female open-ended. Lockett made this work by nailing strips of salvaged metal siding to recycled plywood. It is one of multiple iterations done at the same time, the oth-ers of which also depict a single figure whose femininity is more pronounced. Constructed after he and his girl-friend had both been diagnosed with HIV, the image can be read, in light of the title, as a portrait of her, of him, or of a figure meant to stand in for their composite. A sec-ond piece of siding divides the figure from the lower half of the panel. It is the only component that sculpturally divides the three-dimensional plane of the work, and it appears to be a bed or carpet on which the subject rests. The figures themselves emerge from the tan ground, dis-tinguished through the browns that make up their form. Not only do they lack clear marks of gender identifica-tion, but they are also built from the same material as the support. As a silhouette, the subject's particularities of face, character, and identity remain unknown.

Active between 1991 and 1995 and since 2007, fierce pussy work as a collective of queer women dedicated to making public art and taking direct action to address les-bian identity and visibility.[43] Emerging out of the mem-bers' engagements with AIDS activism, the collective mined modest and readily available resources, including old typewriters, found photographs, its members' baby pictures, and the printing supplies and equipment ac-

Figure 11
fierce pussy
Are You a Boy or a Girl?
2009
Bathroom installation at the Carpenter Center, Harvard University
ACT UP New York: Activism, Art, and the AIDS Crisis, 1987–1993
Photograph courtesy Harvard Art Museums

cessible in their day jobs. Many of their low-tech, low-budget, and ubiquitous wheat-pasted posters and crack-and-peel stickers could be found throughout New York City in the early 1990s.

In 2009, at the invitation of curators Helen Molesworth and Claire Grace, fierce pussy reconvened for a residency and exhibition at Harvard's Carpenter Center for the Visual Arts, and then subsequently at White Columns in New York City. During their residency, artists Nancy Brooks Brody, Joy Episalla, Zoe Leonard, and Carrie Yamaoka worked with students to develop visual material addressing issues of gender and sexuality at Harvard and beyond, and ultimately made two exhibitions, one at each location. The Boston iteration of the show included wheat-pasted photocopied posters sited in several bath-

rooms that reproduced the collective's signature image of grade school class photo over a list of derogatory terms for lesbians with the following text written above and below the image: "Are you a boy or a girl?" (fig. 11). At once questioning the viewer and the young students in the image, the statement's direct address sites the classroom as an early gender-disciplinary institution. It also turns a taunt used against genderqueer children into an open-ended prompt viewers can answer for themselves.

Lockett's *Fever Within* and fierce pussy's recent installations share several formal qualities. Both directly relate to architecture and the built environment. Lockett uses metal siding from three locations in Bessemer for his sculpture's support; fierce pussy's work is facilitated by the building walls they use to make interventions in

public space. Lockett created multiple versions of *Fever Within*, each unique in its treatment, whereas fierce pussy's investment in the multiple as a low-cost, easily reproducible material makes its political use expressly agitprop, operating directly within the public sphere. Yet both of their projects offer articulations of gender in ways that embrace illegibility. While potentially adding to the number of representations of women living with HIV to the metaphorical image bank, they more fundamentally question the need to depict people living with AIDS in cogent representational forms. Neither offers up an image of a subject, instead leaving their identity—gender and otherwise—for the viewer to fill in.

ONCE SOMETHING HAS LIVED
IT CAN NEVER REALLY DIE

Once Something Has Lived It Can Never Really Die (plate 39), from 1996, is among the last of Lockett's *Traps* series. It consists of two vertical sheets of rusted, deteriorated, grime-blackened metal onto which he has placed a painting of a buck's head and torso. Throughout his work, he returned to images of traps and depictions of deer. Often using scraps of chain-link fence or netting, the artist applied paint to the material after the construction of the composition. Lockett's use of deer, does, and bucks has been read in relationship to ideals of love and vulnerability. For example, Bernard L. Herman describes the untitled image of two deer as "at once a commentary on the protective nature of companionate love, the limits of freedom, the struggle to escape, and in the skeletal and fleshed out creature, the sense of mortality."[44] Love—its aspirations and impossibilities—are at once an attempt to reach beyond the self and a recognition of our ultimate total solitude.

Once Something Has Lived resembles both Lockett's *A Place in Time* (plate 20) and *Rebirth* (plate 24) in its use of wire and the appearance of the buck. The skeletal form that appears against a black background in *Rebirth* appears in *A Place in Time* in a passage in its upper right quadrant. The animal in *Rebirth* emerges from another landscape demarcated by a stark shift in color palette from green to black which suggests that time is cyclical and enacts the title's reincarnation. On the other hand, its appearance in *A Place in Time* suggests a sense of immanence in which each moment is unitary and ephemeral.

From 1987 to 1989, the artists collaborative Group Material (which at the time consisted of Doug Ashford, Julie Ault, and Felix Gonzalez-Torres) organized *Democracy: A Project by Group Material* at Dia in its SoHo location (fig. 12). Over the course of more than two years, the artists conceived and directed a series of events that included planning sessions, private roundtable discussions, four exhibitions, and several "town meetings" open to the public. Resulting from a suggestion by Yvonne Rainer, and running parallel to Martha Rosler's *If You Lived Here*, Group Material's *Democracy* explored democratic processes and ideals in the United States through specific issues of public education, politics and elections, cultural participation, and the AIDS crisis.

The third of these exhibitions, which hinged on notions of cultural participation, considered debates around racial distinctions in the art world as well as the status of outsider art as its point of departure. In looking at the installation shot from the exhibition, one can see Bessie Harvey's work placed beneath bags of chips situated serially on a horizon line by Group Material, and in a sight line shared by Cindy Sherman's *Untitled (film still)*.[45] During the run of the exhibition, the collaborative organized a roundtable that included Robert Farris Thompson, who commented:

One thing we should realize is that the black studies in the visual arts now is so powerful that many don't need us. They're doing it without us. Also, we should address the situation of the visionary painters and sculptors in their seventies, eighties, and nineties—groups beyond race and class. I refer to black men and women who are over seventy who respond to a spiritual imperative when they become

painters. This leads me to talk about black "yard-shows," so-called environments (a phrase museums use). This art form is a challenge, by the sheer audacity of turning lawns into yard-shows. Who gives a damn about 57th Street or Soho; black visionaries have their own art projections, some yard-shows seem ritually enacted.[46]

How would Lockett's work have figured into this debate? Was there a place for him in the Group Material show—between the third exhibition, on cultural participation, and the fourth, which dealt with the AIDS crisis? Could his work have lived comfortably sandwiched between Sherman and Harvey? What is more challenging is the fact that the kinds of interventions Thompson

was staging and grappling with recur today. These statements are as urgent now as they were in 1990, a testament both to their speakers' prescience and the amnesia of our moment. Julie Ault's 2013 exhibition, which reconsidered her collecting practices during and through the impact of Group Material, and fierce pussy's 2011 reinterpretation of their own work and its contemporary reception and valence demonstrate a commitment to an interrelated set of questions about the relationship of outsiderness to political struggles for racial and sexual identification. Even if Lockett himself was not included in any of these exhibitions, his understanding of time as at once cyclical and immanent is perhaps an allegory that we can use after the fact to situate him within a current debate around inclusion that is marked by these very

stakes. Articulating this repetition outside of a New York art world, it demonstrates that centers of knowledge production and cultural negotiation can occur in a variety of homes and locations.

Conclusion: Broadening Curatorial Possibilities

In her essay "How to Install Art as a Feminist," curator Helen Molesworth grapples with curatorial models that acknowledge the historical absences of women artists. While the academy has been able to incorporate women into its canon, hire female professors, and create coursework on feminist art practices, she argues, museums have yet to come to terms with how they should address the fact of historical absence. Although she has made exhibitions and given interpretative language to the work of female artists, she asks, "Is it really as simple as reinserting them into a chronological narrative that hitherto hasn't accounted for them? The chronological purist in me loves the idea, but I fear it is the nonfeminist in me that desires such a pat formulation: a broken story required by insisting that these artists occupy their rightful places in a grand narrative."

She goes on to question whether this corrective insertion is really enough: "Is it a revolution of the deepest order to insert women artists back into rooms that have been structured by their very absence? What would it mean to take this absence as the very historical condition under which the work of women artists is both produced and understood?"[47] While curatorial work involves situating artists in the time and place in which they lived and worked—a methodology art histories that attend to the social have emphasized—it is also the responsibility of institutions to narrate the history of the reception of artworks, even if that history is one of exclusion, absence, and belated arrival. Resituating Lockett's work through the above pairings brings his art into a context other than the black vernacular, which was how his art was first contextualized in the 1990s, but it does not purport to seamlessly integrate Lockett into the "grand narrative" that

Molesworth bucks against. Rather than recuperative insertions based only on an extrinsic desire to revise the institutional exclusion of an underrepresented artist, these pairings are structured by deep readings of the works themselves, which uncover common strategies and experiences among artists who, despite differences in training, geography, gender, and race, share a desire to engage in the world around them by picturing it, by refusing to do so, and—in the space in between—by grappling with the transience of lives lived with state abandonment conditioned by AIDS.

Our intent has not been to "liberate" Lockett from the evolving but nonetheless segregated field of black vernacular art, a move that would only further privilege the contemporary as a high altar to which all artists must ascend. In their critique of this assumption, Colin Rhodes and Bernard L. Herman have shown how when an "outsider" artist becomes a "contemporary" artist—a conversion they term the "contemporary turn"—the art world is merely reconsolidating its power by "granting an authority on the margins and then populating it with proxy selves."[48] Moreover, group shows of African American self-taught artists are still productive and eye-opening, materializing most recently in *Soul Stirring: African American Self-Taught Artists from the South* and *Our Faith Affirmed: Works from the Gordon W. Bailey Collection*, at the California African American Museum and the University of Mississippi Museum, respectively.[49] At the Hirshhorn Museum and Sculpture Garden in March 2014, curator John Beardsley owned up to the epistemological shortcomings of his show *Black Folk Art*, but emphasized that the erosion of categories we are experiencing today may leave "everything equal but incompletely understood." In the face of the threat of dehistoricization that rendering everything contemporary represents, Beardsley, Herman, and Rhodes all recommend allowing artists to maintain a multiplicity of identities and categorical allegiances. In other words, there does not need to be "The End of the Outsider" in order for Lockett to be considered a contemporary artist.

Thus this essay not only documents Lockett's historical membership in the field of black vernacular art, but also shows how his work can, in hindsight, find communion with the urban, queer, and feminist contemporaries that he never met. There is no way to know how Lockett would have preferred to have his works displayed once they left his home and the space afforded by Bessemer, and even if we could identify his intention, there remains a gap, as with any artist, between the place of their production and the site of their reception. In lieu of a recovered ambition, however, we find solace in the fact that the stakes of his project are still as vital today as they were in the moment of their original creation.

NOTES

1. David Ebony and Kate Wodell, "Southern Visions," *Art in America* 91, no. 7 (July 2003): 26–27.

2. Additionally, two of Lockett's works have recently been identified at the Rockford Art Museum in Rockford, Illinois. His work is also privately owned by pioneering collectors and advocates like Ronald and June Shelp and Gordon W. Bailey.

3. The Whitney Museum of American Art's biennial survey of American art has been a popular sample for examining the gender, racial, and regional biases of the contemporary art world. The artist activist group Guerrilla Girls, for instance, tracked the demographics of the biennials throughout the 1990s in the piece *Traditional Values and Quality Return to the Whitey Museum* (1995). They recorded that in 1991, 89.7 percent of the artists chosen for the biennial were white (http://hyperallergic.com /93821/the-depressing-stats-of-the-2014-whitney-biennial/). However, because museum exhibitions and acquisitions are dynamic, metrics of the white majority in American institutions are constantly changing and always biased by the chosen sample. For an in-depth examination of the presence of black artists in American museums through case studies that span the twentieth century, see Bridget R. Cooks, *Exhibiting Blackness: African Americans and the American Art Museum* (Amherst: University of Massachusetts Press, 2011).

4. This essay's title echoes cultural and literary critic Saidiya Hartman's "Venus in Two Acts." In that essay Hartman builds on the work of black artists and writers including Stan Douglas and M. NourbeSe Philip to propose "critical fabulation" as a method of reading and narrativizing missing elements in the archive of her subject. She writes, "By playing with and rearranging the basic elements of the story, by re-presenting the sequence of events in divergent stories and from contested points of view, I have attempted to jeopardize the status of the event, to displace the received or authorized account, and to imagine what might have happened or might have been said or might have been done." While our object of study is different in temporal scope and power relations from Hartman's writing of the captive girl in the archive of slavery, we borrow Hartman's narrative strategy of writing through imagination and reconstitution in the space of loss. Saidiya Hartman, "Venus in Two Acts," *Small Axe: A Caribbean Journal of Criticism* 12, no. 2 (June 2008): 11.

5. "Art world" is defined here not as a static, monolithic entity, but rather a dynamic, pluralistic network of actors: artists, curators, collectors, dealers, scholars, and anyone else who is capable of conferring "the status of candidate for appreciation" through institutional contexts like exhibitions, books, collections, and other means of elevating objects to the status of Art. George Dickie, "Defining Art," *American Philosophical Quarterly* 6, no. 3 (1 July 1969): 253–56.

6. This show took place at the Willard Gallery on Seventy-Second Street in Manhattan and had an important domino effect: it inspired the folk art collector and dealer Edmund J. Fuller to begin researching Edmondson's life, and in 1973 he published the first monograph on the artist. Additionally, Stony Point Folk Art Gallery was cofounded by Adele Earnest, who was also one of the founders of the Museum of Early American Folk Art (MEAFA, now AFAM), and MEAFA held another Edmondson show in 1965.

7. Nina Howell Starr, *Minnie Evans* (New York: Whitney Museum of American Art, 1975).

8. Curator Lynda Roscoe Hartigan has characterized this galvanizing event as follows: "The Corcoran's project issued a clarion call, refreshing or recruiting collectors, dealers and scholars, inciting head-over-heels efforts to discover new artists, creating a market, and inspiring the contemporary art world to reexamine its assumptions and priorities." Lynda Roscoe Hartigan, "From the Sahara of the Bozart to the Shoe That Rode the Howling Tornado: Collecting Folk Art in the South," in *Let It Shine: Self-Taught Art from the T. Marshall Hahn Collection* (Atlanta: High Museum of Art; distributed by University Press of Mississippi, 2001), 52.

9. Ibid.

10. Bernard L. Herman and Colin Rhodes, "Canons, Collections and the Contemporary Turn in Outsider Art: A Conversation," in *"Great and Mighty Things": Outsider Art from the Jill and Sheldon Bonovitz Collection*, ed. Ann Percy and Cara

Zimmerman (Philadelphia: Philadelphia Museum of Art, 2013), 246.

11. Chuck Rosenak and Jan Rosenak, eds., "Leroy Almon," *Museum of American Folk Art Encyclopedia of Twentieth-Century American Folk Art and Artists* (New York: Abbeville Press, 1990), 30.

12. Jill Bonovitz remembers of the Corcoran show, "That was when we really saw this material, and both of us were excited by it." Cara Zimmerman and Darielle Mason, "Resonances: A Discussion on Collecting with Jill and Sheldon Bonovitz," in Percy and Zimmerman, *"Great and Mighty Things,"* 18.

13. Hartigan, "From the Sahara of the Bozart," 52. Lenders to the show included individuals like William Arnett and Chuck and Jan Rosenak, galleries such as the Phyllis Kind Gallery, and institutions like MEAFA and the Center for the Study of Southern Culture in Oxford, Mississippi.

14. Eugene W. Metcalf Jr., "Black Art, Folk Art, and Social Control," *Winterthur Portfolio* 18, no. 4 (1983): 281.

15. James Clifford, Hal Foster, Hilton Kramer, Thomas McEvilley, Gil Perry, and others have offered important critiques of *Primitivism*.

16. The National Museum of American Art is now the Smithsonian American Art Museum (SAAM).

17. It should be noted that the work of James Hampton, a self-taught African American artist working in Washington, D.C., entered the collection of SAAM and, prior to that, the National Collection of Fine Arts, in 1970, decades before the collections of Herbert W. Hemphill Jr. or the Rosenaks. Hampton's sprawling altarpiece, *The Throne of the Third Heaven of the Nations' Millennium General Assembly*, c. 1950–64, remains the showstopper of SAAM's folk and self-taught art galleries.

18. Prior to this exhibition, Lockett's work was shown in group shows at three nonmuseum venues: the North Avenue Presbyterian Church in Atlanta (1989), New York's Ricco Maresca Gallery (1991), and the Alabama State Council on the Arts (1991).

19. Tom Patterson, *Àshe: Improvisation and Recycling in African-American Visionary Art* (Winston-Salem, N.C.: Diggs Gallery at Winston-Salem State University, 1993), 6.

20. Ibid., 12. Patterson learned of the Yoruba word/concept *àshe* through the work of Robert Farris Thompson.

21. Thomas McEvilley, "The Missing Tradition," *Art in America* 85, no. 5 (May 1997): 83.

22. Christopher Knight, "Wins, Losses of Olympic Proportions; Art Review: Despite Two Triumphant Exceptions, Visual Components of the Cultural Olympiad Don't Overcome Conceptual Hurdles," *Los Angeles Times*, 4 July 1996, http://

articles.latimes.com/1996-07-04/entertainment/ca-20925_1 _visual-arts.

23. *The Dial Family* and *Bearing Witness* were, like *Testimony*—the show discussed at the opening of this essay— drawn from the collection of the Shelps.

24. William Arnett, interview with the author, 25 June 2014.

25. Apart from the solo exhibitions noted previously, there were group exhibitions such as *Baking in the Sun: Visionary Images from the South* (1987–88) and *Next Generation: Southern Black Aesthetic* (1990), which included the work of black self-taught artists but were not devoted to them. An important antecedent to the second wave, the group exhibition *Another Face of the Diamond: Pathways through the Black Atlantic South* (1989), was devoted to self-taught artists of the African diaspora, although it was a gallery rather than a museum show and had an international scope. None of these exhibitions included Lockett's work.

26. This renewed interest in black vernacular art occurred amid a larger proliferation of exhibitions on self-taught artists in the 1990s, from the Los Angeles County Museum of Art's *Parallel Visions* to a series of collection-based shows drawn from the personal troves not only of the Rosenaks, Michael and Julie Hall, and Bert Hemphill, but also of T. Marshall Hahn, Dr. Kurt Gitter and Alice Rae Yelen, and Baron and Ellin Gordon, among others.

27. Tom Shapiro, Peter Linett, and Betty Farrell, *Campus Art Museums in the 21st Century: A Conversation* (Chicago: Cultural Policy Center at the University of Chicago, 2012), 4.

28. In her introduction to the *Àshe* catalogue, former Diggs director Brooke Davis Anderson positioned the show as kicking off a "curatorial effort to periodically show art that celebrates all of the cultures of the African diaspora." Tom Patterson and Brooke Davis Anderson, introduction to *Àshe*, 2.

29. Patterson, *Àshe*, 6–8.

30. McEvilley, "The Missing Tradition," 85.

31. Michael Kimmelman, "By Whatever Name, Easier to Like," *New York Times*, 14 February 1997, http://www.nytimes .com/1997/02/14/arts/by-whatever-name-easier-to-like.html.

32. Although social and racial difference are uniquely at play when it comes to hailing this subfield of art, frustration with insufficient terminology is not unique to the folk/self-taught /outsider/visionary field. As art historians Griselda Pollock and Fred Orton have argued, "The will to conjure up a movement, to produce an art historically coherent entity is all pervasive," and it has led to other "lumpen" terms like impressionism and postimpressionism that we think of as organic but that are actually highly constructed and insufficient. Fred Orton and

Griselda Pollock, "Les Données Bretonnantes: La Prairie de Représentation," in *Avant-Gardes and Partisans Reviewed* (Manchester: Manchester University Press, 1996), 54.

33. See William Arnett and Paul Arnett, eds., *Souls Grown Deep: African American Vernacular Art of the South*, vol. 1 (Atlanta: Tinwood Books, 2000), and vol. 2 (Atlanta: Tinwood Books, 2001).

34. Mary Ann Calo, "African American Art and Critical Discourse between World Wars," *American Quarterly* 51, no. 3 (1999): 117.

35. Arthur Danto, "The Artworld," *Journal of Philosophy* 61, no. 19 (15 October 1964): 196.

36. Arthur C. Danto, "Art," *Nation* 274, no. 16 (29 April 2002): 35.

37. Arthur C. Danto, "The End of the Outsider," in *Testimony: Vernacular Art of the African-American South: The Ronald and June Shelp Collection* (New York: Harry N. Abrams, 2002), 35–36.

38. Examples include the recent inclusion of Herbert Singleton and Lonnie Holley in *Prospect.3 New Orleans* or Judith Scott's 2014 survey at the Brooklyn Museum.

39. In a 2014 interview between gallerist Barbara Archer and Bernard L. Herman, Archer describes Lockett's demeanor. She says, "I remember him as someone who was extremely quiet, almost to the point of being shut down. Emotionally, intellectually, I guess perhaps physically—in every way, he was very close to being nonverbal. And so it was very difficult to know him. I think that anyone who knew him felt they knew him through his work and what he was trying to express because it was very hard to get anything from him personally."

40. For more about the relationship between queerness and illegibility, see José Esteban Muñoz, *Cruising Utopia: The Then and There of Queer Futurity* (New York: New York University Press, 2009).

41. *Macho Man Tell It to My Heart: Collected by Julie Ault* (2013) was an exhibition of works selected and extended from the collection of Julie Ault, a founding member of the artists' collaborative Group Material (1979–96). The exhibition included a range of artists including Rev. Howard Finster, Felix Gonzalez-Torres, Cindy Sherman, Carrie Mae Weems, and others.

42. Jamaica Kincaid, *My Garden (Book)* (New York: Macmillan, 2011), 4.

43. In reference to the search for visibility, Carrie Yamaoka writes, "In retrospect, perhaps what we were saying was that we had not yet formulated the proper language to name ourselves; that the naming of us was inadequate, determined by the heteronormative, not by us." Carrie Yamaoka, personal correspondence with the author, June 2015.

44. Bernard L. Herman, personal correspondence with the author, June 2014.

45. Also included were Rev. Howard Finster's works.

46. Robert Farris Thompson, "Roundtable," in *Democracy: A Project by Group Material*, ed. Brian Wallis (New York: Dia Art Foundation, 1990), 182.

47. Helen Molesworth, "How to Install Art as a Feminist," in *Modern Women: Women Artists at the Museum of Modern Art*, ed. Cornelia Butler and Alexandra Schwartz (New York: Museum of Modern Art, 2010), 504.

48. Herman and Rhodes, "Canons, Collections and the Contemporary Turn in Outsider Art," 253.

49. The former show was curated by Gordon W. Bailey, featuring many works from his collection as well as the collections of Audrey Heckler, Monty Blanchard, and the High Museum of Art. The latter show, which was accompanied by a moving catalogue with essays by W. Ralph Eubanks, among others, marked Bailey's major 2014 gift to the University of Mississippi Museum.

Passing the Buck

THE EDUCATIONS OF RONALD LOCKETT

Paul Arnett

The noble ambition not to be the kind of people who

unwittingly fetishize and exoticize black or poor white

folk poverty has allowed us to remain the type who don't

stop to ask if the serious treatment of certain folk forms

as essentially high- or higher-art forms might have

originated with the folk themselves.

—John Jeremiah Sullivan, "Unknown Bards"

Ronald Lockett and I were twenty-two in the fall of 1987. (He was the older by a few months.) It seems laughable now, because we subsequently became friends, but I cannot remember when we were first introduced . . . sometime that summer. I would have been told that here was someone such as "a neighbor" or "a cousin"—not "artist." More laughable still, it would surely have been Thornton Dial himself who introduced us; and who would ever want or expect to lose touch with an occasion like that?

Along with my father, William Arnett, and a rotating gallery of fellow art lovers, I was becoming a routine visitor to the Thornton Dial home in the Bessemer, Alabama, neighborhood informally known as Pipe Shop. In midsummer, Birmingham vernacular artist Lonnie Holley had "discovered" Dial (artistic "discovery" being an extra-troublesome concept here because Holley didn't even identify him as an artist that day in Dial's yard, but left with a gift of handcrafted fishing lures that subsequently so mesmerized my father that the two of them made a trip back to Dial's, where they were shown an eight-foot-tall welded-steel effigy of a turkey that Dial stored in a coop in his great-aunt Sarah Dial Lockett's yard). That is a stranger tale than this, but this story—Ronald Lockett's—wouldn't be possible without the many near-miraculous coincidences that fed into the initial encounter between my father and Thornton Dial.

For several years, since finishing high school, Ronald Lockett had hung around Thornton Dial's house and environs. Dial, then in his late fifties, lived two houses away, while Sarah Dial Lockett, the ancient woman whose biography braided the two families together, lived in the house between them. Ronald looked up to Thornton as a kind of surrogate father and mentor, as well as—prophetically—a creator, a proto-artist. Dial—now somewhat famously—didn't call his painted sculptural creations "art," and hid and tore apart and freshened

and recycled his "things" (art) into newer things in his backyard. He was used to Ronald coming and going and didn't mind having him around, even when Dial was making things. Ronald was shy, he was quiet, he was introspective, but he was kin and he was accepted, which meant he could be there without announcing himself. So I don't remember meeting him.

Most laughably, I also cannot remember the first time I saw Ronald's paintings . . . sometime that autumn? . . . or which paintings they were. I only know they must have been small, showed unmistakable signs of talent, and looked not much like the products of any aesthetic genre then in service. (I know this primarily because all of his earliest work possesses those qualities.) One day, out of the blue he told my mother, Judy, that he had been making art since he was a child and had always wanted to be an artist. He asked if she would consider walking over to his garage (Ronald lived with his mother, Betty) and looking at some things. He had never spoken of such to Thornton Dial, for example, or to my father, or to me.

I have thus far been making sport of my chancy memory, but now I'm going to ditch the ellipses concerning an important episode from 1987 that I do remember. And my account will be colliding with Ronald's own memory of the same event, at least as recorded in an interview he gave in 1997, the year before his death. His version seems mildly self-flattering. Mine has the dual virtue of being both what I know happened and the most mind-torqueing compliment I can imagine paying to another person. The (my) truth is a better legend.

Ronald's earliest paintings presented a conundrum. He was far younger than any artist then belonging to the designations "folk" or "outsider," the prevailing terms through the 1980s, before the heyday of the more neutral "self-taught" or the advent of the more culturally descriptive "vernacular." His painting was naturalistic, dreamlike, and, well, "painterly"; there was nothing unexpected in it, yet nothing predictable about how he deployed and imagined elements in space. It was difficult to tell what, if anything, he had been "looking at" (as art enthusiasts

like to say). It was difficult to attach him or his aesthetic to the African American vernacular tradition as we then understood it. It was difficult to envision what he would be able to accomplish artistically, on his own, in his detached garage on Fifteenth Street in Bessemer. Was he really a part of this artistic phenomenon (which included, for example, Thornton Dial and Lonnie Holley), and would he have any chance to succeed as a working artist within its definitions and for its constituencies? Or should we instead encourage him, as a member of a new generation and therefore more worldly, more educated, and more modernity-savvy than, say, Thornton Dial (who, incidentally, never learned to read), to go on to art school and make his way into what we used to call "the mainstream" of the American art world?

When my dad's globally traveled, estimable art historical learning (and my scrawny, five-month-old Harvard art history diploma) proved insufficient to tackle these questions, he asked Xenia Zed, an artist and former editor-in-chief of *Art Papers* magazine, to look at Ronald's art. She found herself at the same loggerheads as we: neither direction for Lockett seemed entirely satisfactory. Both would be risky. This became an ethical dilemma, impervious to reason or experience—and a specific ethical terrain, a cultural one—which meant that we three white people, who might not be comfortable telling anybody which way to go in life, were assuredly uncomfortable advising black Ronald Lockett which way to go with his, if for no other reason than our having had no idea what any of us would do in his position. We felt disqualified and unqualified. It would have to be his choice.

Let's jump forward approximately a decade. In a 1997 videotaped interview, Ronald described his decision about whether to go to art school: "I always wanted to do artwork or whatever, but [Thornton Dial] was a big inspiration to me because you know my mother wasn't very supportive of my artwork and neither was my father. Until I got started, [my father] saw what I was doing, you know, then he was more supportive about what I was try-

ing to do in my artwork. But [Dial] was the kind of, like, driving force of my artwork. I told him I wanted to go to art school and he told me I had the best school of all just making artwork or whatever."[1] From the vistas of 1997, riding the coattails of Dial's renown, it sounds pretty great: the foremost practitioner of Ronald's art-making tradition had advised him in 1987 not to light out for art school and instead to stay in the neighborhood.

I don't remember it that way, and there is almost no chance it happened like that. In the fall of 1987, Dial had only been making art in public (and calling it art) for a few months. He was an unknown. He had never been to a museum or art gallery, knew no artists other than Lonnie Holley, and possessed no familiarity with the concept of an art college. His work hadn't yet sold for any significant amounts (if at all)—in fact, Dial was still scrounging used carpet from empty houses and leftover paint from construction projects. Besides, his ethics have always been sharp, and he was unlikely to offer life-directing advice to anyone. (It's possible he said something to Ronald in private such as "Who knows, maybe Mr. Arnett will be able to help you like he is helping me," which later came to pass.) No, I remember this as Ronald's decision, and his first act of genius.

The truth is really great: in deciding to remain a "vernacular" artist, in opting for the "studio" education of the "junk house" (as the ramshackle tin outbuilding behind Dial's home was known) at the elbow of a then unheralded, emerging "folk artist" (the moniker Dial was saddled with for quite a while), Ronald followed his own vatic intuitions in a direction no one before him had chosen. When offered a chance out, everyone had always taken it. His decision to stay put, on Fifteenth Street, constituted a moment of cultural recognition and self-recognition that placed him ahead of nearly all academics, curators, dealers, and collectors, for in the second half of 1987 almost no one fully comprehended how two or three centuries of black vernacular creative traditions were playing out daily in visual art, which, like the original country blues referenced in this essay's epigraph,[2] were not an unme-diated expression of a raw folk experience but, instead, an intentional raking-up and reframing of virtually anything and everything going on in American civilization. I think Ronald knew, as early as anyone, that Thornton Dial was a rare genius—and that one does what one can to be around such people.

If his decision was to remain a folk artist, he was an odd one: the last folk artist, more or less (so to speak). He decided to "stay" at the final possible cultural moment for doing so. He was descended from and could claim the inheritance of a majestic lineage of homespun art makers—indeed, Dial's art had been "homespun" for most of his life—reaching back at least two documented, symbolically laden generations of ancestors. These folks had clustered, ancestrally, around the rural crossroads of Emelle, in western Alabama, near the Mississippi border, and were Thornton Dial's mentors: James Hutchins (next-door neighbor to the child Thornton, and his father), Buddy Jake Dial, and Sarah Dial Lockett. Their world, opaque and fragmentary as it appears a century later, was agrarian, preindustrial, and comprehensively, corrosively "Jim Crow." Their art—which we can surmise they, like their descendant Thornton, didn't call "art"— took on many openly clandestine incarnations: quilts, strange fences and barns and cow pens, yard dressings, home adornments inside and out, and arrangements of found materials known as, and dismissible as, junk piles: in other words, a rich mélange of aesthetically purposeful yet otherwise utilitarian display. Some still survives. It's what Dial saw and was taught as a child.

It is tempting to label Thornton Dial a transitional figure between James Hutchins's and Ronald Lockett's generations. Born in 1928 into rural, tenant-farming penury, illiterate, and almost fully premodern—it was well into the 1930s before he first encountered electric power and first saw an airplane in flight, which he believed at the time might be the coming of the apocalypse—Dial migrated just before World War II to densely populated, segregated, steel-producing Bessemer, learned a variety of manual trades, welded a lot of boxcars, and sought a

better future for his children during the decades when the civil rights movement pulsated to life and transformed the region. Because Dial's capsule biography is also substantially the story of twentieth-century African American experience in the South, it is perhaps more fitting to consider him a paradigmatic figure instead of a transitional one. For those who came immediately after him, such as Ronald Lockett, Thornton Dial's generation was their culture's greatest.

Lockett's generation should have been the culmination of and the payout for prior suffering in places like Emelle and struggles for uplift in places like Pipe Shop. Instead, Ronald found himself adrift, disconnected from the rather glorious implications of that progression. The Birmingham-area industrial boom, assisted by wartime demand and incrementally opened to African Americans during the civil rights era, had slowly imploded as the American steel industry relocated overseas. By the 1980s factory jobs were no longer plentiful; Ronald never got one. Pipe Shop wasn't the safest place anymore. It was becoming a postindustrial oxbow of detoured and derailed promises, populated with young, urbanized, prospectless men of color.

Given all that, Ronald definitely should have jumped at the prospect of an art education. I doubt Dial or anyone else could have talked him out of it, and Pipe Shop had been talking him into it his entire life. Instead, he picked Dial's junk house, a parlor-size, dimly lit, smoky (cigarettes and kerosene heater), rusting-tin outbuilding Dial had made himself behind the brick home Dial had also made himself. Art shared the junk house with welded-steel patio furniture that Dial and his sons Dan and Richard made and sold under the name "Shade Tree Comfort." The junk house became Lockett's CalArts and his Met, a classroom where he received practical, art-production tutelage by "auditing" Thornton Dial at work and an atelier for discovering the outer limits of what vernacular visual art could look like and say. (And remember, if anyone—be it slave owner, sheriff, or carload of white Alabamians passing through—should ask any questions, there's nothing stored in the junk house except a bunch of old junk. The juke of misdirecting linguistic inversion has been going on in black culture for a long, long time.)

Before the end of the year, Ronald announced himself as much more than neophyte or "student." With *Rebirth* (plate 24) he became a precocious artistic force of his own. I remember *Rebirth* well. It is a placemat-scale painting, scored with a handful of nails linked by wire that contribute to the image of an animal skeleton, what Lockett called a "baby" and was, in fact, a deer, seemingly ambulating along a roadlike white strip from right to left across the picture plane, and apparently departing a schematically blue and green region for a larger black zone that takes up most of the picture's center and left side. I was, and am, startled by its mysteriousness and its playfulness—a strange unteachable mix not necessarily contradictory in strong art. The unteachable skill to pull it off lies in tweaking audience expectations and representational norms while maintaining the weight of mystery and the lightness of play. It was clear then that Ronald had it. But the piece doesn't stop there. The convention it flouts is our civilization's "left-to-rightness," especially the tradition of depicting Time, on the page, as a movement from left to right. The concept of "rebirth" should "naturally" point the animal toward the right. *Rebirth* is backward. The skeleton is, first of all, facing the "wrong" way; and to add insult to injured conventions, the (living? dead?) animal is leaving the terrestrial daytime for the pitch black. What can "rebirth" possibly mean in this painting?

The long-standing association of black with negation—by night of day, by emptiness of presence, by death of life, by gloom of cheer, by sin of innocence, and so on—seems to be under review and possibly on trial here. One's eyes expect a picture about death and negation of some kind (a subsequent, similar work, *Holocaust* [plate 26], implies that this black does represent death), but the title demands that we interpret the painting in terms of life, new life. Aha! An artwork with some theology, then—

and indeed it is (in many ways), as nearly all of Lockett's work turned out to be (among other things). The word points left to right; the image points right to left. Later, as Lockett began to explore specifically American and African American themes, this clash of renewal and finality assumed a social and moral dimension, namely, the competition between liberationist and eschatological interpretations/predictions of black history's, our civilization's, and the planet's destinies.

For almost a quarter century, the above was my understanding of *Rebirth*, which I admired alongside the very best American paintings of its era. In writing this essay, however—in thinking about Ronald's decision to turn away from an art school future and to remain in Pipe Shop, and the proximity of that choice to this painting—it occurs to me that this little skeleton may be autobiographical: that *Rebirth*/"rebirth" may be about that psychological conflict Ronald had gone through, about his rejection of the obvious "progress" toward a new life (art school)—the painting's blue and green—in favor of a different, ostensibly "wrong" or "backward" direction for himself in choosing to remain/exist within the social death of bleak, postindustrial (and nearly all-black) Pipe Shop, where he might nevertheless be reborn as an artist of a yet unknown type. And that it all was a quasi-religious proposal, a risk taken on faith.

In those years, Thornton Dial did not like to be observed while creating. Until the 2000s he would not work at all if anyone else was present. For three years, from 1987 to 1990, Ronald Lockett was the constant and sole exception to Dial's rule. Ronald got to be there, at the most formative period of Dial's development. I don't know how much they may have talked about art or anything else, but Ronald had the only ticket to the performance. The privilege exhilarated and humbled him; it was addictive and demoralizing, fueling and encumbering his ambition. Dial had boundless energy and psychological resiliency. Ronald was a depressive, and no fan of manual labor. Dial solved his (infrequent) artistic impasses by steamrolling them—sometimes building up

an entirely new painting on top of an existing painting, if necessary—and was not afraid to take a sledgehammer to his sculptural false starts. Ronald solved his artistic impasses by sitting in a chair for hours in front of a piece of plywood in his garage—a solitary chair facing a partially finished painting will always be my main memory of that garage (fig. 13). Dial could juggle four, five, six, or more works-in-progress simultaneously; Ronald did his best. Dial could sculpt fluently with Splash Zone Compound (the entire family's favorite bonding putty) in the half hour before it hardened; Ronald (and everyone else) couldn't—though Lockett did find effective pedestrian uses for it.

Pretty quickly Lockett figured out something even more dispiriting than the disparities in physical energy and technical magic: (1) Dial, as a member of the transitional-cum-paradigmatic generation that preceded Ronald's, possessed superior artistic access to lived history, the thematic grail that transfixed and eluded Ronald until much later in his career; and (2) aesthetics and history were somehow twinned in Dial's hands, therefore his art had scalable potential—he could create epics.

None of this diminishes Ronald. Part of an effective education is learning what you aren't, so you can discover what you are and what you can become. Ronald set about becoming an artist. It's obvious in retrospect that he began patiently and deliberately, through working and observing, to acquire important skills: how to gain deft control of construction tools such as tin snips, handsaws, and hammers; how to combine drawing (his lifelong favorite activity) and painting, and various ways paint could be deployed; how to think organically through the creative act rather than sequentially from concept to execution; and how to edit himself.

Most importantly, despite his awe of Dial's work, Lockett gradually initiated an understated, and increasingly sophisticated, set of responses to it which ultimately became a full-fledged artistic dialogue as the elder artist subsequently developed an interest in Lockett's work. This was a strategy nearly as brilliant as Ronald's decision to stay in Pipe Shop. Lockett benefited immeasurably from the long delay Dial had endured before his overdue "discovery" and artistic emancipation. He witnessed belated artistic output of an older generation, personified by Dial, taking shape right before his eyes, where he could enter a visual dialogue with it almost in real time and, in so doing, become one of its principal contemporary avatars.

We speak of "self-taught" artists, "vernacular" artists, and "outsider" artists, and there may be a place for Lockett and Dial in all three definitions, but it's a quality of artistic dialogue that unites both men with the main run of artists in the polyglot of world traditions throughout time. What's endlessly varied within the southern African American tradition are the ways its Dials and Locketts (must) discover, create, structure, and teach themselves their aesthetic dialogues and "epistolary" terms. For influence isn't dialogue; response is. To repeat: Lockett won the lottery, and knew it, when he became Thornton Dial's respondent. The Dial of the late 1980s, though, was in dialogue only with himself. The fury of his output, the lifetime of pent-up observations billowing forth, the Slinkylike momentum of his themes and thoughts, the ready-made storehouse of skills and creative experience, his continual referencing of earlier works and uncanny foreshadowing of later ones, as well as his oft-spoken credo "The more you do, the more you see to do" made him a veritable tradition of one; only after a few years of that, when he had achieved a kind of artistic critical mass, did he begin to look for other art and artists to respond to. (And, ironically enough, Lockett's art then began to influence Dial's.)

Ronald's early efforts are sometimes ravishing and often poignant, yet provisional and experimental. Their experimentality derives largely from the relative directness of their dialogic response and debt to things Dial was then doing. Dial made some found-object animals. So did Lockett—*Untitled (Elephant)* (plate 1), fashioned from a vacuum-cleaner hose; eloquent snipped-tin hobbyhorses (plate 2). Dial might produce a forest made of

cut metal or painted tree branches. Lockett would make his own, such as *Untitled* (plate 12).

Other pieces demonstrate just how scrupulously, inch by inch, Lockett was beginning to examine Dial's handiwork for tricks of the trade. In the interview cited earlier, Lockett also said, "I was always kind of surprised at some of the things that [Dial] did. He did a piece on Jesus Christ when Jesus Christ was in the tomb and I was kind of, like, you know, so amazed, and you know, he just captured that scene and artwork the way Jesus Christ would be in tomb. It looked good to me, the way he made it and the way he painted it. It came out right."[3] The referenced Dial piece depicts the Entombment, with a three-dimensional Christ, crowned with thorny rose stems, on an oval burlap bier that dominates a sheet of painted plywood. Lockett's *Morning of Peace* (plate 6), a nativity scene, was most likely his reply, an early major work dappled with recitations of Dial's technique, as in the scruffy, scumbled yellow brushwork depicting hay, and the bravura, dashed-off rooster, straight out of some Dial menagerie. It has the elder artist's calligraphic bursts of paint (the cockscomb, beak, and legs), tail feathers "sketched" with a cord that also worms around to imply a chicken's body, and a perfect cartoon eye to animate it. Throughout, however, key characteristics remain Ronald's own. There is a mood of stillness, mildness, and gentleness; an allegiance to naturalism; an acknowledgment of perspectival space; and the primacy of drawing and contour for delineating forms.

Some of Lockett's most memorable artworks of the period turn his earlier imitative responses on their heads. As he gained artistic self-knowledge, he really did begin to stake out ever-maturing replies to Dial's moves. For example, Dial could, almost as a matter of course, magnify any old autobiographical anecdote or offhand observation about social mores into a broad visual critique of injustice and exploitation. Lockett, as related earlier, didn't have this ability, but he wanted just as much as his mentor to represent the way(s) it felt to be black in America (even if the ultimate goal was to represent alternative

ways of being). So he came at this challenge from the opposite direction. He didn't have the same close contact with the lived local past or personal experience with Jim Crow that Dial did, either. Lockett scouted much further afield, to events of historical gravity—wrenching sites of mass psychological pilgrimage frequently saddled with artistic overexposure, about which nothing fresh could seemingly be said—then succeeded in finding in them something intimate, poetic, and personal anyway. *Hiroshima* (plate 27), *Holocaust* (plate 26), and *Smoke-Filled Sky* (plate 28), the last of which references the Ku Klux Klan torchings of black homes, are the most outstanding examples of this thematic tack.

Lockett's self-defined, make-it-up-as-you-go-along art school in Pipe Shop (of course, no one ever talked of Ronald's life like that, and I don't remember ever discussing art school again with him after 1987) had its extracurricular activities, as well. He didn't just attend "class" in the junk house and practice in the studio. He also went to the public library, for example, to learn about Jackson Pollock and other artists. Works such as *Poison River* (plate 14) and *Civil Rights Marchers* (plate 15), both of which were painted flat on the ground, point as much toward abstract expressionism as toward Dial (who also routinely poured and spattered and dripped his preferred medium, enamel house paint). A dam of pebbles rings *Poison River*'s edges to contain the pools of enamel. Ronald wasn't distinguishing between high and kitsch sources, either. The glazes and washes, as well as the use of trees and geological features as framing devices, that began to appear in his work are most likely traceable to ideas he picked up from watching the PBS television series *The Joy of Painting*, hosted by landscapist Bob Ross, who completed a painting on camera every episode. What other artist, real or fictional, could claim, without irony, to have as three core influences Jackson Pollock, Bob Ross, and Thornton Dial?

In 1987 Dial created his first "tiger cat" (fig. 14), the iconic image that would make his name, culminating in a one-person exhibition of them in New York in 1992

at the New Museum of Contemporary Art and the Museum of American Folk Art. The tiger works are among the greatest recontextualizations of the African American folktale—which is not to say I consider the tigers folk art at all—for their celebration of the culture hero and the trickster, their anthropomorphized fauna, their disguised social critiques, and, not least, their entertaining wisdom. Dial's tiger is also an omnibus, up-to-the-minute artistic symbol embracing popular culture (the Auburn University sports mascot, for example), local history, and autobiography. One of Dial's personal heroes was Perry "Tiger" Thompson, a Bessemer labor leader, coworker at the Pullman-Standard factory, boxer, radio host, and manager of a noted gospel group, the Sterling Jubilee Singers (later the CIO Singers), that sometimes sang at the Dial family's church.[4] The tiger merged Thompson's and Dial's selves, at least originally. Dial's tiger would find itself in all kinds of predicaments, from which it inevitably escaped and over which it triumphed. It bound together almost everything Dial wanted to say in the late 1980s and early '90s about being black in Alabama during his lifetime.[5] Eventually the tiger would stand for all kinds of crusaders and martyrs, including Martin Luther King Jr. To boot, the tiger's coloration and stripes opened up kaleidoscopic graphic possibilities.

This is not an essay about Dial's tigers. My intention is to give some inkling of how they do take over a room, and how hard it can be, artistically, if you are Ronald Lockett looking at Dial tigers all day in the junk house. It seems pertinent, however, to state my opinion that until Dial's work began to routinely feature tigers and they began to receive acclaim, Lockett had no consistent style. He had tendencies and characteristics only, as I mentioned in connection with his earliest pieces. He was a talented artist in his early twenties, testing out various media, technical possibilities, scales, and thematic approaches—and often coming up with works of enduring quality. He was looking at art any way he could think to find it—he was always ravenously curious—and certainly

wasn't committed to any one means of making a picture. Faced with and somewhat overwhelmed by this expressionist, narrator-hero tiger image, which perfectly suited Dial's life experiences and aesthetic but had little to do with Lockett's world or artistic gifts, the reasonable "response" for Lockett would probably have been to go off in an entirely different direction, toward anything except developing an animal protagonist of his own. Moreover, the tiger, like Dial, straddled two worlds two ways. It was a folkloric beast and a modern marcher for equality and justice; and it was hailed as a hybrid of folk art and contemporary art sensibilities (as exemplified by the museum partnership that presented the tiger exhibition). Ronald considered himself, if anything, to be, as regards his placement in African American culture, posthistorical and postfolkloric. Dial's eras preceded and felt lost to him.

Instead, the tiger's gauntlet became Lockett's final exam. Ronald had already created his share of animal-themed works, usually pertaining to endangerment, ecological despoliation, and extinction. A sequence in Lockett's art travels unhurriedly from his early, "hobbyhorse" stags to the silhouetted, paint-flicked buck and doe pressed behind chain-link fencing (plate 18) and then to what would emerge as Lockett's signature protagonist animal, the deer in his extensive *Traps* series, which was undertaken in the heart of Dial's "tiger" period. I think he did something surprising and profound. Unlike Dial, Lockett didn't have access to any experience with an epochal past. He was also barred access to the well of folklore so easily available to Dial. But he did have access to himself, to his own expanding body of work, and he turned his final exam into an unexpectedly comprehensive display of what he had learned from Dial. Lockett became his own version of Dial's "tradition of one." He mined his prior work, his talents, his views, and his interests to create the deer of *Traps*, all the while replying personally, and on behalf of his generation of black males, to Dial's tiger.

I'm guessing there were at least a dozen *Traps* in 1989 and 1990, and several stragglers later on as Lockett's interest in painting declined and he became fascinated with oxidized recycled tin. The classics of the series usually contain a number of stock and formulaic elements (like a folktale?). There is a solitary male deer, depicted mainly from the side. The torso and head are cut from tin, like the early hobbyhorses, and painted with naturalistic eyes, nostrils, and ears. Antlers are usually kneaded from Splash Zone Compound, a ferrous resin that "reads" as a ceramic. From the torso protrude hindquarters of wood, typically a length of two-by-four- or two-by-six-inch scantling, with legs of spindly tree branches. The deer is caught beneath a section of wire fencing or rope netting draped almost fashionably or decorously over and around the antlers and legs. Behind the deer is a landscape, of the type Lockett had been painting since the start of his artistic career, and a curated selection of images from earlier Lockett series (such as *Rebirth* or a group of paintings about the Garden of Eden) floating freely in space.

Materially and stylistically, *Traps* brought into one artistic conversation all Lockett had learned by doing and by looking—the series contains painting, drawing, cut tin, found wood and metal, Splash Zone Compound—and did it seamlessly, without hint of pastiche. The deer was also an excellent choice from among the many mammals Lockett had previously used. Although Pipe Shop is part of a midsize industrial city, patches of pastureland pop up within a few blocks of the Lockett home, and riparian woodland (more like scrubland) follows the creeks wandering through the neighborhood. Deer are indigenous and local (my father once took a great photo of one next to the junk house), whereas, significantly, the tiger was always treated by Dial as an exotic creature, captured, caged, and carried to America, like a slave. The fence/net in Lockett's traps can be considered the remains of that original tiger cage; that the trapped deer aren't really in complete cages, but are entangled in

small remnants of netting, adds to the sense of psychological self-confinement—something Dial's supremely self-confident tigers would never countenance.

The *Traps* deer are everything the tiger is not, while somehow remaining historically/artistically continuous with it. Deer are prey, not predators (but both deer and tigers trade on stealth). They are plain colored, even drab (though a tiger's bright coat and bold stripes also blend in for camouflage). They are frail (but, like tigers, are among nature's most sublimely athletic creatures). Lockett's art deer are passive, uncharismatic, without claim to heroic stature (yet it's unclear whether to consider them victims; deer have been and will be surviving in all types of environments). They hold graceful poses while tied up by minuscule pieces of fence that a Dial tiger would treat as nothing more than bugs on its windshield (yet even Dial's tigers, while almost always in motion, are also often heraldic). There is no narrative, no action, no struggle, no discernible obstacle or objective, just moods of exquisite enervation. The stillness of *Morning of Peace* has become stasis, mildness has become passivity, gentleness has become helplessness. We may be experiencing the trapped deer's daydreams.

The most overdetermined continuity with Dial's tiger is that Lockett's *Traps*-series deer are bucks. Thornton Dial has always been known exclusively as "Buck" by friends and family, so consistently that many of his acquaintances do not know his given name. Thornton Jr. is Little Buck. Thornton III is called Dwayne but sometimes felicitously referred to as Buck Wayne. I have always read the *Traps* series, accordingly, as Lockett's claim to an inheritance from Dial—a generational and artistic inheritance. (Given Ronald's strained relationship with his father at that time, and his lifelong turning toward Dial as a kind of second father, there is certainly much more worth considering in the autobiographical selection of a buck.) Yet I had always thought "the trap" referred more to the generational side of the inheritance: that the deer, in standing for Ronald and his post–civil

rights generation, was trapped by American society's stacked deck where the fortunes of young black men are concerned.

Certainly so, only now I also see the Lockett's trapped buck more transparently, as a twenty-something painter trying to contend with daunting aesthetic inheritances, an almost-too-heavy rack of antlers. So completely, yet so deferentially, does the deer represent everything the tiger is not, and still the deer is trapped when it should be free. The young artist had found a solution to nearly all of the tiger's challenges, and Ronald's answer, the deer, didn't back down from the burdens of history, autobiography, or the complicated psychology in play. Lockett was progressing at a geometric rate of development. But Dial's was exponential. As Lockett's skillfulness approached mastery, Dial's mastery approached genius.

Of all the works in the *Traps* series, 1989's *A Place in Time* (plate 20) hits me hardest. In it, the animal's movement has been halted by a swatch of what appears to be volleyball net. The buck looks back, where two porthole-like, cameo-like inserts have been painted into the sky. One of these portholes is black, with a small white skeleton—the *Rebirth* figure. Like a man meeting his childhood self in a dream, the now mature artist's alter ego, a trapped deer, gazes upon the artist's first nonjuvenile work. (Could the Lockett who painted *Rebirth* possibly have foreseen *A Place in Time*?) The early artistic statement about the future has led, after a more remarkable art education than anyone could concoct, to a not-so-minor masterpiece of ambivalence and self-doubt. How would Ronald ever get past the buck?

In 1990 Thornton Dial moved away and the junk house went dark. Ballooning fame and the need for increased studio space convinced him to find a bigger home with better security. He resettled in McCalla, close enough for him to drop in on his relatives in Pipe Shop (his half-brother, Arthur; two of his sons; "Auntie" Sarah Lockett; and Ronald) and for Ronald to visit the new studio regularly. Nevertheless, something had been severed, like an umbilical cord, and Ronald found himself, for the first time, on his own as an artist; yet I believe the move could not have come at a better time for both men. For Dial, the assertion is incontestable: his ambition, quality of life, and output skyrocketed. For Lockett, it is ambiguous: he had to grow up artistically (ultimately, he did) and personally (less successfully so), as Dial—that stabilizing presence—and several of his family members left town.

The years 1990–92 were probably the most artistically frustrating of Ronald's creative life. It was as if he was starting over, albeit with a highly developed set of skills, because he had so few new ideas. At Dial University, ideas reigned. Dial has always maintained, "Art is about ideas." The junk-house dialogue in which Ronald had participated was only nominally about technique and practical knowledge, and he had taken from it what he needed as a working painter. He was producing attractive, often beautiful art that also seems to have juggled his existing ideas without exploring new territory. One potent work does stand out from those years. In appearance, it is old hat for him: a black deer, with chicken-wire "hair," spread across a somber black-and-white ground lifted from the earlier *Smoke-Filled Sky* series—though by now Ronald could paint with even more delicacy. Ronald made the piece, *Instinct for Survival* (plate 30), in 1990 while his brother David was held captive by the Iraqi government during the first Gulf War. David and his duty partner, Specialist Melissa Rathbun-Nealy, were captured in Kuwait, then taken to a Baghdad prison—where as American POWs they became an international news item—before being released thirty-three days later. Ronald started *Instinct for Survival* not knowing David's prospects. Despite its conventionality, this piece and the inspiration of his brother brought some legitimate historical stakes into Ronald's immediate world. Nobody knew what was getting ready to happen in Ronald's work, but the reorientation toward courage-within-distress that began with *Instinct for Survival* would define Ronald's artistic sensibility right up to the final stages of his life.

I don't want to make too much of what happened next—at least, I don't want to make too much of the earliest works (because I don't think its significance sank in for him for a while). Somehow, in 1992 (most likely), he came across some oxidized tin somewhere in the neighborhood and decided to use it as a support or ground for a painting instead of snipping it into animal or human forms. (I think he made that decision because the tin's surfaces were simply too lovely to consider cutting it up.) Soon enough, he was using tin like plywood. Instead of painting on it, however, he was exploring everything except painting: punching holes to make silhouettes, nailing smaller slivers of tin to a tin background to arrange composite images, creating animal forms from the negative spaces of scissored tin (as in the remarkable *The Beginning* [plate 41], from 1993). He was teaching himself to "draw" with recalcitrant metal by cutting it into thin strips of varying lengths and regimenting them much like a zebra's stripes, to suggest animals or people. Pentimenti of pencil lines and nail holes insinuate time-lapse motion that frees images from the stasis that had been plaguing his paintings. We see a lot that is truly new—for Ronald's art and, so far as I am aware, art generally—except for one omission: the compositions remain fundamentally the same as *Instinct for Survival*—an iconic animal or a person on a mood-saturated background.

Some of this tin has a recondite history. It was scavenged from barnlike buildings owned by the Dial family that Thornton himself had painted decades earlier. Their evocative colors and textures are holdover paint brushed on by Dial long before his "discovery." (Later on, Lockett would pry his tin from all kinds of structures, including those on his own property and his father's.) Now, there is something weird going on those particular works. I don't exactly know what it is. In the tin works, Lockett has found/discovered/invented some techniques all his own—things Dial didn't do "first"—and he's doing them with and on a medium brimming with the older artist's presence. Perhaps a tribute, perhaps a supplanting, perhaps simply an acknowledgment that everything accretes

on things that have come before; or, most likely, all of these. For the first time, though, Lockett asserted control of the relationship as it plays out in his work.

And this tin really was a panacea for Lockett. It opened up solutions to so many of his impasses. It offered a way "out" of painting, a way of letting the old tin's intrinsic beauty (Ronald always wanted to have beauty in his work) do much of the job that paint had performed, freeing him to explore new techniques, ideas, and subjects. That he was forced to rely on rough implements and tools to achieve fine-grained results gave his tin work the street cred he had always believed his art lacked when compared to the ex–factory worker Dial's heavy-duty processes.

Weathered tin offered a conceptual bonanza, too. The intangible quality of history he had always found so present in Dial's life and art, and so wanting in his, lay waiting—tangibly—in the metal siding. The actions of time and human labor were etched deeply and intricately into the tin's surfaces. "Blooming" paint (whether faded or strongly colored), rust, stains, dents, cracks, cavities, pockmarks: the accrued visual and tactile interest instantly embeds in tin the grit of history, an archeology and an anthropology, assertions that the past supports and informs the present.

There was another connection to the past, a literal, local, and familial link. Lockett's artistic incubators had been rusted-tin buildings: the junk house and his garage. Some of his earliest surviving drawings had been made on tin outbuildings when he was a child. And the turkey coop that figured so prominently in Dial's "discovery" (and eventually made possible Ronald's artistic life)? Tin. It's straightforward enough to posit recycled tin sheeting as the chief building material of poverty, in the South and worldwide, and I think Lockett's tin pieces are mindful of that association, but they are more like ideal vessels made of the same cultural DNA they transport.

In the midst of these artistic revelations, unfairness intervened as never before: Ronald learned he was HIV positive. I am not exactly sure when this happened—

probably sometime in 1994. (He may have concealed his test result for a while; there were two women also involved somehow, and I don't know what else; I never asked him about anything in his personal life that he didn't volunteer to me.) Amid his bleakness and disorientation, his artistic uses of the tin deepened further. His interest in eschatology and liberation reawakened fully in the way he approached tin. Old tin decays, forecasting its own death, and its surface appearance progresses toward a bittersweet, happenstance glory, as if the tin were dying materially and revivifying aesthetically. His anxieties about the destinies of his body and his art found their form and forum.

Timothy McVeigh supplied the terror. The bomb blast at the Murrah Federal Building in Oklahoma City on 19 April 1995 catalyzed Lockett's most powerful series, *Oklahoma* (plates 51–55). At once the historical traumas Lockett had had to search so far afield for (as in *Hiroshima* and *Holocaust*) found us. And Ronald was one of us. Consider the following statement:

> I like how [the piece *Timothy* from the *Oklahoma* series] came out because I didn't want to offend anybody that was kind of connected to that tragedy. . . . It just came out the way I would have wanted it to. I don't think I could have asked for any more out of that one particular piece. I hope that when some people see it one day that they would feel the same way I do. That they can see something into it that I was expressing an honest emotion about it, not trying to offend anybody, but just trying to express what happened on April 19 when that Oklahoma bombing happened.[6]

That's Ronald talking, in 1997, about his *Oklahoma* series. He's an artist who feels intimately connected to the event he's depicting; who is comfortable with artistic decisions made in a political minefield; and who feels a sense of responsibility to the survivors and the bereaved (and their sensitivities), to future audiences, and to the truth as he perceives it. These *Oklahoma* pieces are blis-

tered buildings, cityscapes, patchwork quilts of old metal. Junk houses of human decency opposed to human evil.

Now it was as if the tin could represent anything Ronald wanted: *Fever Within* (a friend with AIDS), *The Inferior Man That Proved Hitler Wrong* (Jesse Owens at the 1936 Berlin Olympics), and, most piercingly, *Once Something Has Lived It Can Never Really Die* (the *Traps* deer/Ronald with HIV, as well as everything I've tried to write about the tin, condensed into nine words). And still more: *England's Rose* (plate 58), about Princess Diana's death in 1997, and *Sarah Lockett's Roses* (plate 57), about her death in 1995. These two are special because Ronald made them and a few related pieces in 1997, after his health had begun to fail. Each has a loose, improvisational grace, the undiscovered rock that remained—I'm guessing—after mountains of existential tension and technical-conceptual artistic worry eroded away. These last were the only colorfully painted tin pieces; he brightened up the rusty bits. Ronald probably knew he didn't have long himself. *England's Rose* and *Sarah Lockett's Roses*, works obliquely about Lockett's own approaching death, contain a valedictory nod to his mentor, Thornton Dial: ten years previously, in 1987, Dial had painted a red rose on the metal junk-house door (fig. 15).

Much as I would love to report differently, this is as far as Ronald's artistic development got.

NOTES

1. Ronald Lockett, interview with David Seehausen, 1997.

2. John Jeremiah Sullivan, "Unknown Bards," in *Pulphead: Essays* (New York: Farrar, Straus & Giroux, 2011), 275.

3. Lockett, interview with Seehausen.

4. See John Beardsley, "His Story/History: Thornton Dial in the Twentieth Century," in *Thornton Dial in the 21st Century* (Atlanta: Tinwood Books, 2005), 287. Beardsley's essay in this exhibition catalogue remains the most comprehensive biography of Thornton Dial.

5. It bears noting that Dial stopped using the tiger in his work around 1994, at about the same time that his attitudes toward the prospects for full racial equality clouded over and grew increasingly complex.

6. Lockett, interview with Seehausen.

CONTRIBUTORS

PAUL ARNETT has been documenting and researching African American vernacular art, artists, and culture since the 1980s. He was formerly the editorial director of Tinwood Books, where his major publication and exhibition projects included *Souls Grown Deep: African American Vernacular Art of the South* (vols. 1 and 2), *The Quilts of Gee's Bend, Thornton Dial in the 21st Century*, and *Gee's Bend: The Architecture of the Quilt*, among others. He is currently chairman of the Board of Trustees of the Souls Grown Deep Foundation, a nonprofit dedicated to the preservation and appreciation of African American vernacular art.

BERNARD L. HERMAN is the George B. Tindall Distinguished Professor of American Studies and Folklore at the University of North Carolina–Chapel Hill. His recent books include *Thornton Dial: Thoughts on Paper* (2011) and *Town House: Architecture and Material Life in the Early American City, 1780–1830* (2005). He is a past recipient of a National Endowment for the Humanities Fellowship for Independent Study and Research and held a John Simon Guggenheim Fellowship in 2011 for a collection of essays, *Troublesome Things in the Borderlands of American Art*. His *Saveur* essay on an Eastern Shore of Virginia Thanksgiving was anthologized in the best food writing of 2013. He serves as an Associate Fellow of the International Quilt Study Center, University of Nebraska–Lincoln; and on the regional board of the Slow Food Movement's *Ark of Taste*, the Board of Directors of the *Souls Grown Deep Foundation*, and several international editorial boards. His blog, *Meditations on the Worlds of Things* (http://blherman.wordpress.com/) reflects on ways of thinking about the textures of everyday life.

SHARON PATRICIA HOLLAND, professor in and associate chair of the Department of American Studies at The University of North Carolina at Chapel Hill, is a graduate of Princeton University (1986) and holds a PhD in English and African American studies from the University of Michigan, Ann Arbor (1992). She is the author of *Raising the Dead: Readings of Death and (Black) Subjectivity* (Duke University Press, 2000), which won the Lora Romero First Book Prize from the American Studies Association in 2002. She is also coauthor of a collection of transatlantic Afro-Native criticism with Professor Tiya Miles titled *Crossing Waters/Crossing Worlds: The African Diaspora in Indian Country*. Professor Holland is also responsible for bringing a feminist classic, *The Queen Is in the Garbage*, by Lila Karp, to the attention of the Feminist Press for publication (2007). She is the author of *The Erotic Life of Racism*, a theoretical project that explores the intersection of critical race, feminist, and queer theory. She is working on two book projects: one is titled simply "little black girl," and the other, "Perishment," is an investigation of the human/animal distinction and the place of discourse on blackness. You can see her work on food, writing, and all things equestrian on her blog, http://theprofessorstable.wordpress.com.

KATHERINE L. JENTLESON is the Merrie and Dan Boone Curator of Folk and Self-Taught Art at the High Museum of Art in Atlanta. Jentleson has been the recipient of awards and fellowships from Duke University, where she earned her doctorate in art history; the Smithsonian American Art Museum; the Evan Frankel Foundation; the Douglass Foundation; the Archives of American Art; and the Dedalus Foundation. She has also contributed research and writing to exhibitions at the American Folk Art Museum, the Ackland Art Museum, the Nasher Museum of Art, the Studio Museum in Harlem, and Prospect.3 New Orleans. Her dissertation, "Gatecrashers: The First Generation of Outsider Artists in America," examines how self-taught painters like Anna Mary Robertson "Grandma" Moses, John Kane, and Horace Pippin engaged and challenged diverse conceptions of American modernism after World War I.

THOMAS J. LAX was appointed associate curator of media and performance art at the Museum of Modern Art in 2014. For the previous seven years, he worked at the Studio Museum in Harlem, where he organized over a dozen exhibitions as well as numerous screenings, performances, and public programs. Thomas is a faculty member at the Institute for Curatorial Practice in Performance at Wesleyan University's Center for the Arts and on the Advisory Committee Vera List Center for Arts and Politics. Thomas received his BA from Brown University in Africana studies and art/semiotics, and an MA in modern art from Columbia University. In 2015, Thomas was awarded the Walter Hopps Award for Curatorial Achievement.

COLIN RHODES is professor of art history and theory and dean at the University of Sydney, Australia. He is a writer and artist. His books include the influential *Primitivism and Modern Art* and *Outsider Art: Spontaneous Alternatives*, both published by Thames & Hudson. He is editor (with John Maizels) of *Raw Erotica: Sex, Lust and Desire in Outsider Art*. He has written on various aspects of vernacular and self-taught art, including essays on Thornton Dial and (with Bernard Herman) an essay titled "Canons, Collections, and the Contemporary Turn in Outsider Art." He shows his work occasionally, including, most recently, exhibitions in Sydney, Guangzhou, and Seoul.

INDEX

Page and plate numbers in italics refer to illustrations.